100 Masterworks

from the Detroit Institute of Arts

The 100 Masterworks Presentation and Catalogue
have been made possible by a generous grant from
MICHIGAN BELL, AMERITECH, AND AMERITECH PUBLISHING, INC.

100 Masterworks
from the Detroit Institute of Arts

EDITED BY JULIA P. HENSHAW
INTRODUCTION BY WILLIAM H. PECK

HUDSON HILLS PRESS, NEW YORK
in Association with the Founders Society, Detroit Institute of Arts

Editor and Publisher: Paul Anbinder
Copy editor: E. B. Sanders
Designer: Betty Binns Graphics
Composition: U. S. Lithograph Inc.
Manufactured in Japan by Toppan
Printing Company.

First Edition
© 1985 by Founders Society
Detroit Institute of Arts.

Published in the United States by
Hudson Hills Press, Inc., Suite 301,
220 Fifth Avenue, New York, NY 10001.

Distributed in the United States by
Viking Penguin Inc.

Distributed in Canada by Irwin
Publishing Inc.

Distributed in the United Kingdom, Eire,
Europe, Israel, and the Middle East by
Phaidon Press Limited.

Distributed in Japan by Yohan (Western
Publications Distribution Agency).

Library of Congress Cataloguing in
Publication Data

Detroit Institute of Arts.
100 masterworks from the Detroit Institute
of Arts.
Bibliography: p.
Includes index.
1. Art—Michigan—Detroit. 2. Detroit
Institute of Arts. I. Henshaw, Julia P.
(Julia Plummer), 1941– .
II. Title. III. Title: One hundred
masterworks from the Detroit Institute
of Arts.
N560.A484 1985 708.1′74′34 84-48804
ISBN 0-933920-65-2

Contents

Foreword by Michael Kan, 9

The Detroit Institute of Arts and Its Collections by William H. Peck, 11

100 Masterworks from the Detroit Institute of Arts

Ancient Art

MESOPOTAMIAN, NEO-SUMERIAN PERIOD
Gudea of Lagash 20

EGYPTIAN, DYNASTY EIGHTEEN
Seated Scribe 22

ASSYRIAN
Tiglath-Pileser III Receiving
Homage 24

NEO-BABYLONIAN
Dragon of Marduk 26

PERSIAN, ACHAEMENID DYNASTY
Relief of a Persian Spearman 28

ROMAN COPY AFTER A GREEK ORIGINAL
Torso of Aphrodite 30

ETRUSCAN
Rider 32

SOUTH ITALIAN, APULIAN
Volute Krater 34

ROMAN, JULIO-CLAUDIAN PERIOD
Togate Statue of a Youth,
possibly Nero 36

EGYPTIAN, ROMAN PERIOD
Portrait of a Woman 38

PERSIAN, ILKHANID DYNASTY
Ardashir Battling Bahman,
Son of Ardawan 40

Asian Art

INDIAN, TAMILNADU, CHOLA DYNASTY
Chāmuṇḍā, Goddess of Death
and Destruction 44

INDIAN, TAMILNADU
Pārvatī, Consort of Śiva 46

QIAN XUAN
Early Autumn 48

CHINESE, YUAN DYNASTY
Śākyamuni Emerging from the
Mountains 50

CHINESE
Tray with Design of Cranes
and Chrysanthemums 52

DONG QICHANG
Freehand Copy of Zhang Xu's
Writing of the Stone Record 54

JAPANESE, MOMOYAMA PERIOD
Document Box 56

MARUYAMA ŌKYO
Entertainments of the Four Seasons
in Kyoto 58

JAPANESE, EDO PERIOD
Nō Robe 60

SUZUKI KIITSU
Reeds and Cranes 62

KOREAN, KORYŎ DYNASTY
Pillow 64

African, Oceanic, and New World Cultures

WESTERN KONGO, MAYOMBE
Nail Figure 68

BAMGBOYE
Epa Cult Mask 70

ZAÏRE, MANGBETU
Harp 72

GABON, FANG
Mask 74

EASTER ISLAND
Gorget 76

ALASKAN ESKIMO, ŌKVIK
Winged Object 78

PERU, NASCA PERIOD
Ceremonial Textile 80

MAYA
Embracing Couple 82

MEXICO, VERA CRUZ CULTURE
Palma with Maize God
Receiving a Human Sacrifice 84

NATIVE AMERICAN, SAUK AND FOX
Bear Claw Necklace 86

NATIVE AMERICAN, CHEYENNE
Shield 88

European Painting

JAN VAN EYCK
Saint Jerome in His Study 92

BENOZZO GOZZOLI
Madonna and Child with Angels 94

GIOVANNI BELLINI
Madonna and Child 96

HANS HOLBEIN THE YOUNGER
Portrait of a Woman 98

PIETER BRUEGEL THE ELDER
The Wedding Dance 100

PETER PAUL RUBENS
The Meeting of David and Abigail 102

NICOLAS POUSSIN
Selene and Endymion 104

GUIDO RENI
The Angel Appearing to Saint
Jerome 106

REMBRANDT HARMENSZ. VAN RIJN
The Visitation 108

JACOB VAN RUISDAEL
The Cemetery 110

GERARD TERBORCH
A Lady at Her Toilet 112

JEAN-SIMÉON CHARDIN
Still Life 114

HENRY FUSELI
The Nightmare 116

HILAIRE-GERMAIN-EDGAR DEGAS
Violinist and Young Woman 118

VINCENT VAN GOGH
Self-Portrait 120

PAUL CÉZANNE
Portrait of Madame Cézanne 122

GEORGES SEURAT
View of Le Crotoy, Upstream 124

PAUL GAUGUIN
Self-Portrait 126

PIERRE-AUGUSTE RENOIR
Seated Bather 128

European Sculpture and Decorative Arts

FRENCH
Crozier Head with Saint Michael
and the Dragon 132

NINO PISANO
Madonna and Child 134

LUCA DELLA ROBBIA
The Genoese Madonna 136

CIRCLE OF ROGIER VAN DER WEYDEN
The Lamentation 138

HUBERT GERHARD
Hebe 140

GIOVANNI LORENZO BERNINI
Model for the Chair of Saint Peter 142

ANDRÉ-CHARLES BOULLE
Clock of the Four Continents 144

JOHANN GOTTLOB KIRCHNER
Court Jester Joseph Fröhlich 146

JOHANN JOACHIM KÄNDLER
Court Jester "Postmaster"
Schmiedel 146

FRANZ IGNAZ GÜNTHER
Christ at the Column 148

MARTIN CARLIN
Jewel Cabinet 150

JEAN-BAPTISTE CARPEAUX
Le Génie de la Danse 152

Graphic Arts

ALBRECHT DÜRER
Adam and Eve 156

MICHELANGELO BUONARROTI
Scheme for the Decoration
of the Sistine Chapel Ceiling 158

JEAN-AUGUSTE-DOMINIQUE INGRES
Portrait of Marie Marcoz, later
Vicomtesse Alexandre de Senonnes 160

DAVID OCTAVIUS HILL AND ROBERT ADAMSON
Miss Elizabeth Rigby 162

HILAIRE-GERMAIN-EDGAR DEGAS
Ballet Dancer Adjusting Her
Costume 164

THOMAS EAKINS
Three Female Nudes, Pennsylvania
Academy of the Fine Arts 166

HENRI MATISSE
The Plumed Hat 168

CHARLES DEMUTH
Still Life: Apples and Bananas 170

EMIL NOLDE
Portrait of the Artist and His Wife 172

PABLO RUIZ Y PICASSO
Bather by the Sea (Dora Maar) 174

CHARLES SHEELER
Drive Wheels 176

American Art

JOHN SINGLETON COPLEY
Hannah Loring 180

AMERICAN
Desk and Bookcase 182

NATHAN BOWEN
Chest-on-Chest 184

THOMAS HARLAND AND ABISHAI WOODWARD
Tall Case Clock 186

PAUL REVERE II
Teapot 188

BENJAMIN WEST
Death on the Pale Horse 190

CHARLES WILLSON PEALE
James Peale (The Lamplight
Portrait) 192

REMBRANDT PEALE
Self-Portrait 194

GEORGE CALEB BINGHAM
The Trappers' Return 196

FREDERIC EDWIN CHURCH
Cotopaxi 198

JAMES ABBOTT McNEILL WHISTLER
Arrangement in Gray:
Portrait of the Painter 200

JAMES ABBOTT McNEILL WHISTLER
Nocturne in Black and Gold:
The Falling Rocket 202

JOHN SINGER SARGENT
Madame Paul Poirson 204

MARY CASSATT
Women Admiring a Child 206

MAURICE PRENDERGAST
Promenade 208

Modern Art

PABLO RUIZ Y PICASSO
Portrait of Manuel Pallarés 212

OTTO DIX
Self-Portrait 214

HENRI MATISSE
The Window 216

ERNST LUDWIG KIRCHNER
Winter Landscape in Moonlight 218

OSKAR KOKOSCHKA
Girl with a Doll 220

YVES TANGUY
Shadow Country 222

DIEGO RIVERA
Detroit Industry 224

JOAN MIRÓ
Self-Portrait II 226

HENRY MOORE
Reclining Figure 228

BARNETT NEWMAN
Be I 230

TONY SMITH
Gracehoper 232

Index of Names, 235

Foreword

The Detroit Institute of Arts is proud of the wide range and high quality of the many outstanding works of art that have been acquired in a century of collecting. It is appropriate in this centennial year that one hundred of the museum's finest pieces be featured in this publication, where such well-established favorites as *The Wedding Dance* by Pieter Bruegel are joined by more recent additions like the astonishing Kongo *Nail Figure*. We hope that this handsome book with its historical introduction to the museum and brief discussion of each piece will serve to amplify the pleasure of many visits to the Detroit Institute of Arts.

I would like to thank the following members of the museum staff who wrote entries for this catalogue: Timothy A. Motz, Elsie H. Peck, William H. Peck, and Penelope Slough, Department of Ancient Art; Sandra F. Collins and Suzanne W. Mitchell, Department of Asian Art; Vada Dunifer and David W. Penney, Department of African, Oceanic, and New World Cultures; Iva Lisikewycz, Jean Patrice Marandel, and John D. Turner, Department of European Painting; Peter Barnet, Alan P. Darr, Mary Kotner, and Bonita LaMarche, Department of European Sculpture and Decorative Arts; Kathleen Erwin, Ellen Sharp, and Marilyn F. Symmes, Department of Graphic Arts; Sarah Towne Hufford and Nancy Rivard Shaw, Department of American Art; and Davira S. Taragin and MaryAnn Wilkinson, Department of Modern Art. Arrangements for the *100 Masterworks* presentation in the galleries were handled by William H. Peck, Acting Chief Curator, who also wrote the historical introduction, and Suzanne W. Mitchell, Curator of Asian Art, with the assistance of Louis Gauci, Chief Museum Designer, and Janet Landay, Assistant Curator of Education.

The catalogue was edited by Julia P. Henshaw, Director, Publications, with the assistance of A. D. Miller, Editorial Aide. Catalogue photography was executed by Chief Museum Photographer Dirk Bakker and Robert Hensleigh, Associate Museum Photographer. In addition, our special thanks go to Paul Anbinder, President of Hudson Hills Press, for his commitment to this publication.

MICHAEL KAN
Acting Director
The Detroit Institute of Arts

The Detroit Institute of Arts and Its Collections

by William H. Peck, Acting Chief Curator

To celebrate one hundred years in the history of the Detroit Institute of Arts, it is appropriate to call attention to the great works of art that make up its permanent collection. The selection of a limited number of works from the various departments of the museum can only suggest the richness and the depth of the collection as a whole. The works of art *are* the museum; the strength and quality of the institution · ultimately rest with them.

A retelling of the history of any art museum will call attention to those attitudes of collecting that are peculiar to a particular community—attitudes that are subject to change as notions about the worthwhile values of art change and that have widened as more has become known about the artistic expression of peoples distant in time, place, and cultural background. The history of any art museum will, of necessity, reflect the history of art collecting. The community of Detroit in the 1880s was a considerably different place from the city of the 1980s, but the need was felt then as now for the kinds of inspiration and edification that can be gained from exposure to the visual arts. In 1883, following the lead of previously established American institutions, a group of public-spirited citizens organized the Detroit Art Loan Exhibition. A special building was constructed to house the exhibition and, in the ten weeks it was open to the public, the remarkable attendance was 130,000 people, approximately double the local population. A historical painting by the American artist Francis D. Millet entitled *Reading the Story of Oenone* (fig. 1) was purchased from the proceeds of the exhibition to become the foundation on which the Detroit collection would be built. Given the popular taste of the time, it was a perfect choice. The painting was meticulously realistic; it had its inspiration in classical antiquity; and, above all, it told a good story.

Figure 1 (*above*). Francis Davis Millet (American, 1846–1912), *Reading the Story of Oenone,* ca. 1882, oil on canvas, 76.2 × 147 cm (30 × 57⅞ in.). Purchased with the proceeds of the Art Loan Exhibition and Popular Subscription (83.1).

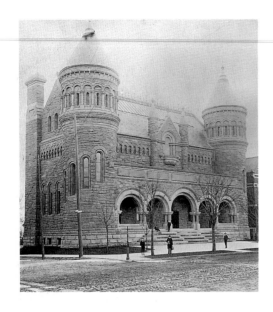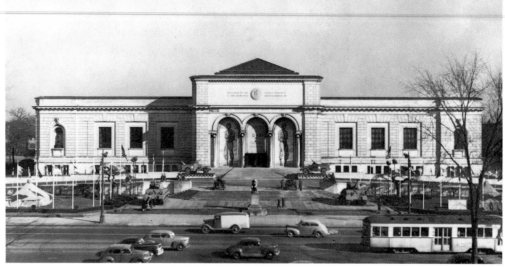

Figure 2 (*above*). The Detroit Museum of Art, ca. 1890.

Figure 3 (*above right*). The Detroit Institute of Arts, 1944.

In deciding to build its permanent "palace of the muses," Detroit acted somewhat later in the century than other cities in the United States, but the momentum generated by the Art Loan Exhibition had lasting results, as it led to the incorporation of the Detroit Museum of Art on March 25, 1885. Thomas W. Palmer and thirty-one other civic leaders joined in the act of incorporation, and plans for the permanent home of the new institution went forward. The Romanesque-style museum building on East Jefferson Avenue (fig. 2) was opened to the public on September 1, 1888. The first important collection to be exhibited in the new building was the group of old master paintings brought together by James E. Scripps, who recognized the possibility of making Detroit a center of artistic excellence through the acquisition of works of acknowledged quality. To Scripps this meant Dutch, Flemish, Italian, and English paintings by recognized painters of obvious skill. Many of the pictures acquired by Mr. Scripps are still on view in the galleries, a

tribute to his ideas of artistic excellence. Some of them are now attributed to different artists, however, because subsequent developments in art historical knowledge have made it possible to be more precise in such determinations. Principal among Scripps's paintings is *The Meeting of David and Abigail* by Peter Paul Rubens (p. 103); this and other works of painting and the graphic arts given by him, and later by his widow in 1909, formed the nucleus of the European collections. The important group of Dutch paintings in the museum owes its original strength to those early donations. It is not difficult to appreciate the appeal to a late-nineteenth-century newspaper magnate of the solid materialism of seventeenth-century Dutch paintings.

In its first years of rapid growth, the new Detroit museum devoted considerable space to plaster casts of classical sculpture, a practice common among American museums of the time. The traditions of Greece and Rome

Introduction

could be demonstrated only through this medium because collections of actual antiquities had not been made in this country. The galleries for Near and Far Eastern art were furnished principally with the large collection of artifacts accumulated by Frederick Stearns, the head of a Detroit pharmaceutical company, on his travels. Many of those objects are mainly of ethnographic interest, but even today there are Egyptian, Mesopotamian, and African objects from the Stearns collection on exhibit, indicating that some of these have stood the test of time.

In the first decade of the twentieth century, an attempt was made to broaden the collections of the museum. Money was subscribed to support excavations in Egypt, which resulted in the acquisition of some archaeological material. The important paintings and sculpture added during those years were primarily recent European and American works of a familiar and comfortable character, including examples by Mary Cassatt (p. 207), Childe Hassam, Constant Troyon, Thomas Dewing, Gari Melchers, Daniel Chester French, Paul Manship, and Elie Nadelman. It would be possible to describe the prevalent attitude as a reflection of a somewhat provincial outlook, but the direction taken during this period could also have been an attempt to balance the foundation of the Scripps old masters with what was then more modern, contemporary material.

In 1919, the Jefferson Avenue building with its art collections was given to the city of Detroit, and plans for a new structure on the present Woodward Avenue site were implemented. Begun in 1921 and opened to the public in 1927, the new municipal art museum was renamed the Detroit Institute of Arts (fig. 3). With the new building and organization came an expanded philosophy of collecting under the guidance of William R. Valentiner, who had first joined the staff as an advisor and became director in 1924.

With the promise of greatly increased space and the generous support of the city government, the museum initiated an acquisition program designed to make the collections a comprehensive survey of the history of art. The plan of the larger facility was devised to take the visitor on an imaginative walk through the ages. Paintings, sculpture, and the decorative arts were shown in galleries designed to reflect cultural origins. The acquisitions of the 1920s were based on the goals of furnishing the museum with the best works of art then available while filling as many significant gaps in the historical presentation as possible.

Works of art acquired during this phase of the collections' growth ranged from European paintings of the stature of *Saint Jerome in His Study* (p. 93), now recognized as a work by Jan van Eyck, and *The Wedding Dance* (p. 101) by Pieter Bruegel, to antiquities of various cultures including the Egyptian *Portrait of a Woman* (p. 39) and the Babylonian glazed tile relief of the *Dragon of Marduk* (p. 27). More modern and contemporary works were not neglected, as paintings by the French Realists (fig. 4) and Impressionists, including Claude Monet, Camille Pissarro, and Edgar Degas, entered the collection. The *Self-Portrait* (p. 121) by Vincent van Gogh and *The Window* (p. 217) by Henri Matisse represented radical departures in acquisitions for the museum.

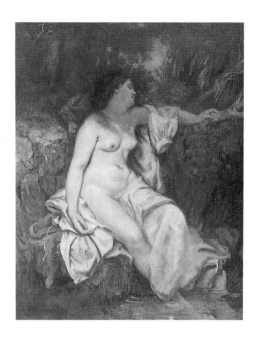

Figure 4. Gustave Courbet (French, 1819–1877), *Bather Sleeping by a Brook,* 1845, oil on canvas, 81.3 × 64.8 cm (32 × 25½ in.). City of Detroit Purchase (27.202).

13

Introduction

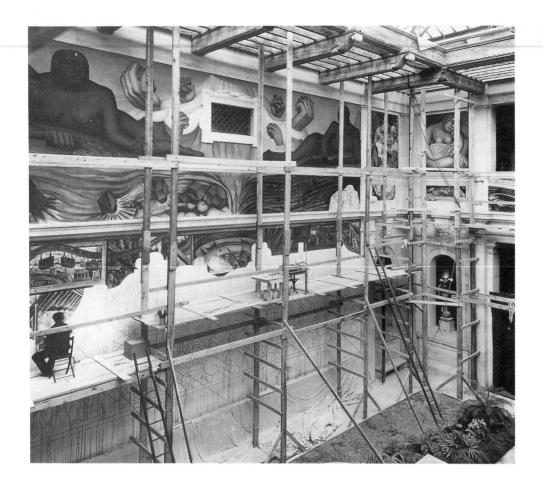

Figure 5. The *Detroit Industry* frescoes in progress, 1932.

Figure 6 (*right*). Titian (Tiziano Vecelli, Italian, 1485/90–1576), *Judith,* ca. 1570, oil on canvas, 113 × 95.2 cm (44½ × 37½ in.). Gift of Edsel B. Ford (35.10).

Figure 7 (*far right*). Agnolo Bronzino (Italian, 1503–1572), *Eleanora of Toledo and Her Son,* ca. 1555, oil on panel, 120.7 × 99.7 cm (47½ × 39¼ in.). Gift of Mrs. Ralph H. Booth in memory of her husband (42.57).

The first paintings by members of the German Expressionist movement, then daringly avant-garde and a favorite interest of Valentiner, were acquired. One of the great masterpieces in the Asian art collection, the *Early Autumn* (pp. 48–49) handscroll by Qian Xuan, indicates the breadth of the museum's attempt at encyclopedic representation.

The appointment of Valentiner, with his wide knowledge and vision, resulted in the development of the professional staff at the Detroit museum. During his long tenure, the essential character of the museum and its collections was formed, and departments of such varied character as Asian, Islamic, Textiles, and Graphic Arts had their beginnings. To a museum that had been interested in the local and the familiar, Valentiner brought a world view and created a substantial legacy for the city.

The period of the Great Depression and the decade of the 1930s was naturally one of serious restrictions on the growth of the museum. The Detroit city government could no longer be called on to appropriate large funds for the acquisition of art objects, so it was to the Founders Society and individual supporters that the museum had to turn. The generosity of enlightened patrons such as Mr. and Mrs. Edsel Ford and Mr. and Mrs. Edgar B. Whitcomb must be singled out. Edsel Ford commissioned the Mexican muralist Diego Rivera to create *Detroit Industry* (p. 225, fig. 5), the cycle of fresco paintings that is one of the jewels of the museum. Ford was also responsible during this period for a number of other important gifts, including a page from the Demotte *Shahnama* (p. 41), the most important Persian painting in the collection. His other donations include the *Judith* by Titian (fig. 6) and an important bronze by Pollaiuolo, another image of the biblical Judith.

 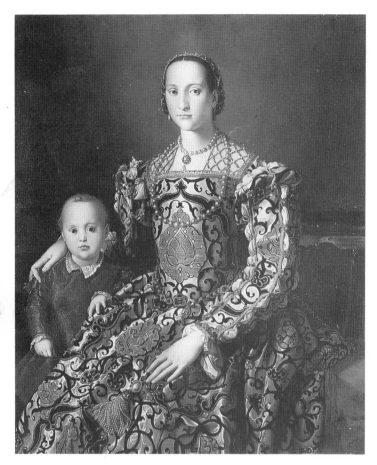

Edgar B. Whitcomb and Mrs. Whitcomb, daughter of James Scripps, began a series of donations in the 1930s that would continue until their bequest in 1953. In the decade of the 1930s, additions to the American collections continued with paintings such as a portrait by Thomas Eakins, a gift of Dexter M. Ferry, who gave much support to the acquisition of American art, and the James Abbott McNeill Whistler *Arrangement in Gray: Portrait of the Painter* (p. 201).

The time of the Second World War and the immediate postwar period was one of fine additions that filled gaps in a number of areas of the collection. The Etruscan bronze *Rider* (p. 33), the Indian stone sculpture of *Pārvatī* (p. 47), and paintings by great artists as diverse as Francisco Goya, Agnolo Bronzino (fig. 7), Frans Hals, and Jusepe Ribera suggest the range of the additions made.

Valentiner was succeeded as director in 1945 by Edgar F. Richardson, who had been a member of the staff since 1930. Under Richardson's direction, the American collection took on greater depth and breadth to become what is today one of the most important surveys of American art in the country. Into the 1950s, Richardson continued the policy of filling gaps in the general historical surveys of the museum. Assyrian reliefs (p. 25), Egyptian sculpture, and pieces of Irish Bronze Age gold vied for attention with a bronze *Eve* by Rodin, a painting of *Judith* (fig. 8) by Artemisia Gentileschi, and *The Nightmare* (p. 117) by Henry Fuseli.

The 1950s also saw the beginning of a series of substantial gifts and bequests that would do much to add to the quality and scope of the collections. In 1953 the Hearst Foundation

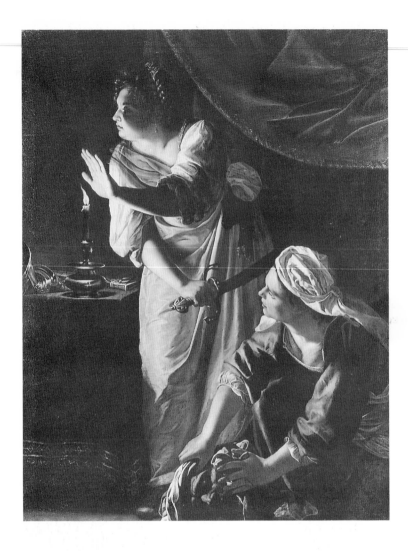

Figure 8. Artemisia Gentileschi (Italian, 1593–ca. 1651), *Judith and Her Maidservant with the Head of Holofernes*, ca. 1620–25, oil on canvas, 184.2 × 141.6 cm (72½ × 55¾ in.). Gift of Leslie H. Green (52.253).

Figure 9. *Boy's Corselet*, Italian, ca. 1605, blued steel, h. 75 cm (29½ in.). Gift of the William Randolph Hearst Foundation (53.200).

gave the museum a significant group of art objects, including Flemish tapestries, arms and armor (fig. 9), and architectural elements. The armor and tapestries exhibited in the Great Hall are among the great attractions of the museum. A number of bequests of collections came from individuals who had long associations with the museum and who had contributed greatly to its development over the years. Typical of these were the German Expressionist works, such as *Girl with a Doll* (p. 221) by Kokoschka, left to the museum in 1963 by Valentiner, who had been responsible for the beginning of this already fine collection. The bequest of John S. Newberry, curator of Graphic Arts from 1946 to 1957 and a great supporter of the Institute in many other ways, came to the museum in 1965. This bequest was the last in a long series of gifts that had contributed many drawings, watercolors, and sculptures, principally in the areas of French, German, and American art. These included works by such important artists as Cézanne, Degas (p. 165), Ingres, and Matisse (p. 169).

Willis F. Woods joined the staff as the successor to Richardson in 1962 and began expansion of both the building and the curatorial staff. The decade of the 1960s saw the addition of the Edsel and Eleanor Ford and the Jerome P. Cavanagh wings to the original building. The department of Performing Arts took on new importance in the activities of the institution. The department of Graphic Arts was expanded

as the collections were augmented under a new curator. Separate departments of American Art, European Art, and Ancient Art were constituted, and major acquisitions were added in almost every part of the collection. In 1973, Woods was succeeded as director by Frederick J. Cummings. The decade of leadership by Cummings was one of increased support from the state of Michigan, greater expansion of the staff and services of the museum, and important acquisitions, such as works by Frederic Edwin Church (p. 199) and Barnett Newman (p. 231). The department of African, Oceanic, and New World Cultures was formed and has since been responsible for major acquisitions, for example the Kongo *Nail Figure* (p. 69), and the addition of the Chandler/Pohrt Collection of Native American art and artifacts (p. 87). The department of Asian Art was reestablished after decades of dormancy and acquired a number of significant works in a short time (see pp. 53–65).

Of the fine private collections in the Detroit area that have come to the Institute of Arts, one must stand out as a truly great accomplishment on the part of a collector. Throughout his life Robert Hudson Tannahill was one of the strongest supporters of the institution and its activities. He was a guiding spirit not only for the museum, but also for the artistic life of the city of Detroit. The Tannahill paintings that came to the museum after his death in 1970 completed a lifetime of involvement. The museum's holdings in the areas of French Impressionism and Post-Impressionism (fig. 10) as well as early-twentieth-century art (fig. 11) were made a major strength of the

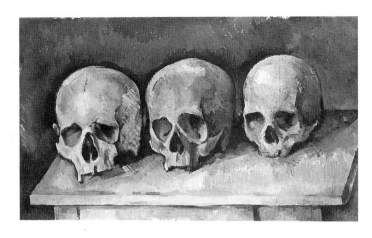

Figure 10. Paul Cézanne (French, 1839–1906), *Three Skulls*, ca. 1900, oil on canvas, 34.9 × 61 cm (13¾ × 24 in.). Robert H. Tannahill Bequest (70.163).

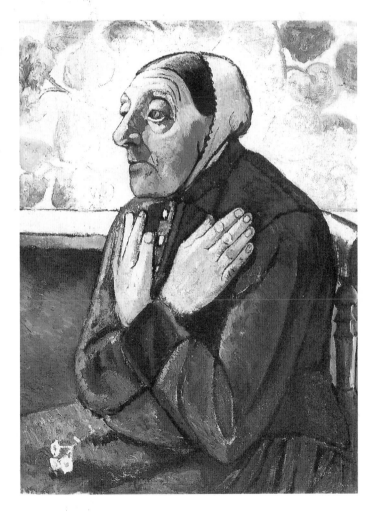

Figure 11. Paula Modersohn-Becker (German, 1876–1907), *Old Peasant Woman Praying*, 1905, oil on canvas, 75.6 × 57.8 cm (29¾ × 22¼ in.). Gift of Robert H. Tannahill (58.385).

Introduction

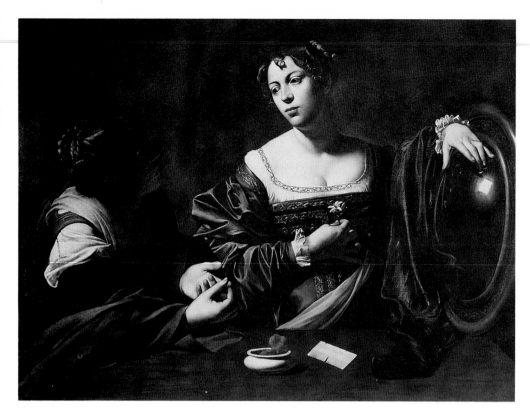

Figure 12. Michelangelo Merisi da Caravaggio (Italian, 1573–1610), *Conversion of the Magdalen*, 1597–98, oil on canvas, 97.8 × 132.7 cm (38½ × 52¼ in.). Gift of the Kresge Foundation and Mrs. Edsel B. Ford (73.268).

institution through his gift. Important works by Cézanne (p. 123), Picasso, van Gogh, Seurat (p. 125), Gauguin (p. 127), Renoir (p. 128), and Modigliani, to mention a small selection, joined the collection along with African sculpture, American and French decorative arts, drawings, and watercolors.

The bequest of Anna Thompson Dodge in 1971 further enriched the museum with a group of European objects, including fine French furniture such as the *Jewel Cabinet* (p. 151), porcelains, and other examples of the decorative arts. In 1977, Eleanor Clay Ford bequeathed to the Detroit Institute of Arts a group of Italian Renaissance paintings and English portraits—including works by Fra Angelico, Holbein (p. 99), Benozzo Gozzoli (p. 95), Perugino, Gainsborough, and Reynolds—the culmination of a long and generous involvement in the affairs of the institution. Mrs. Ford's continued support and the Eleanor Clay Ford Bequest Fund have made possible the purchase of many fine works, including Caravaggio's *Conversion of the Magdalen* (fig. 12). In one hundred years of its history, the Detroit Institute of Arts has undergone change through development and expansion.

The heritage of the past can be preserved for the edification of future generations by the dedication of a fine professional staff and the commitment of patrons and supporters. The growth of the Detroit Institute of Arts and its collections reflects the concurrent advancement of knowledge and increased appreciation of the visual arts and their importance to the quality of life. The accomplishments of the past provide us with the challenge for the future.

Introduction

Ancient Art

SOUTHERN Mesopotamia was invaded between circa 2220 and 2120 B.C. by the Guti, wild tribesmen from the mountains to the northeast, causing the fall of the powerful Akkadian Dynasty. For sixty years the region was in political turmoil under the Guti until the city-states, united under the leadership of the kings of Ur, drove the tribes out. The city-state of Lagash, west of the Tigris River, seems to have been spared by the Guti. Under the able rule of its *Ensis* (governors), Lagash enjoyed prosperity and peace, particularly during the twenty-year reign of the most powerful and celebrated of these rulers, Gudea (ca. 2141–2122 B.C.).

Inscriptions from the time of his reign reveal that Gudea was a pious ruler and a strong administrator who kept his state at peace. These inscriptions stress not military conquests and campaigns but rather his many building programs and dedications of statues and temples to the gods.

The Detroit *Gudea* is sculpted of paragonite, a semitranslucent gray-green stone. He is represented wearing a fur cap (a symbol of office) and a simple, shawl-like fringed garment which leaves his right shoulder bare. His hands are clasped in the traditional Sumerian attitude of worship. The cuneiform inscription on the shoulder and back emphasizes Gudea's piety, describing the building of a temple for his personal god, Ningiszida, and Ningiszida's consort, Gestinanna. The practice of placing an inscribed votive statue of a donor in a temple to express eternal devotion was initiated by the ancient Sumerians. The Detroit sculpture was carved and named for Gestinanna and was to be brought into her temple to honor her forever.

REFERENCES

A. Parrot, *Tello,* Paris, 1938, p. 165.

Henri Frankfort, *The Art and Architecture of the Ancient Orient,* Baltimore, 1955, pp. 47, 48, 49.

Eva Strommenger, "Das Menschenbild in der altmesopotamischen Rundplastik von Mesilim bis Hammurapi," *Baghdader Mitteilungen,* vol. 1 (1960), p. 65.

Gudea of Lagash

Mesopotamian, Neo-Sumerian period, ca. 2141–2122 B.C.

Paragonite; h. 41 cm (16⅛ in.)

Founders Society Purchase, Robert H. Tannahill Foundation Fund (82.64)

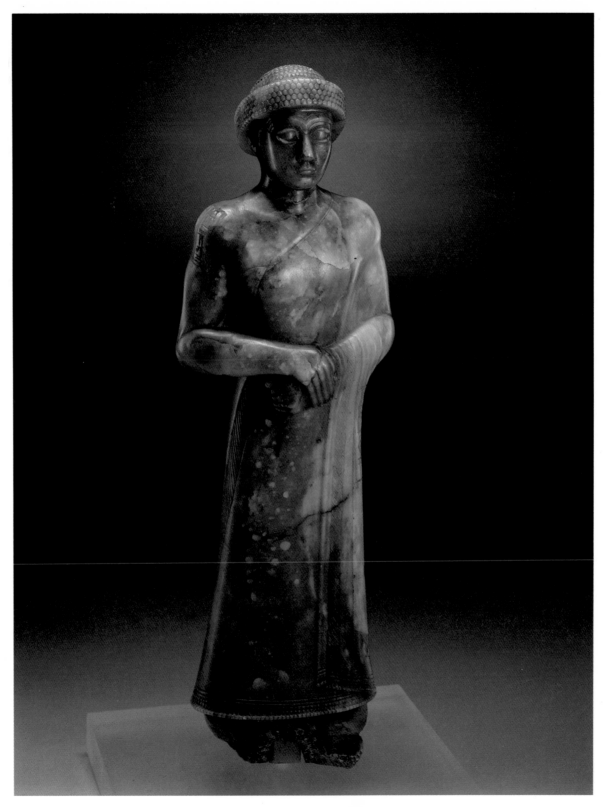

MESOPOTAMIAN, NEO-SUMERIAN PERIOD

Gudea of Lagash

IN the three-thousand-year history of ancient Egyptian civilization, one of the great periods of artistic accomplishment was in Dynasty Eighteen during the New Kingdom. The culture was at its height commercially, intellectually, and artistically. Artistic style reflected the opulent life of the court; a relaxed realism depicted an ideal quality of life seldom attained in Egypt.

More formal examples of Egyptian sculpture hardly prepare us for the expressive qualities and subtle rendering of this small masterpiece, *Seated Scribe*. The pose of the figure is relaxed but attentive. He sits with a papyrus scroll unrolled on his kilt and draped from the raised knee downward. While one hand holds the scroll, the other is poised in the act of writing, and the head is lowered in concentration, as if the scribe were receiving divine inspiration. A sculpture such as this served as a visible and permanent "prayer" to the patron of scribes, the god Thoth.

The rank of scribe was one of great importance in the Egyptian hierarchy. The education and training of scribes prepared them for important positions in the complex bureaucracy of the country. They could rise within the ranks to the highest levels, filling posts of trust and responsibility.

The sculptor who produced this image must have worked at the end of the reign of Amenhotep III and the beginning of that of his son, the so-called heretic king, Akhenaton. The style is consistent with one that developed slowly through Dynasty Eighteen and culminated in the intimate and increasingly realistic representations from the time of Akhenaton's short revolution. Similar pieces have been found at Akhenaton's capital at Tel el-Amarna.

REFERENCE

William H. Peck, "Two Seated Scribes of Dynasty Eighteen," *Journal of Egyptian Archaeology,* vol. 64 (1978), pp. 72–75.

Seated Scribe

Egyptian, Dynasty Eighteen, reign of Amenhotep III, 1403–1365 B.C.

Basalt; h. 6.4 cm (2½ in.)

Gift of Mrs. Lillian Henkel Haass and Miss Constance Haass (31.70)

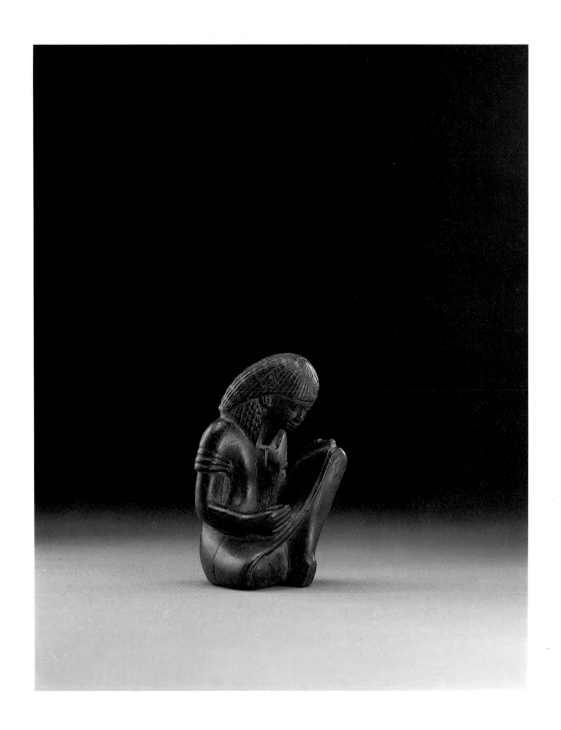

EGYPTIAN, DYNASTY EIGHTEEN

Seated Scribe

TIGLATH-PILESER, king of Assyria, built a royal palace at Nimrud (the biblical city of Calah) in northern Iraq. The walls of its principal rooms and courtyards were decorated with large carved-stone slabs of which this relief formed a part. The sculptures were intended as propaganda, impressing visitors with the power and importance of the king. From the ninth to the end of the seventh century B.C., the kings of Assyria adorned their various palaces with reliefs depicting scenes of war and the hunt as well as solemn court rituals, accompanying the scenes with a written account of their deeds.

This relief shows the king in a tall headdress, his hand raised in greeting, while three courtiers stand before him. A helmeted warrior prostrates himself before the king, who is attended by a servant with a fly whisk. The slab is the lower half of a two-register relief, and a small portion of a cuneiform inscription describing a military campaign is visible just above the heads of the figures. The king's wars are also documented in the Bible. His campaigns into Syria and Palestine are recorded, and his attacks are mentioned in the accounts of three of the kings of Israel, in which he is called Pul (II Kings 15:19, 29; 16:7).

Within little more than a hundred years after the creation of this royal relief, the kingdom of Assyria, exhausted by foreign military excursions, disappeared.

REFERENCE

R. D. Barnett and Margarete Falkner, *The Sculptures of Assur-nasir-apli II (883–859 B.C.), Tiglath-Pileser III (747–727 B.C.), Esarhaddon (681–669 B.C.)*, London, 1962, p. 27.

Tiglath-Pileser III Receiving Homage

Assyrian, 745–727 B.C.

Limestone; 122 × 239 cm (48 × 94 in.)

Founders Society Purchase, Ralph H. Booth Fund (50.32)

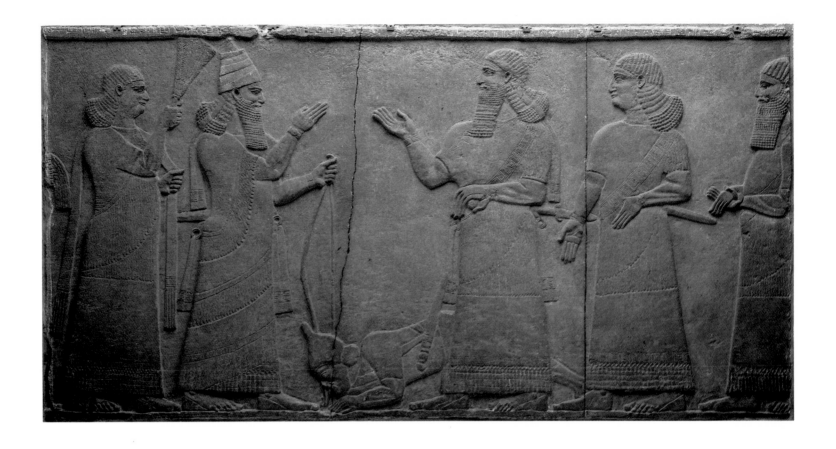

Tiglath-Pileser III Receiving Homage

In an extensive building program, King Nebuchadnezzar of Babylon embellished his capital city with palaces, temples, a monumental processional way, and a gateway. This gateway, dedicated to the goddess Ishtar, led through the fortification walls of the inner city to the religious center. It was decorated with molded bricks covered with colored glazes, forming images of dragons and bulls in alternating tiers standing in relief against a dark-blue tile background. The dragon seen here was a mythical creature sacred to Marduk, the principal god of the city of Babylon, and displays the characteristics of several animals: the head of a serpent with a viper's horns, a body covered with scales, the front feet of a feline, the hind feet of a bird of prey, and a scorpion's tail.

The Ishtar Gate and its processional way, lined with glazed-brick images of lions, was created to impress the visitor and glorify the Babylonian king. It must have also awed the prisoners of war (among them the Hebrews) that Nebuchadnezzar's army brought back as captives from their many foreign military campaigns. Nebuchadnezzar's campaigns, transportation of captured people, and the eventual destruction of Jerusalem are recorded in the book of II Kings (24:10–16, 25:8–15).

The art produced under Nebuchadnezzar represents the last flowering of Babylonian culture which came to an end with the Persian conquest of all the land between the Tigris and Euphrates rivers in 583 B.C.

REFERENCE

Joan Oates, *Babylon,* London, 1979, pp. 144–59.

Dragon of Marduk

Neo-Babylonian, reign of Nebuchadnezzar II, 604–562 B.C.

Glazed brick; 115.6 × 167 cm (45½ × 65¾ in.)

Founders Society Purchase (31.25)

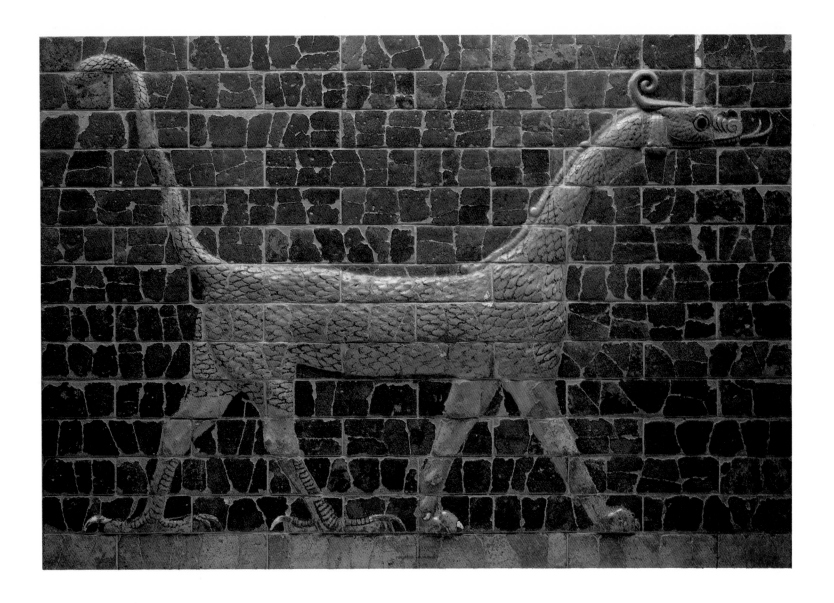

NEO-BABYLONIAN

Dragon of Marduk

DARIUS I (522–486 B.C.), the greatest of the Achaemenid kings of Persia, ruled an empire that for two hundred years stretched from central Asia to Egypt. In 518 B.C. he began the construction of Persepolis in southwestern Iran, a ceremonial capital that probably also had religious significance. What remains today of the lavish palaces and administrative buildings set on a vast platform are monumental limestone stairways, doorjambs, window frames, and columns, all splendidly decorated with carvings such as this one, a fragment of a relief from a balustrade.

The high quality of the Detroit relief indicates that it probably decorated a building constructed under the rule of Xerxes I (485–465 B.C.). Originally the entire relief represented a procession of Persian spearmen clad in long draped and pleated robes, wearing headdresses made of feathers or felt, and holding spears before them.

The head of this spearman illustrates the various artistic influences that contributed to the formation of the Achaemenid style. The large frontal eye and elaborately curled hair are Assyrian stylizations, whereas the subtle modeling around the brow and cheek are derived from the Ionian Greek style. While the forms of Achaemenid art are derived from foreign sources, the static and repetitious nature of this sculpture, as well as its exquisite detail and courtly quality, make it uniquely Persian. The austere polished limestone surfaces would have been enlivened by bright colors and metal fittings representing weapons or jewelry. Despite its unfinished condition—the beard was never delineated into curls—this portrayal of a spearman is one of extreme elegance and harmonious proportions.

The Achaemenid Dynasty was so weakened by internal strife that when Alexander the Great successfully invaded Persia and burned Persepolis in 330 B.C., the dynasty crumbled.

Relief of a Persian Spearman

Persian, Achaemenid Dynasty, fifth century B.C.

Limestone; 26.4 × 29.5 cm (10⅜ × 11⅝ in.)

Robert H. Tannahill Foundation Fund (78.47)

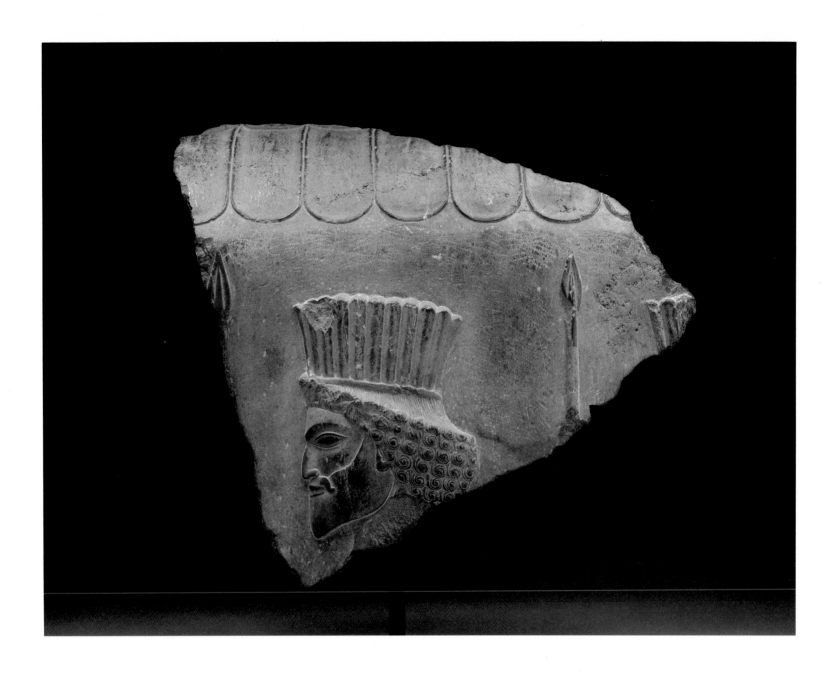

PERSIAN, ACHAEMENID DYNASTY

Relief of a Persian Spearman

MANY pieces of so-called Greek sculpture in museums are actually Roman copies of earlier Greek statues. Some of these pieces are exact, almost mechanical copies, and some are free adaptations of the figure, pose, and style of the earlier work. The Greek originals were usually cult statues, decorations for temples, or idealized portraits honoring public figures. The Roman copies were used for these purposes as well, but also to ornament public and private buildings and gardens and even, in altered copies, for such decorative purposes as monumental candle stands. These copies are collected today not only for their value as Roman works of art but because often they provide our only indication of the appearance of well-known Greek originals mentioned by ancient authors.

This figure of Aphrodite of the Venus Genetrix type, based on an original of the last quarter of the fifth century B.C., shows the goddess disrobing to compete with Hera and Athena for the title as the fairest of goddesses. Her right hand would have held a corner of her chiton, or inner garment, while her left held the trophy of the competition, a golden apple. The artist of the original on which this copy was based worked within the bounds of propriety and revealed the figure of the goddess through a thin garment which clings to the body as if wet. In contrast to the somewhat roughened texture of the clothing, the exposed areas have been highly polished to imitate the smoothness of human skin.

Although the head of the original would have carried the idealized features of Aphrodite, it is likely that this example did not. It was common during the period of the Roman Empire for a public or private person to be represented in the guise of a god or goddess, a deity to whom the person was particularly devoted or one whose qualities he or she was thought to possess. Thus, the head of this figure may well have borne the features of a prominent Roman woman, perhaps even a member of the imperial family.

REFERENCE

William H. Peck, "A New Aphrodite in Detroit," *Bulletin of the Detroit Institute of Arts,* vol. 54 (1976), pp. 124–32.

Torso of Aphrodite

Roman copy of the first or second century A.D. after a Greek original of the late fifth century B.C.

Marble; h. 153.7 cm (60½ in.)

Gift of Mr. and Mrs. Henry Ford II (74.53)

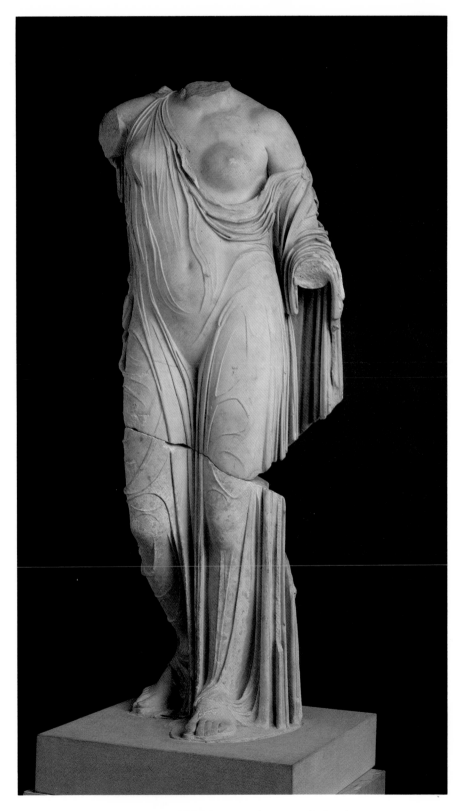

ROMAN COPY AFTER A GREEK ORIGINAL

Torso of Aphrodite

THROUGH contact with mainland Greece and Greeks living in southern Italy, the Etruscans of central Italy developed a liking for Greek art and collected it avidly. Their artifacts show considerable influence from Greek art, but Etruscan artists adapted the styles and treated the themes in their own distinctive ways.

The *Rider* shows this creative adaptation at its best. Originally mounted on a bronze horse, the figure was most likely a votive offering left at a temple. It is said to have come from Spina, an Etruscan town on the northern Adriatic coast, which had close trade connections with Athens in the fifth century B.C. The pose is quiet and restrained, in keeping with the spirit of classical Greek art. The musculature is naturalistic yet softly modeled in a way that contributes to a sense of tranquility in the figure.

In marked contrast is the treatment of the face and garment of the rider. The artist has avoided the naturalistic, clinging garments shown, for example, in the Parthenon frieze sculptures and has instead stressed the ridges and folds of cloth in a stylized fashion, which emphasizes by contrast the soft modeling of the body. The face is deliberately archaic, quite symmetrical, and more boldly rendered than the rest of the body. The eyes are large and almond-shaped with each iris and pupil shown as one large, ridged hole. With these devices the artist draws the viewer's attention to the face.

The *Rider* is an excellent example of the way Etruscan artists combined disparate elements to create something distinctively new. The result is a figure with a great deal more presence than we would expect in such a small statue.

REFERENCES

Emeline Hill Richardson, "The Etruscan Origin of Early Roman Sculpture," *Memoirs of the American Academy in Rome*, vol. 21 (1953), pp. 77, 115–16, 118, 123.

Fogg Art Museum, Cambridge, Massachusetts, *Master Bronzes from the Classical World*, 1967, p. 176, no. 179.

Otto J. Brendel, *Etruscan Art*, Harmondsworth, Middlesex, 1978, pp. 317–18.

Rider

Etruscan, second half of the fifth century B.C.

Bronze; h. 26.7 cm (10½ in.)

City of Detroit Purchase (46.260)

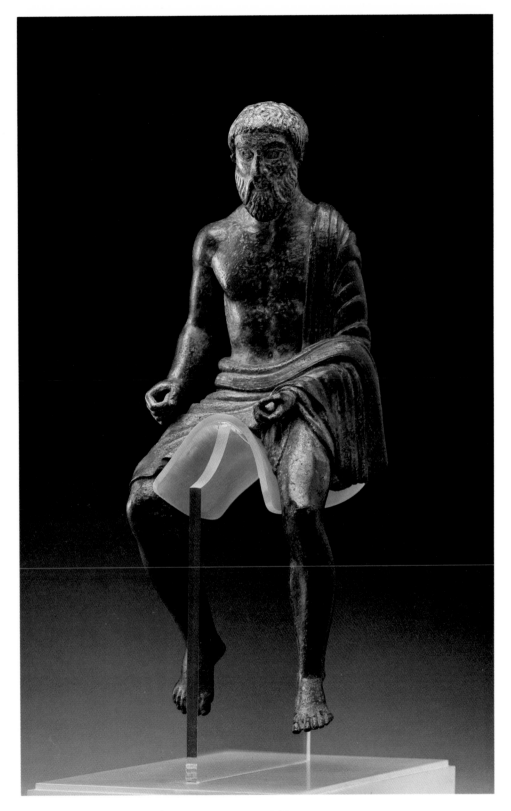

ETRUSCAN

Rider

Near the end of the fifth century B.C., there arose in the Greek colonies of South Italy and Sicily a distinctive style of ceramic production and decoration which, while having its roots in the mainland Greek Attic tradition, developed in a direction that has come to be characterized as South Italian style. More exuberant than its Attic antecedents, work in this style at the same time conveys an attitude of great seriousness toward life and religious experience.

Intended to serve a funerary function, this elaborate volute krater, from the region of Apulia in the southeast of the Italian peninsula, has been attributed to a master designated as the Baltimore Painter (so-called after a work by the same hand in the collection of the Walters Art Gallery, Baltimore), one of the most important and influential artists working at the end of the fourth century B.C. His large-scale vase paintings are rich in imagery and complex in composition.

The Detroit krater bears a depiction on one side of a sculpted image of the deceased in a shrine, probably in imitation of the grave monuments of mainland Greece. Other subjects on this side include youths and maidens bringing offerings to the tomb, and a banquet scene. On the other side are an assemblage of the Olympian gods grouped around Zeus and Hera, a triumphant procession of Dionysus in his panther-drawn chariot, and a battle of Greeks and Amazons.

The vase painters of South Italy drew on Greek religious beliefs and tradition and invented a style that conveyed the range and depth of their concern with the afterlife. Freed from the restrictions of mainland conventions, they created a style expressive of their own convictions.

Volute Krater

South Italian, Apulian, 320–310 B.C.

Glazed ceramic; h. 120 cm (47¼ in.)

Founders Society Purchase, Hill Memorial Fund, William H. Murphy Fund, Dr. and Mrs. Arthur R. Bloom Fund, and Antiquaries Fund (1983.25)

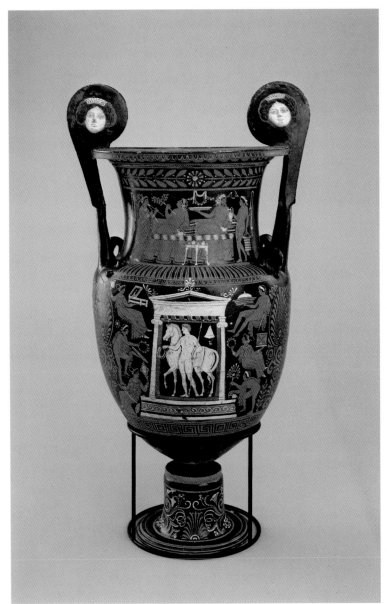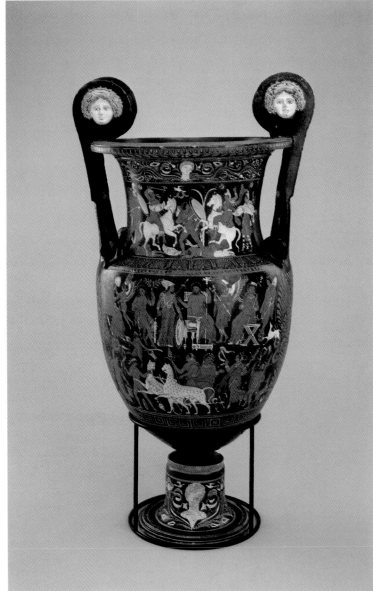

Volute Krater

PORTRAITS from the Roman Empire draw upon the inheritance of the Romans from three peoples: the Greeks, the Etruscans, and the inhabitants of central Italy. Greek artists contributed an understanding of anatomy and a tendency to idealize the features of the model. Etruscans captured both individual expression and intensity of personality. Italic artists represented every crease and blemish of the skin in extreme realism. These tendencies are combined in the portraiture of the Roman Empire, with various elements emerging in different periods.

This figure is an example of the relatively realistic sculpture from the mid-first century A.D. Although the general shape of the head and the large, wide-set eyes are reminiscent of earlier portraits of the Emperor Augustus, the hairstyle, full cheeks, and prominent ears mark this as a probable portrait of Nero, the last of the Julio-Claudian emperors; the adopted son of the emperor Claudius, he was named heir to the throne in preference to Britannicus, Claudius's natural son.

This statue shows the young Nero, aged fourteen or fifteen, donning the toga virilis, the cloak of the adult Roman male, his right hand pulling the cloth down in front to form a fold known as an umbo. Within a few years, Nero would profit from the murders of his adopted father and brother and later would murder his wife and his mother. There is no foreshadowing in this portrait, though, of these or other crimes attributed to him, only the graceful figure of a boy stepping with uncertainty into the world of adults.

REFERENCES

Cornelius Vermeule, "Three Imperial Portraits in America: Nero, Britannicus, and Faustina II from Asia Minor," *Boston Museum Bulletin,* no. 349 (1969), pp. 124-25.

"Major Acquisition by the Detroit Institute of Arts," *Archaeology,* vol. 24 (1971), p. 54.

Ulrich W. Hiesinger, "The Portrait of Nero," *American Journal of Archaeology,* vol. 79 (1975), p. 116.

Togate Statue of a Youth, possibly Nero

Roman, Julio-Claudian period, ca. A.D. 50

Marble; h. 139.7 cm (55 in.)

Founders Society Purchase, Mr. and Mrs. Walter B. Ford II Fund, General Endowment Fund, Hill Memorial Fund, Miscellaneous Gifts Fund, William E. Murphy Fund, Slovak Fund, the sale of three Study Collection paintings, and donations from Mr. and Mrs. Lester Gruber, Mr. and Mrs. Richard Manoogian, J. M. Pincus Foundation, the Volunteer Committee, and Mr. and Mrs. Theodore O. Yntema (69.218)

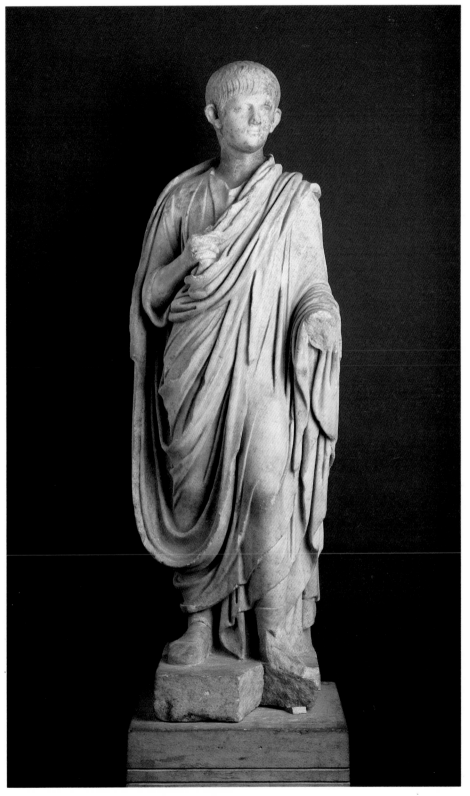

ROMAN, JULIO-CLAUDIAN PERIOD

Togate Statue of a Youth, possibly Nero

WITH the coming of foreign influences to Egypt in its centuries of declining glory, customs that were typically Egyptian, such as the practice of mummification, underwent important changes. Traditionally, the face of the mummified body had been covered with a three-dimensional mask modeled to represent the features of the deceased. After the conquest of Egypt by Alexander the Great and the rule of the country by the dynasty of the Ptolemys, the influence of the Greco-Roman world became apparent. Portraits like this one, painted on a wooden panel in encaustic (a wax-based medium), often were substituted for the sculpted mummy masks.

Examples like the *Portrait of a Woman* are among the best-preserved and most vivid painted images from antiquity, and they reflect a cosmopolitan Egypt at a time of contact with Greece and Rome. Realistic portraiture on panel was one of the acknowledged glories of both Greek and Roman art, according to descriptions by ancient authors, but it is only in the dry climate of Egyptian burial grounds that a large number of such paintings have survived. From evidence such as titles painted on the panels, the tombs in which they were found, or the nature of the representations themselves, it is apparent that these painted faces represent a cross-section of the affluent middle class of the first through fourth centuries A.D. The arresting image of this woman provides the viewer with a glimpse of life in the ancient world.

REFERENCE

The Detroit Institute of Arts, *Mummy Portraits from Roman Egypt,* 1967, pp. 17, 19, no. 10.

Portrait of a Woman

Egyptian, Roman period, A.D. 100–300

Encaustic on wood; 44.5 × 24.5 cm (17½ × 9⅝ in.)

Gift of Julius H. Haass (25.2)

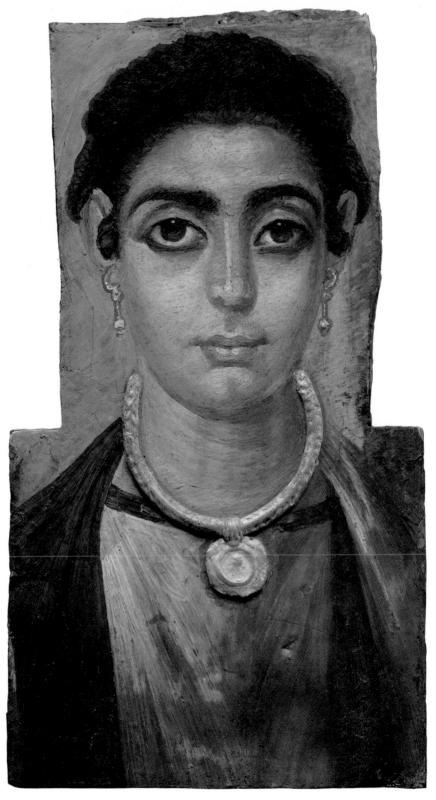

EGYPTIAN, ROMAN PERIOD

Portrait of a Woman

In the 1920s Paris art dealer Georges J. Demotte acquired a *Shahnama* manuscript, the epic Book of Kings by the eleventh-century Persian poet Firdausi. Demotte dispersed the manuscript, selling the fine miniatures to collectors and museums throughout Europe and America. Only fifty-eight paintings exist today although originally the book must have contained over a hundred.

The Demotte *Shahnama* is one of the earliest surviving and most important Islamic manuscripts, famous for its monumental paintings charged with drama and a sense of tragedy. It was painted at a time of upheaval in Iran when the canons of Persian painting were being formed. The Mongols had devastated the Near East, entering Baghdad in 1258. Tabriz, in northwestern Iran, became the capital and a center of culture and learning in the early fourteenth century under the Mongol vizier Rashid al-Din. The Demotte *Shahnama* was probably produced in Tabriz under the patronage of his son, the vizier Ghiyath al-Din between November 1335, when he appointed Arpa Khan as sultan, and May 3, 1336, when the sultan was killed.

In the Detroit miniature, the historic hero Ardashir is seen on the right as he battles the son of his enemy Ardawan for the throne of Persia. The painting reflects an earlier fourteenth-century Mongol style as well as Western influences. More important, however, are new Chinese landscape elements derived from contemporary textiles and ceramics and earlier T'ang cave paintings. These include the delineation of trees, grasses, and strange rock formations and an increasing interest in three-dimensional space. Added to these Chinese features is a subtle feeling for color which heightens the drama of the scene, as in the sinister darkness of the tree beside the delicate colors of the armor.

REFERENCES

Ivan Stchoukine, "Les Peintures du Shah-nameh Demotte," *Arts Asiatiques,* vol. 5 (1958), pp. 83–96.

Ernst Grube, *Muslim Miniature Paintings from the XIII–XIX Century from Collections in the United States and Canada,* Venice, 1962, p. 17.

Oleg Grabar and Sheila Blair, *Epic Images and Contemporary History: The Illustrations of the Great Mongol Shahnama,* Chicago and London, 1980, pp. 4, 12, 14, 17, 19, 21, 22, 24, 29, 33, 35, 37, 38, 43.

Ardashir Battling Bahman, Son of Ardawan

Persian, Ilkhanid Dynasty, first half of the fourteenth century

Tempera and ink on paper; 59 × 39.7 cm (23¼ × 15⅝ in.)

Gift of the Edsel B. Ford Fund (35.54)

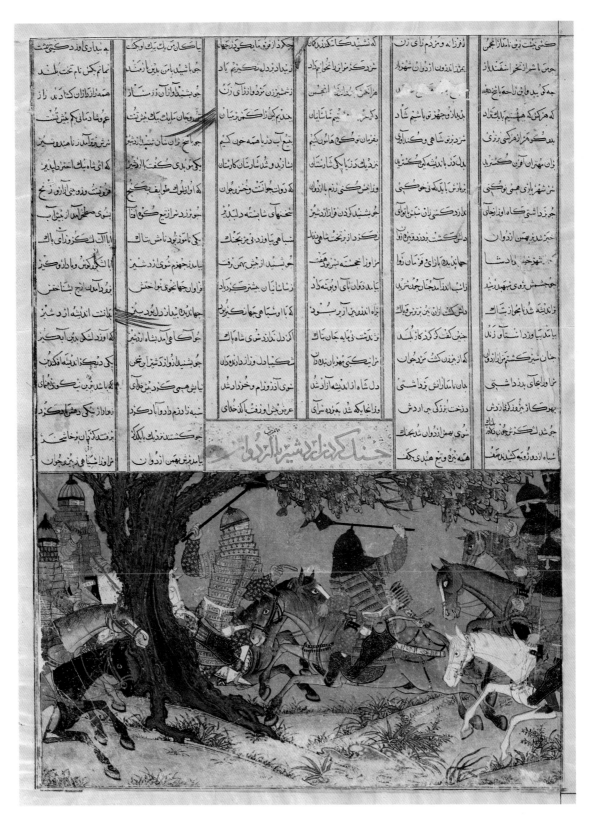

Ardashir Battling Bahman, Son of Ardawan

Asian Art

THE subject of this stone sculpture is Chāmuṇḍā, goddess of death and destruction. In this manifestation, she personifies the wrathful aspect of the Great Goddess Devī. Sometimes known as the fearsome Kālī or "the Black One," Chāmuṇḍā, it is believed, was originally a bloodthirsty tribal goddess who was assimilated into the vast Hindu pantheon. Masterfully chiseled from black dolerite, this piece typifies the high level of sculptural excellence achieved by the artists of the Chola Dynasty (846–1173).

Here, Chāmuṇḍā carries a club, a shield, and a skull cup from which she drinks the blood of her victims; her fourth arm is broken at the elbow. Her armlets and the sacred cord running diagonally between her breasts are in the form of snakes, and she sits cross-legged over a *preta*, or figure of a ghost, carved in low relief on her pedestal. Chāmuṇḍā's gruesome, forbidding character is further accentuated by her raised eyebrows, bulging eyes, fangs, and nimbus of radiant hair. However, despite her formidable appearance, her torso is that of a beautiful woman and is imbued with sensuality.

Although Chāmuṇḍā is considered one of the *Mātrikās*, or mother goddesses, who are worshipped during childbirth and as guardians of the young, her incorporation into this group is curious, for she is anything but maternal. More dreaded than loved, she is rarely worshipped as a domestic deity. The practice of her cult often includes bloody sacrifices and her sanctuaries are located away from villages, at crossroads or near funeral grounds.

REFERENCE

Pratapaditya Pal, "The Moon-Crested God and Related Images," *Bulletin of the Detroit Institute of Arts,* vol. 59 (1981), pp. 77–84.

Chāmuṇḍā, Goddess of Death and Destruction

Indian, Tamilnadu, Chola Dynasty, eleventh century

Black dolerite; h. 111.8 cm (44 in.)

Founders Society Purchase, L. A. Young Fund (57.88)

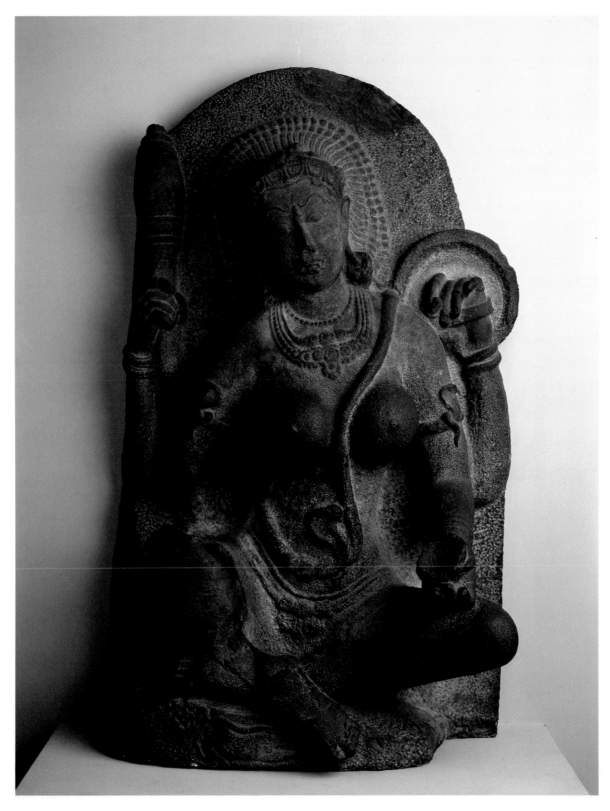

INDIAN, TAMILNADU, CHOLA DYNASTY

Chāmuṇḍā, Goddess of Death and Destruction

THE mellifluous grace of this image of Pārvatī, consort of Śiva, reflects its lineage from the great bronze sculptures of the Chola Dynasty (846–1173). As with all religious sculptures of India, the proportions, pose, and gestures are based on detailed iconographical descriptions provided in sacred manuals to ensure the sculpture's fitness as an object of worship. Pārvatī's long-limbed figure stands in a state of self-assured, sensuous grace; her weight is carried on one leg, causing the flection of the hip and resulting in a sharp but elegant tilt to her body. Her left arm is pendent while her right hand probably held a lotus.

In typical Chola fashion, the Great Goddess was modeled in the round and her back is as carefully detailed as her front. The elaborate ornaments and fine textile pattern that richly adorn her torso were carefully hand-tooled after the image was cast in the lost wax method. This concern for detailing is especially remarkable in light of the fact that bronze images such as Pārvatī were used only for special religious processions and were fully wrapped in clothes and covered with flower garlands, rendering them barely visible. Further substantiating her role as a processional image are the four loops on her base through which poles would have been secured for transport.

Although Pārvatī now stands in isolation, originally she would have had a place near the image of Śiva. According to established canons, which equate height with importance, in this role as divine companion to Śiva her image probably would not have been higher than the shoulder of the Great God.

REFERENCE

Stella Kramrisch, *Manifestations of Shiva,* Philadelphia, 1981, p. 141, cat. no. 115.

Pārvatī, Consort of Śiva

Indian, Tamilnadu, thirteenth century

Bronze; h. 103.6 cm (40¾ in.)

Founders Society Purchase, Sarah Bacon Hill Fund (41.81)

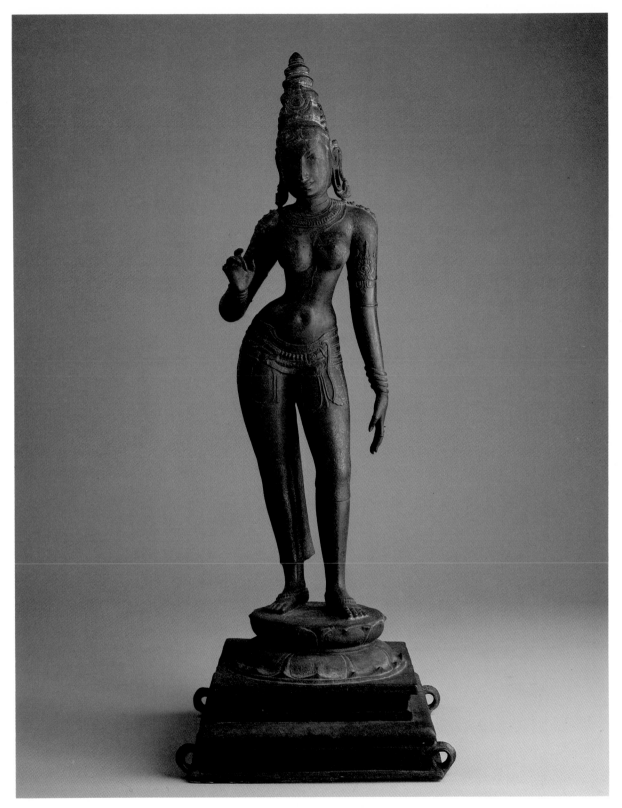

INDIAN, TAMILNADU

47

Pārvatī, Consort of Śiva

For nearly a millennium, Chinese painters have delighted in producing small and intimate views of nature. Most popular among these have traditionally been birds, flowers, blossoming trees, insects, and grasses. Over the centuries there evolved a systematic categorization of these subjects under specific headings. *Early Autumn,* as the scroll is now known, is inscribed with the characters for "Grasses and Insects," which places the painting within its proper category.

Early Autumn draws the viewer effortlessly into this microcosm of nature's seasonal cycle on the wane. As the scroll opens, three dragonflies feast on a swarm of midges as frogs below make their way across withering lotus leaves. Beyond, a bee and black dragonfly hover while grasshoppers, a katydid, and a long-horned beetle crawl amid the drying grasses.

With an emphasis on color and a minimum of linear detail, the painter effectively sets the stage. A palette of ochers, browns, and dull greens effectively conveys the crunchy texture of drying leaves. Against this background are set realistically depicted insects, glowing with translucent colors or soft ink tones. Characteristically of the Chinese painter, exact outer likeness is not sought, but just enough detail is used to convey the essence of the insect. The muted colors and restricted linear detail combine to impart a haziness to the scene, redolent with the heavy atmosphere of the last days of summer as they foreshadow autumn's approach.

The painting is inscribed with the signature of the famous master Qian Xuan. The scroll bears fifty-seven seals and numerous colophons dating from the Yuan to the end of the Ming period. Although the correctness of placing this scroll within the oeuvre of Qian Xuan has been a topic of lively debate for decades, there is little doubt that it stands as one of the most beautiful of Chinese paintings.

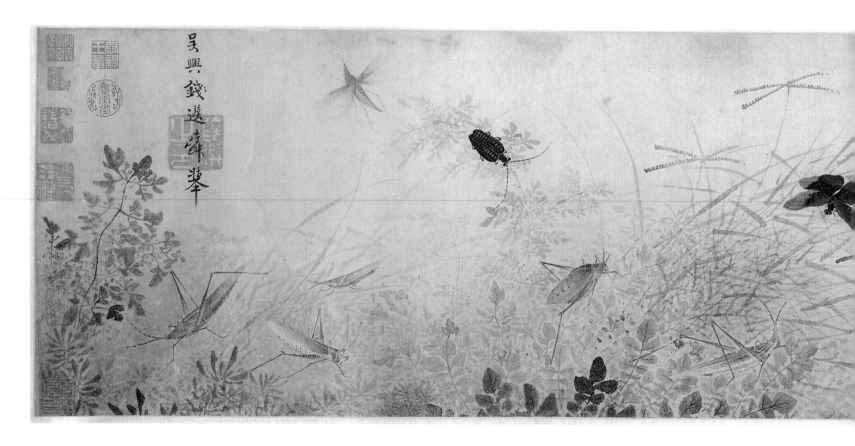

REFERENCE

R. Edwards, "Ch'ien Hsüan and 'Early Autumn,'" *Archives of the Chinese Art Society of America,* vol. 7 (1953), pp. 71–83.

Qian Xuan

Chinese, 1235–after 1301, Yuan Dynasty

Early Autumn

Handscroll; ink and color on paper; 26.7 × 120 cm (10½ × 47¼ in.)

Founders Society Purchase, General Membership and Donations Fund (29.1)

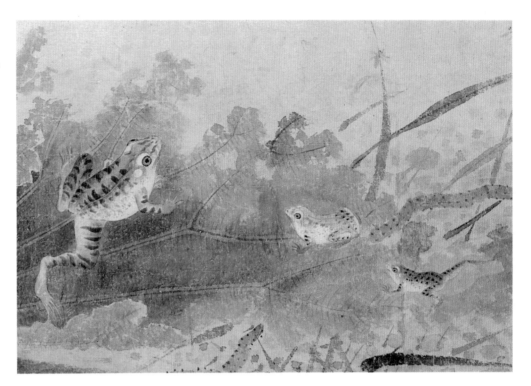

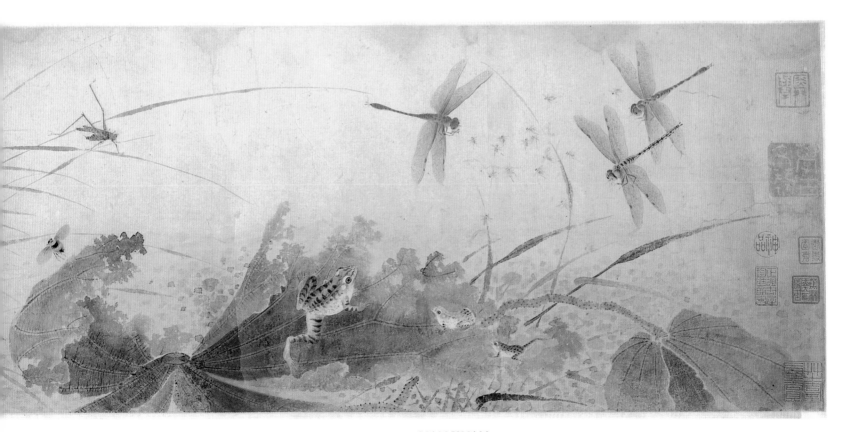

QIAN XUAN

Early Autumn

IN this image Śākyamuni, the historical Buddha, has renounced the princely comforts of his birth and is shown on his return from the mountains after six years of arduous fasting and hardship. This theme does not appear in traditional orthodox Mahāyāna Buddhist art but rather is distinctive to Chan (Zen) iconography. To the devotee of Chan Buddhism, enlightenment is a personal responsibility to be attained only through self-discipline, individual effort, and intensive meditation.

Although there are references to paintings depicting Śākyamuni Emerging from the Mountains by the late eleventh century in China, sculptural depictions of the emaciated Buddha appear to have originated during the Yuan Dynasty (1279–1368). In this piece the artist has emphasized the gaunt and skeletal body of Śākyamuni. His rib cage, neck tendons, and spinal cord are realistically rendered, showing him as he appeared after years of ascetic practice; the only reminders of his earlier life are his earlobes distended by the jewelry he had worn as a prince. He sits in a naturalistic posture similar to that commonly assumed by Indians; his head, resting on his hands, is bowed in deep meditation. Originally his flesh was entirely gold, the curling locks of his hair and beard were blue, and his red robe was finely detailed with a stylized floral pattern.

REFERENCE

Sherman E. Lee and Wai-kam Ho, *Chinese Art under the Mongols: The Yüan Dynasty (1279–1368),* Cleveland, Ohio, 1968, cat. no. 20.

Śākyamuni Emerging from the Mountains

Chinese, Yuan Dynasty, 1279–1368

Wood with red and gold lacquer; h. 29.8 cm (11¾ in.)

City of Detroit Purchase (29.172)

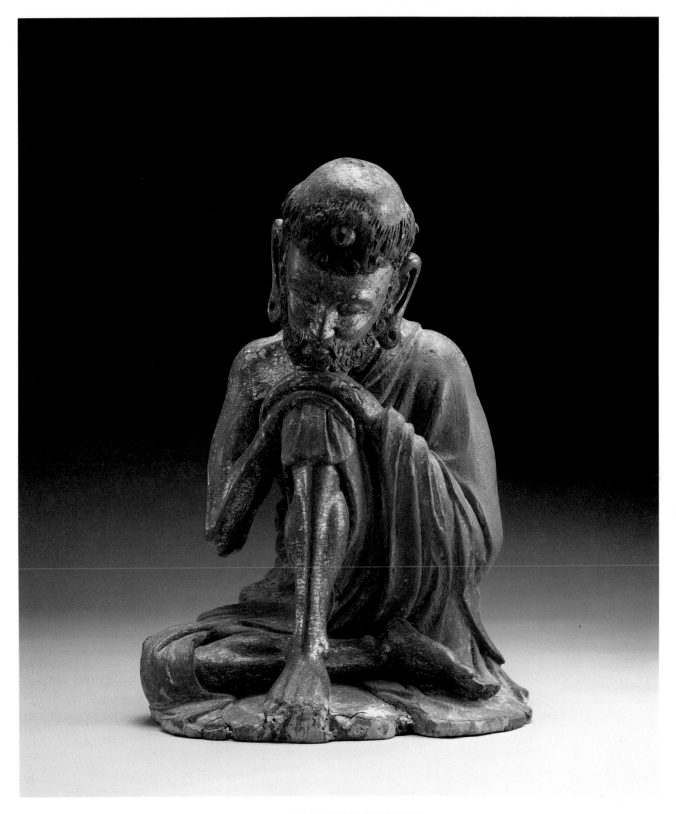

CHINESE, YUAN DYNASTY

Śākyamuni Emerging from the Mountains

EAST ASIAN lacquer is made from the sap of a variety of sumac (usually *Rhus vernicifera*) that is indigenous to China and was cultivated there at least as early as 500 B.C. Making lacquer ware requires not only great skill but also infinite patience. Paper-thin layers of lacquer are applied to a base material, frequently wood, and each must dry thoroughly for several days before being polished with charcoal sticks. Methods of decoration in China have traditionally produced lacquer ware that is painted, engraved, inlaid with metals, shells, or colored lacquers, and, perhaps most highly regarded, carved lacquer.

A carved lacquer such as the Detroit tray is made of hundreds of layers of lacquer. The first layers on this piece are of an ocher color, which was revealed as the ground color when the artist carved the overlying layers of black lacquer. A hair-thin, barely perceptible layer of red lacquer was put down just above the ocher layers to serve as a warning that the ground was being approached.

This tray is one of a small number of early carved Chinese lacquers that are grouped together because of common stylistic characteristics. Either red or black, they are decorated with two birds in flight against a field of flowers and hence have come to be known as "two-bird" types. Wares in this group have long been treasured in Japan where, it is believed, they arrived shortly after manufacture as precious items of exchange between Chinese and Japanese Buddhist priests. Evidence of exchanges can be found in temple records that contain inventories of gifts sent by the Chinese court to the Japanese shoguns. One such list, dated 1403, includes a reference to six lacquer trays of similar size, each uniquely decorated with various birds on floral grounds. While secure dating of these wares is difficult, it is generally accepted that they represent the precursors of the carved "official wares" of the later Ming and Qing periods.

REFERENCE

Sir John Figgess, "A Masterpiece of Chinese Carved Lacquerware," *Bulletin of the Detroit Institute of Arts,* vol. 59 (1981), pp. 66–75.

Tray with Design of Cranes and Chrysanthemums

Chinese, fourteenth century

Carved black lacquer; diam. 29.2 cm (11½ in.)

Founders Society Purchase, Stoddard Fund for Asian Art and funds from the Gerald W. Chamberlin Foundation, Inc. (80.25)

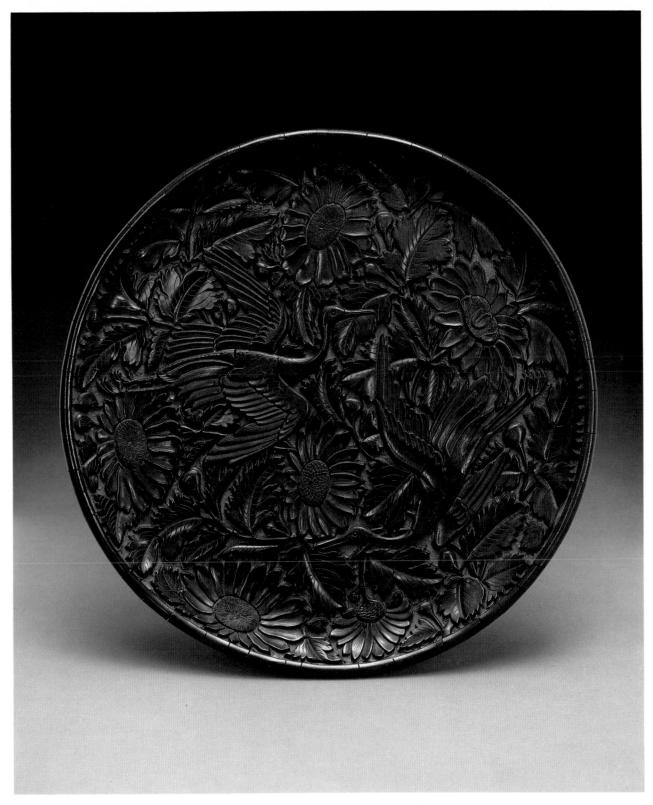

CHINESE

Tray with Cranes and Chrysanthemums

This scroll provides an excellent example of calligraphy, practiced and appreciated as an art in China for more than two thousand years. Over the centuries a range of script forms developed, and facility in these various forms was the mark of a literary man. Versatility was essential since script styles were selected to harmonize with textual content or sometimes simply to show accomplishment by an artist in the manners of great calligraphers of the past.

In the Detroit scroll, Dong Qichang pays homage to the great Tang master Zhang Xu (ca. 700–750). Bohemian in nature, Zhang loved wine and did his best work while drinking, perhaps in part explaining why his famous cursive writing, which departed markedly from earlier models of cursive calligraphy, was referred to as

"delirious script." Like Zhang's work in this style, Dong's calligraphy is as abstractly expressionistic as any product of the twentieth-century movement in the West. Characters are transformed and linked together in an unorthodox fashion. The resulting forms are beautifully pure, and yet often nearly illegible, abbreviations that appear to come from the hand of an artist in a state of inspiration and sustained exhilaration. Dong's characters flow unhesitatingly down and across the satin scroll for more than ten feet.

Dong Qichang was a renowned scholar, calligrapher, art critic, theoretician, and connoisseur of the late Ming period. Schooled in the styles of the ancient masters, Dong was careful to reflect the spirit of their brush styles if not always the outward appearance.

Though undated, the scroll is inscribed and signed by the artist. It bears colophons at the beginning and end by Zhang Zhao (1691–1745) and Gao Shiqi (1615–1701), two noted calligraphers of the Qing period, who were deeply influenced by Dong Qichang. Among the collector's seals affixed to the scroll are the imperial seals of Emperors Qian Long (reigned 1736–95), Jia Qing (reigned 1796–1820), and Xuan Dong (reigned 1908–11).

REFERENCE

Yūjirō Nakata and Shen C. Y. Fu, *Ōbei Shūzo Chūgoku Hōsho Meiseki Shū* [Masterpieces of Chinese Art in American and European Collections], Tokyo, 1968, vol. 2, pp. 6–8, 133.

Dong Qichang

Chinese, 1555–1636, Ming Dynasty

Freehand Copy of Zhang Xu's Writing of the Stone Record (detail)

Handscroll; ink on satin: .267 × 3.283 m (10½ in. × 10 ft. 9¼ in.)

Founders Society Purchase, Henry Ford II Fund (77.63)

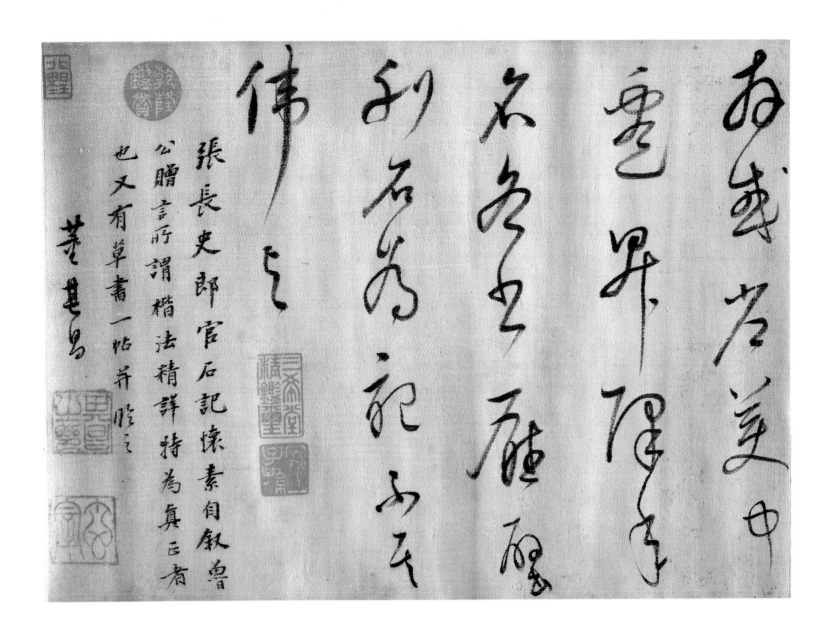

張長史郎官石記懷素自敘魯
公贈言所謂楷法精詳特為真正者
也又有草書一帖并臨之

其昌

Freehand Copy of Zhang Xu's Writing

ALTHOUGH lacquer craft did not originate in Japan, the Japanese have made significant technical and aesthetic contributions since an indigenous practice developed during the Heian period (794–1185). Perhaps the single most important contribution was the development of *maki-e*, designs of gold or silver powders sprinkled on a wet lacquer surface. Wares with strikingly bold designs in *maki-e* technique typify much of the work of the Momoyama period (1573–1615). *Kōdai-ji maki-e* is a term referring to a characteristic type of lacquer ware from this period that is associated with Kōdai-ji, a Buddhist temple and mausoleum in Kyoto founded by the widow of Hideyoshi (1536–1568), the great warlord and statesman whose power and tastes dominated both the political and cultural milieus of the late sixteenth century. Although the term *Kōdai-ji maki-e* was originally reserved for wares associated with the temple, it has come to be applied to any lacquer ware of like technique and decoration produced during the Momoyama and early Edo periods.

Kōdai-ji lacquers include furnishings and personal items, such as this document box. Among the different techniques associated with these wares, flat gold designs (*hiramaki-e*) on black or brownish-black lacquer predominate. Autumnal flowers and grasses, especially chrysanthemums, bush clover, and pampas grass, comprise the favorite motifs.

All four sides of the Detroit box are decorated with flowering bush clover and pampas grass combined with a superimposed random pattern of chrysanthemum roundels and paulownia leaf crests, the family crest of Hideyoshi. Dew drops of gold establish a staccato surface pattern throughout. Although the sides of the cover extend nearly over the entire depth of the box, the design is carefully matched and is repeated in full on the box sides. Gilded fittings in the shape of chrysanthemum flowers are mounted on the two long sides to secure the silk cords that tie the box. In contrast to the casual arrangement of grasses and flowers on the sides, the top of the box has a strikingly formalized pattern of chrysanthemum roundels and paulownia crests. In both design and technique this box stands as a typical and beautiful example of the famous Kōdai-ji style of Japanese lacquer.

Document Box (Ryōshibako)

Japanese, Momoyama period, sixteenth century

Lacquer and gold *maki-e*; 17.8 × 27.9 × 44.5 cm (7 × 11 × 17½ in.)

Founders Society Purchase, with funds from an anonymous donor (81.1)

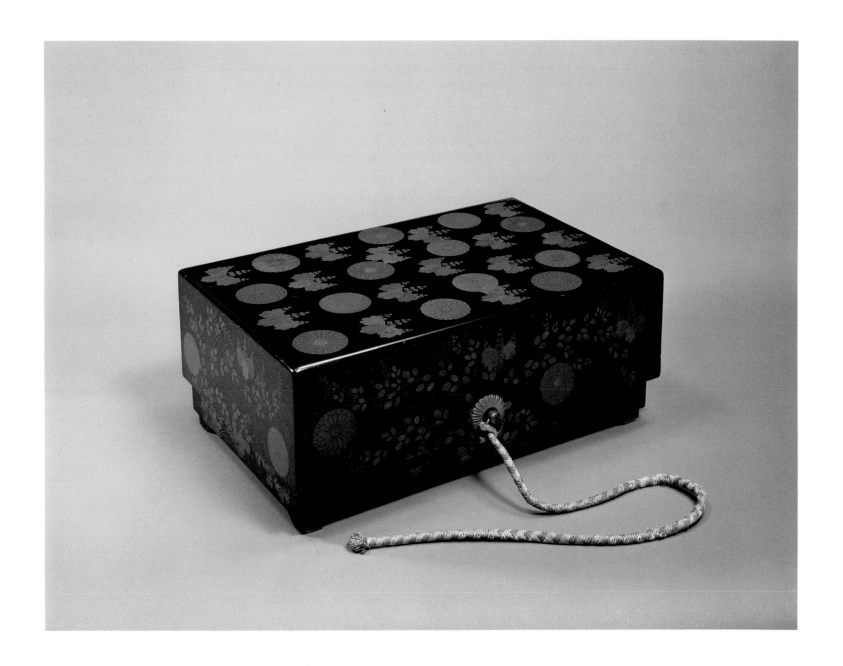

JAPANESE, MOMOYAMA PERIOD

Document Box

Since the Fujiwara period (897–1185), themes of seasonal activities have been popular subjects for Japanese artists. In contrast to the earlier Heian painters, who characteristically depicted members of the aristocracy engaged in these pursuits, the artists of the Momoyama (1573–1615) and Edo (1615–1868) periods developed genre paintings featuring the urban commoners living in the flourishing cities of Kyoto and Edo (Tokyo).

Working with ink only and a fast, sure touch, the artist of the Detroit scroll presents familiar pastimes of the four seasons, each separated by narrative text interspersed between the sketches. The scroll, which continues for more than forty-six feet, opens with a depiction of springtime at Arashiyama, a scenic spot outside Kyoto which is famous for its cherry blossoms. Merrymakers picnic at the riverside while others ply the water for the best views of the famous hillside just beyond. The summer season follows, represented by an urban scene of townsmen enjoying cool evening breezes along the

banks of the Kamo River at the intersection of Shijō Street. The thoroughfare is alive with strollers chatting and browsing by the peddlers' stalls, while more sedentary types relax on platforms set up on the shoal. The third segment depicts festival dances in the streets of Kyoto during the autumn *Bon,* the festival dedicated to honoring one's ancestors. Children and adults dance with glee under the paper lanterns hung for this occasion. Appropriately, the scroll concludes with the winter season's year-end cleaning and

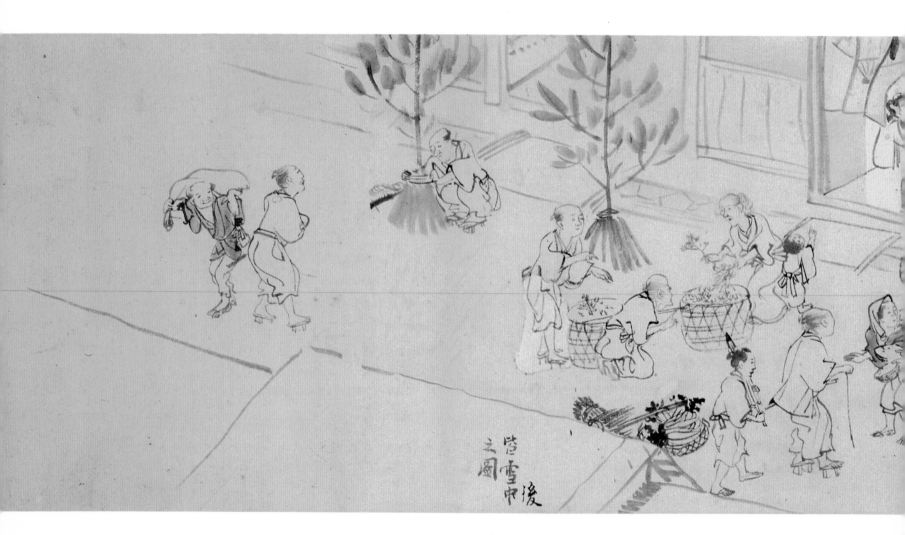

Asian Art

preparations for the new year's festivities, illustrated here. The painter's interest in realistically portrayed genre details is everywhere apparent in this section. Men and women bustle about, cleaning interiors and decorating entrances as children in the street roll a giant snowball.

Though the scroll is unsigned, the colophon at the end attributes the painting to Maruyama Ōkyo, master of the realist school of painting in eighteenth-century Japan, and the narrative text to Takahashi Munenao, an aristocrat and calligrapher renowned in Kyōto. This scroll is believed to be a preliminary study for a set of two scrolls of identical subjects painted with colors and ink on silk in the Tokugawa Art Museum, Nagoya, Japan.

REFERENCE

Seiichi Taki, *"Maruyama Ōkyo Hitsu Shiki Yūraku Zukan"* [*The Entertainments of the Four Seasons* by Maruyama Ōkyo], *Kokka*, no. 331 (1916), pp. 201–5.

Maruyama Ōkyo

Japanese, 1733–1795, Edo period

Entertainments of the Four Seasons in Kyoto (detail: *Winter*)

Handscroll, ink on paper; scroll: 28.5 cm × 14.106 m (11¼ in. × 46 ft. 3½ in.)

Founders Society Purchase, Edsel and Eleanor Ford Exhibition and Acquisition Fund, Alan and Marianne Schwartz Fund, with funds from Michigan National Corporation, Mrs. Howard J. Stoddard, and Mr. and Mrs. Stanford C. Stoddard (1983.21)

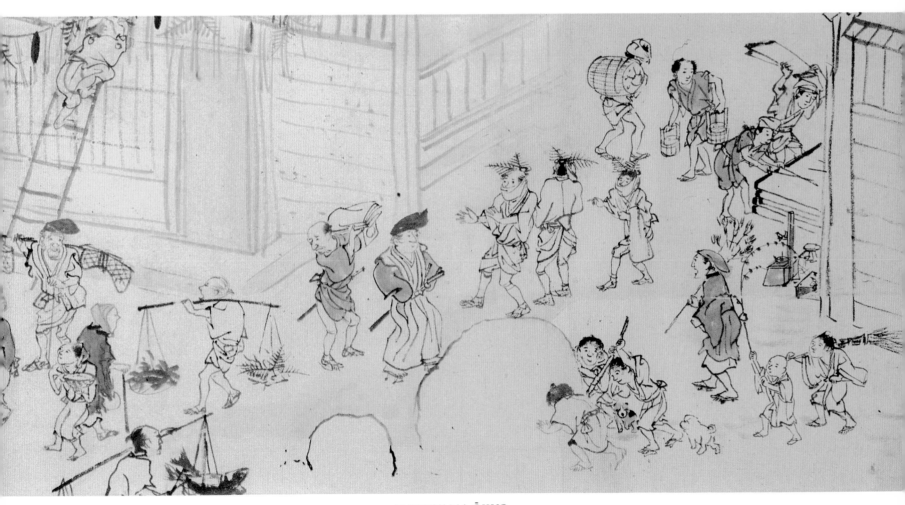

MARUYAMA ŌKYO

Entertainments of the Four Seasons in Kyoto

AMONG Japanese brocaded robes the most beautiful and sumptuous are Nō costumes. The Nō drama is a highly refined performance that combines mime, music, chant, and costume. In Nō theater, the setting of the play is minimal; three small pine trees line the front of the runway along which the performers make their entrances onto a stage that is bare but for a wall painting of a lone, ancient pine. Against this spare backdrop, elegantly robed, masked actors recite their lines to the accompaniment of orchestra and chorus.

Derived from earlier performing arts based on dance, the aesthetics of Nō were codified under shogunal patronage during the fourteenth century, and by the Edo period (1615–1868) Nō enjoyed a status as the official theater of the shogunate. Influential *daimyo* in service to the shogun constructed stages in their castles, supported entire troupes of actors and musicians, and competed among themselves in assembling wardrobes of sumptuous costumes. In fact, only these splendid robes, made specifically for Nō performers, were exempted from the strict sumptuary edicts that governed other garments during this period.

This Nō robe in Detroit is a *karaori*—an outer robe generally used for female roles and of all Nō costume types the most resplendent. Here, on an orange ground, autumnal designs of chrysanthemums, butterflies, and grasses are woven with long floats of brilliant multicolored silk and are scattered across a subordinate pattern of metallic gold grasses.

The term *karaori* means "Chinese weaving," and it originally described imported, figured woven textiles; later it was used to identify these lavish brocade robes woven in Kyoto by the weavers of the Nishijin district. Although a *karaori* is characteristically a heavy garment, stiffly enveloping the body with little response to the contours beneath, the formal, regal effect is aptly suited to the slow, deliberate movement of the Nō drama.

Nō Robe (Karaori type)

Japanese, Edo period, seventeenth or eighteenth century

Metallic and colored brocade on silk ground; h. 152.7 cm (59¾ in.)

Founders Society Purchase, Henry Ford II Fund (1984.23)

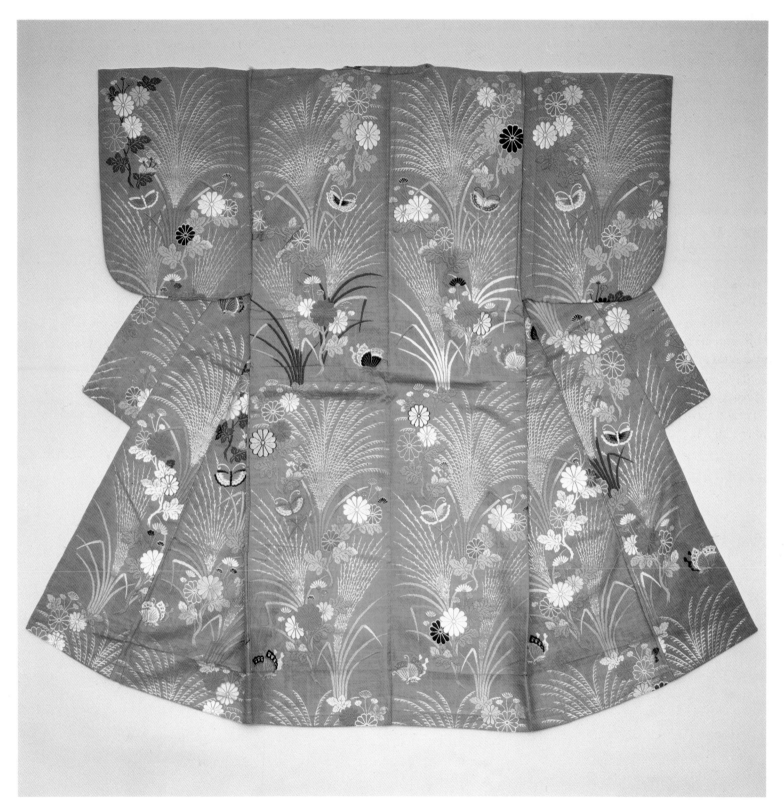

JAPANESE, EDO PERIOD

Nō Robe

Although the folding-screen format is of Chinese origin, the Japanese innovation of unobtrusive paper hinges resulted in screens with unprecedented expanses of nearly contiguous paint surfaces. Subjects previously interrupted by borders on each panel could now be continued across the entire breadth of the screen, thereby providing the Japanese painter with a challenging new format for bold, large-scale compositions.

The crane, a traditional symbol of longevity and good fortune, is a familiar and well-loved subject in Japanese art. As the predominant, often the sole, motif, cranes provided a popular theme within the genre of bird and flower screens throughout the Edo period. Viewing *Reeds and Cranes* in the traditional Asian manner, from right to left, we see a group of Manchurian cranes (*Grus japonensis*) standing amid water reeds in various poses of calling, preening, and resting. A flock directly overhead moves the action upward and across the panels to the

left screen where cranes in flight extend across all six panels. The elliptical composition of birds spanning both screens establishes a continuous movement that is playfully halted by three diminutive rocks, anchoring the composition at the lower corner of the left screen next to the artist's signature and seal.

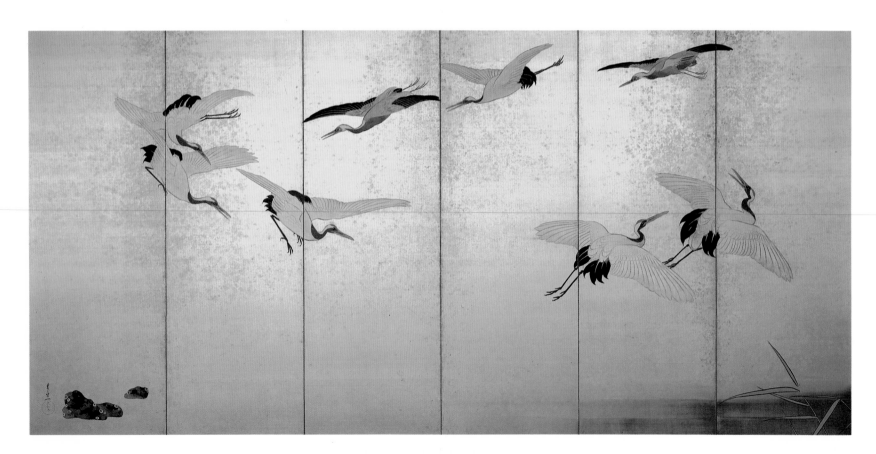

Asian Art

Kiitsu's *Reeds and Cranes* is a successful combination of decorative techniques with a readily apparent interest in realism, so prevalent among artists in nineteenth-century Japan. The cranes exhibit a naturalism that seems likely to derive from the artist's direct observation of birds in flight and at rest. This sense of realism emerges despite the flat, decorative application of colors from a palette restricted almost exclusively to black, white, red, blue, and green on a gilded silk ground.

Suzuki Kiitsu is considered by many to be the last great master of the Rimpa school, a school of decorative art inspired by native painting techniques and motifs and whose origin may by traced to the early-seventeenth-century Japanese painters Kōetsu and Sōtatsu.

REFERENCE

Nobuo Tsuji, *Rimpa Kaiga Zenshū,* ed. Yūzō Yamane, Tokyo, 1978, vol. 5, no. 130, pls. 145, 167–69.

Suzuki Kiitsu

Japanese, 1796–1858, Edo period

Reeds and Cranes

Color on gilded silk; each screen 1.78 × 3.69 m (5 ft. 9½ in. × 12 ft. 1¼ in.)

Founders Society Purchase, with funds from the Gerald W. Chamberlin Foundation, Inc., Mr. and Mrs. Charles M. Endicott, Mrs. Howard J. Stoddard, Mr. Howard P. Stoddard, and Mr. and Mrs. Stanford C. Stoddard (79.28.1–.2)

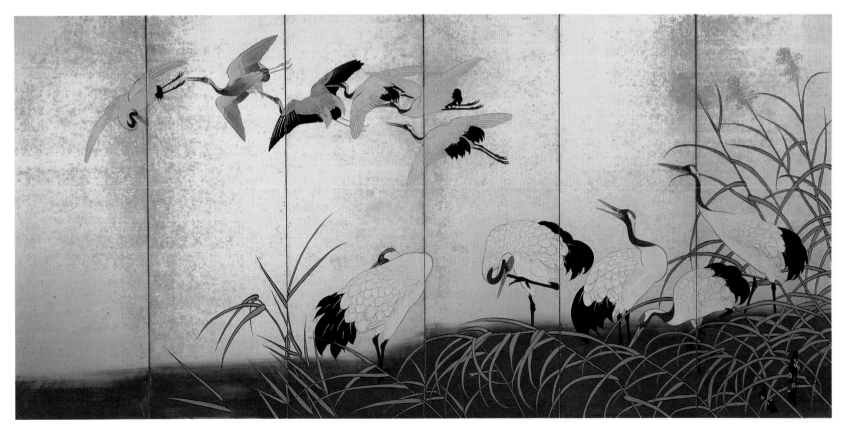

SUZUKI KIITSU

Reeds and Cranes

KOREAN celadons of the Koryŏ period (918–1392) are among the most celebrated of Asian ceramic wares. It is believed that the popularity of this ware is due to the blue-green glaze, reminiscent of precious jade. *Celadon* is a Western descriptive term that refers to the distinctive color and derives from the seventeenth-century French play *L'Astrée,* in which a character named Céladon is costumed in gray-green apparel.

Koryŏ celadons were produced for the court and aristocracy in government-controlled potteries located in the major kiln centers of Kangjin and Puan, at the southern tip of the peninsula. Celadon wares were produced from stoneware bodies covered with a transparent feldspathic glaze and fired in a reduction kiln to approximately 1200 degrees centigrade. The color, which ranges from soft gray-blue to brilliant blue-green, is dependent upon the amount of oxygen present and the iron content of the glaze.

The celadon pillow in Detroit reflects the high degree of craftsmanship attained by the anonymous Koryŏ potters. An elegantly styled headrest, this piece consists of a concave, tongue-shaped surface supported at each end by a lion sculpted in the round, and a base on which the lions stand. Although the lion motif is not indigenous to Korea, it figures importantly in Buddhist iconography and is frequently found in these wares commissioned by a court that was predominantly Buddhist. The top of the headrest is decorated with motifs produced by an intricate technique using inlays of different colored slip. Inlaid celadons are a uniquely Korean contribution believed to have been developed during the second quarter of the twelfth century. The Detroit pillow exhibits the rare technique of reverse inlay as well as standard inlay.

Pillows with lion supports are so rare that only four Koryŏ examples are known. The Detroit pillow is further exceptional in that it is the only extant example to combine the techniques of inlaid decoration and modeling in the round.

REFERENCE

Godfrey St. G. M. Gompertz, "A Note on an Inlaid Celadon Pillow of the Koryŏ Period," *Bulletin of the Detroit Institute of Arts,* vol. 59 (1981), pp. 96–100.

Pillow

Korean, Koryŏ Dynasty, late twelfth century

Glazed stoneware; 12 × 23 cm (4¾ × 9 in.)

Founders Society Purchase, New Endowment Fund and Benson and Edith Ford Fund (80.39)

KOREAN, KORYŎ DYNASTY

Pillow

African, Oceanic, and
New World Cultures

THE *Nail Figure (nkisi n'kondi)* is attributed to a master sculptor of the Mayombe in the Shiloango River area of western Kongo. It was brought out of Africa by a missionary in 1903.

Carved from a sacred tree, the icon functioned as surrogate chief, judge, notary, priest, physician, peacemaker, avenger, lie detector, and receiver and transmitter of good and evil forces. Before this statue, evidence was given, oaths were taken, and ceremonies of judgment, blessing, cursing, healing, and vindication were performed. Words spoken in evidence and judgment were symbolically recorded by applying tokens of the adjudicants and their problems to specially chosen nails, which were driven into the figure. The statue thus became a legal document as well as a vindictive force empowered to punish false witnesses, oath breakers, and wrongdoers, and to protect society against evil powers.

The Kongo name for this type of statue, *n'kondi,* derives from the verb *konda* (to hunt), and some of the images are in the shape of hunting dogs, symbolizing the hunter's dogged perseverance in tracking a quarry. Aspects of this statue that contribute to its potency include the cap resembling those worn by ancient Kongo chiefs and the attentive, aggressive stance symbolizing a readiness to deal with the most serious and complex problems. These powerful instruments were to be entrusted only to worthy guardians well-versed in the complex lore of medicines and ceremonies. That it was an effective combination of theology, psychology, law, and the occult is evidenced by the fact that many extant icons of this type show extensive use.

The compact, powerful, clean lines and expressive pose and features of the *n'kondi* appeal to individuals with a taste for bold and striking modern forms. However, to view the statue merely for its superb aesthetic qualities is to overlook the sophisticated cultural milieu which brought it into being.

REFERENCES

Robert Farris Thompson, "The Grand Detroit *N'kondi*," *Bulletin of the Detroit Institute of Arts,* vol. 56 (1978), pp. 206–21.

Robert Farris Thompson and Joseph Cornet, *The Four Moments of the Sun: Kongo Art in Two Worlds,* Washington, D.C., 1981, p. 38, cat. no. 80.

William Rubin, ed., *"Primitivism" in 20th Century Art: Affinity of the Tribal and the Modern,* New York, 1984, vol. 1, frontispiece.

Nail Figure (nkisi n'kondi)

Western Kongo, Mayombe, ca. 1875–1900

Wood with screws, nails, blades, cowrie shell, and other materials; h. 116.8 cm (46 in.)

Eleanor Clay Ford Fund for African Art (76.79)

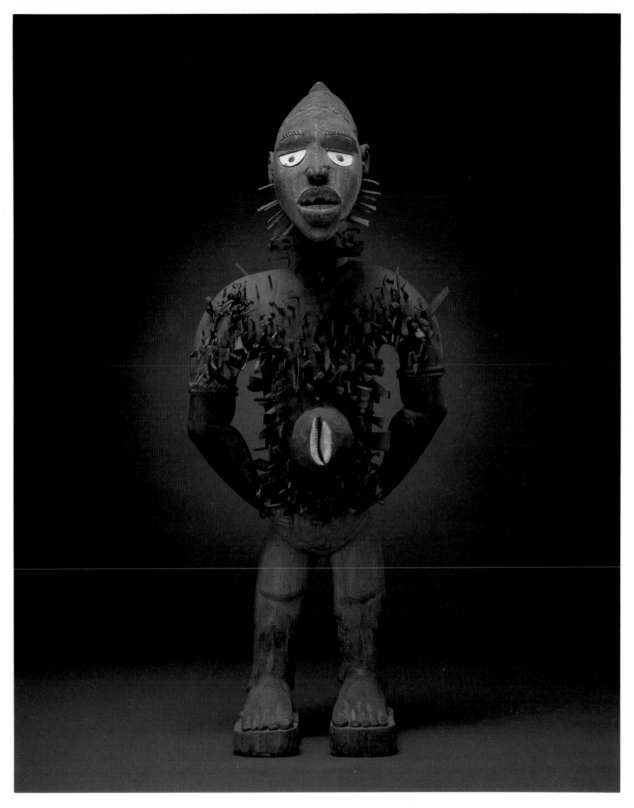

WESTERN KONGO, MAYOMBE

Nail Figure

The attribution of African sculpture to individual artists is a difficult task and such attributions are rare. However, of the Yoruba people in western Nigeria and Dahomey, several master carvers are known by name. The Detroit Institute of Arts is privileged to own one of the great masterpieces by the Yoruba carver Bamgboye, from the Odo-owa area, near the city of Ilofa. Bamgboye was most active during the 1920s and 1930s.

Yoruba carvers are carefully trained in an elaborate apprenticeship with recognized master carvers, who are widely known and appreciated. Masters accept commissions for masks, figures, and other wooden ritual objects from a variety of Yoruba religious cults, and an artist produces a commissioned work according to strict formal requirements for each category of sculpture.

The Detroit mask by Bamgboye was produced for a masquerade staged by the cult of Epa, a cult that celebrates the athletic and virile strength of young men. Muscular strength and endurance characterize the performance since the masks often weigh in excess of fifty pounds. Several masks are used during the ritual, the last and most important representing Orangun, "the mighty king," who is the subject of this mask. The mask depicts the equestrian king accompanied by a large retinue of soldiers and musicians. It is a masterpiece of intricacy and hierarchical composition; the minor figures are condensed and tiered to frame the imposing image of the king without overwhelming it. This monumental mask represents a major commission, and the resulting work confirms the status of Bamgboye as one of the Yoruba's greatest masters of carving.

REFERENCES

Evelyn S. Brown, *Africa's Contemporary Art and Artists,* New York, 1966, p. 68.

Robert F. Thompson, *African Art in Motion: Icon and Act in the Collection of Katherine Cosjan White,* Washington, D.C., 1974, pp. 20, 28, 33–35, 37, 40, 42, 45, 50.

Bamgboye

Nigeria, Yoruba, active 1920s–1930s, died 1978

Epa Cult Mask

Wood; h. 121.9 cm (48 in.)

Founders Society Purchase, Friends of African Art Fund (77.71)

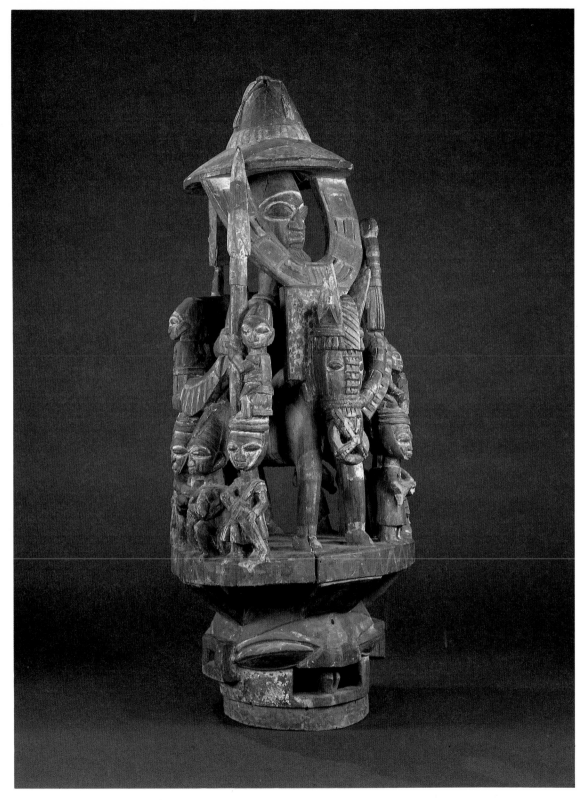

BAMGBOYE

Epa Cult Mask

THE Mangbetu people of northeastern Zaïre project in their art a refined sense of elegance that is reflected also in their high regard for aesthetic personal appearance and adornment. Mangbetu women decorate their bodies with delicate patterns of scarification, arrange their coiffures in elaborate, scaffoldlike constructions, and bind the heads of their female infants in order to produce the characteristic flattened forehead, raised eyebrows, and stretched, oval eyelids that are the Mangbetu standards of female beauty. This ideal of feminine appearance is the predominant theme of Mangbetu art.

By 1800 the Mangbetu had established a kingdom and a small economic empire based on the slave trade, which grew to its height under King Munza during the third quarter of the nineteenth century. With the kingdom came an aristocracy of the court and surrounding tributary villages, creating a demand for luxury items, such as artistically fashioned pottery and bark containers with sculpted lids, all of which celebrated the beauty of Mangbetu women. Itinerant singers who entertained the court and aristocratic households played small, skin-covered, five-string harps, most of which were ornamented at the end of the curving neck by a carved finial representing the head of a Mangbetu woman.

The Detroit harp is one of few known in which the neck is sculpted as a full-length female figure; such pieces are thought to have belonged to the aristocratic class, if not to Mangbetu royalty. Among these rare items, the Detroit harp is exceptional in having a figure with articulated arms bent at the elbows and fully modeled, voluptuously curved buttocks and legs. All other known examples of the type incorporate the female body into the cylindrical curve of the harp's neck with little emphasis on the waist and limbs. The posture of the figure, her curvaceous shape heightened by understated adornments, and the positions of her arms suggest that she is a dancer, perhaps an entertainer or concubine attached to the royal court. Certainly the sculptural quality of the harp, its detailing, and its sumptuousness confirm its association with the highest echelons of Mangbetu society.

REFERENCES

G. Schweinfurt, *En coeur de l'Afrique 1868–1871: Voyages et découvertes dans les régions inexplorées de l'Afrique centrale,* 2 vols., Paris, 1875.

François Neyt, *Traditional Arts and History of Zaïre,* Brussels, 1981, pp. 63–71.

Harp

Zaïre, Mangbetu, nineteenth century

Wood, hide, metal, and beads; 41.9 × 48.9 cm (16½ × 19¼ in.)

Founders Society Purchase, Henry Ford II Fund and Benson and Edith Ford Fund (82.29)

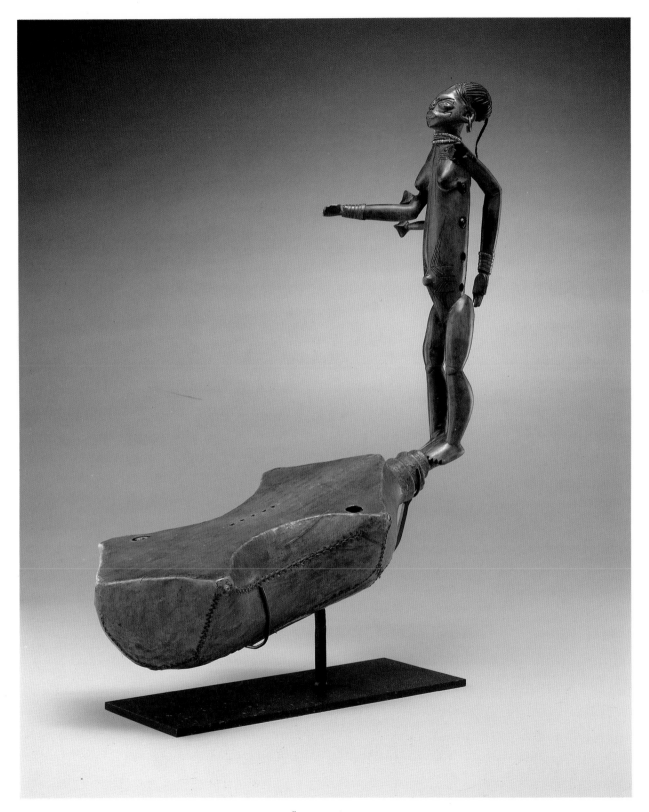

ZAÏRE, MANGBETU

Harp

GABON, the crossroads between the northern savannahs and equatorial Africa, has been inhabited by a mixture of ethnic peoples and consequently has developed a rich tradition of ritual arts. Speakers of the Fang language migrated from the plateaus of Africa's central grasslands to the forests of Gabon during the late eighteenth century. They settled in scattered independent villages along the Ogowe River but never organized themselves into any regional polity. Their rituals and art reflect the concerns of the village, the family, and the individual rather than the affairs of state or the pomp of a chiefly court.

The four-faced mask, called *ngou-ntangha*, represents a white-faced visitor from the land of the dead. Informants have interpreted the faces as describing either the four stages of life (birth, life, sickness, and death) or the paradigmatic family (father, mother, son, and daughter). The mask is used during village rituals of great solemnity, such as birth or mourning, and during important village councils. This visitor from the other world acts to observe, supervise, and sanctify these events, and to protect the participants from misfortune, conflict, or spiritual harm.

The Detroit *ngou-ntangha* is considered one of the finest examples of Fang sculpture. It was shown in 1935 at the Museum of Modern Art, New York, in the landmark exhibition "African Negro Art," which established the universal aesthetic significance of African sculpture.

REFERENCE

Louis Perrois, *Arts du Gabon,* supplement to vol. 20 of *Arts d'Afrique Noire,* Asnouville, 1976, pp. 97–102.

Mask (ngou-ntangha)

Gabon, Fang, late nineteenth or early twentieth century

Wood and kaolin; h. 35.5 cm (14 in.)

Founders Society Purchase, New Endowment Fund (1983.24)

African, Oceanic, and New World Cultures

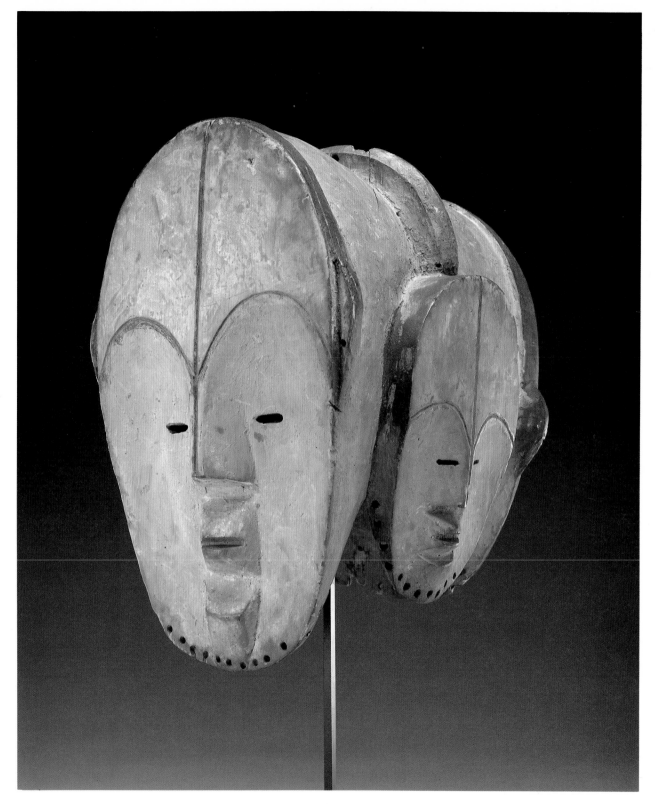

GABON, FANG

Mask

EASTER ISLAND, a windswept volcanic island located in the eastern Pacific some 2,200 miles off the coast of Chile, is the easternmost point of land reached by the Polynesians during their maritime migrations more than 2,000 years ago. Discovered by the Europeans during the eighteenth century and subsequently decimated by disease and raided for slaves, Easter Island revealed little of its heritage to outsiders before the native culture was destroyed. Consequently, Easter Island culture has remained shrouded in mystery.

Easter Islanders carved small pieces of ritual sculpture from the wood of the *toromiro,* a small, twisted, ground-hugging bush that grows sparsely on the island. The gorget, called *rei miro* ("valuable treasure of *toromiro* wood"), is an ornament worn around the neck by the Easter Island aristocracy and priesthood. The Polynesian word *rei,* meaning "valuable treasure," and its derivatives are usually applied to ornaments made of whale ivory or white shell, such as the Maori *rei puta,* a whale ivory pendant, the Marquesas *ei,* a shell ornament, the Tahitian *parae,* or cut-shell pectoral, and the Hawaiian *lei palaoa,* an ivory necklace, all of which are symbols of high and sacred social status. The crescent shape of the Easter Island *rei miro* is undoubtedly related to the Tahitian cut-shell ornament, and perhaps also to the crescent-shaped sperm whale tooth, which may have been the prototype for this kind of Polynesian symbolic ornament (as in the Fijian *tambua*).

This superb *rei miro* displays the classic Easter Island sculptural style prior to the commercialization of Easter Island wood carving during the mid-nineteenth century. The elongated faces on the finials, with their extended chins and brows, echo the graceful curve of the gorget itself. The facial details possess the plasticity and warm elegance of line associated with shell-tool carving, as opposed to the more mechanical precision visible in later pieces carved with metal tools. Stylistically, the Detroit *rei miro* compares closely with the earliest documented wood sculptures collected on Easter Island.

REFERENCE

Alfred Métraux, "Ethnology of Easter Island," *Bernice P. Bishop Museum Bulletin,* 160 (1940), p. 132.

Gorget (rei miro)

Easter Island, 1775–1800

Toromiro wood; w. 62.2 cm (24½ in.)

Founders Society Purchase, Henry Ford II Fund (81.698)

African, Oceanic, and New World Cultures

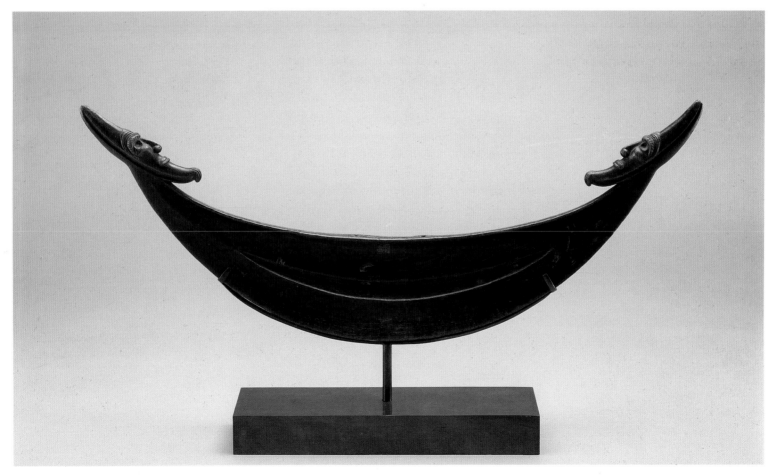

EASTER ISLAND

Gorget

ONE of the earliest artistic styles visible in the archaeological record of North America was developed by the ancient Eskimo culture known as the Okvik, who inhabited the small, desolate islands of the Bering Strait and the neighboring coastlands of present-day Siberia and Alaska during the fourth through first centuries B.C. Like the historic Eskimo, who are their ethnic descendants, the Okvik lived in small coastal villages, fishing and hunting sea mammals such as seal, sea lion, and walrus. Walrus tusks provided the material for many Okvik weapons and tools, which were decorated in finely incised, weblike patterns of circles, curves, and linear formations evocative of animal shapes.

The winged object is a somewhat mysterious Okvik artifact; its strong, symmetrical shape and delicate engraved detailing long defied any interpretation of the object's function. Recently scholars have proposed that this type of winged object was fitted onto the base of a harpoon and acted as a stabilizer, similar to the tail of an airplane. Due to the hard use they received, unbroken Okvik winged objects are extremely rare. This masterful example was recovered from the Kukulik site on Saint Lawrence Island, Alaska, in 1982. It accompanied an important burial of a mature male, along with several other finely made harpoon objects and fragments of ivory implements.

It is difficult to reconcile the laborious and fastidious craftsmanship displayed in the winged object with the fact that it was thrown, with the harpoon of which it was a part, at the hunted animal, possibly to be lost or, more frequently, broken. It should be noted, however, that the Eskimos believed the technical efficacy of their weapons was not the only factor contributing to the success of a hunter. In order to allow itself to be killed, the animal must be willing to give itself to the hunter; therefore magic and ritual played a substantial role in Eskimo hunting. The stylized animal faces and fragments of animal forms that adorn Okvik harpoon parts may have been intended to honor the animal and influence its behavior, increasing the chances of a successful hunt.

REFERENCES

Otto William Geist and Froelich G. Rainey, *Archaeological Excavations at Kukulik, St. Lawrence Island, Alaska,* Washington, D.C., 1936.

Henry B. Collins, "The Arctic and Subarctic," *Prehistoric Man in the New World,* ed. J. D. Jennings and E. Norbeck, Chicago, 1964.

Winged Object

Alaskan Eskimo, Okvik, 300 B.C.

Walrus ivory; w. 18.8 cm (7⅜ in.)

Founders Society Purchase, Stroh Brewery Foundation Fund (1983.7)

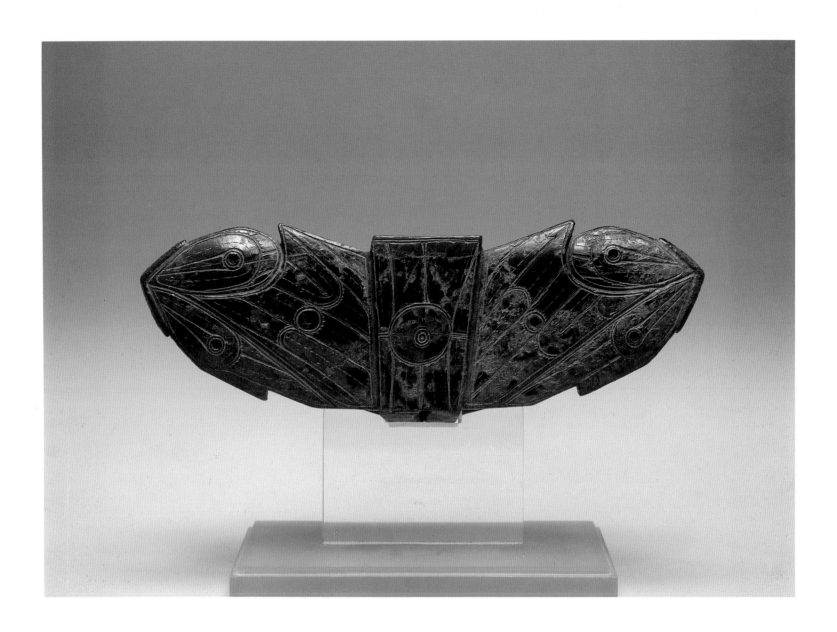

ALASKAN ESKIMO, OKVIK

Winged Object

This unusually large and boldly patterned textile is composed of two nearly equal loom widths of cloth joined together at their long edges. The background, woven of vegetable-dyed red alpaca yarns, is a brilliant foil for inset tapestry medallions of red, yellow, blue, and tan. The medallions are executed in various techniques and exhibit thirty-nine geometric and representational motifs. A key to interpreting the motifs has not been discovered; it is even possible that they merely indicate a fascination with simple designs. The medallions do provide scholars with an indication of the range and variety of weaving and embroidery techniques and designs known to Nasca weavers. A comparison of the Detroit textile with others of the same period shows little attempt at standardization.

Although the place of origin of this textile is not known, it probably came from a tomb. The dry desert sands along the coast of Peru have yielded many well-preserved artifacts of this period, especially from tombs. The size and the richly varied decorations may have commemorated the wealth and prestige of the deceased.

There is no way to determine the function of such a textile in daily life. It could have been used to wrap valuable objects, enshroud the dead, decorate rooms or tombs, or been worn as a part of a costume. The textile must not be considered a practice piece or sampler, for the skill and inventiveness of the weaver betoken an artist in full command of the medium.

REFERENCE

Ann Pollard Rowe, "A Late Nasca Derived Textile with Tapestry Medallions," *Bulletin of the Detroit Institute of Arts,* vol. 57 (1979), pp. 114–23.

Ceremonial Textile

Peru, Nasca period, ca. 500–700

Alpaca yarns; 1.137 × 2.813 m (44¾ in. × 9 ft. 2¾ in.)

Gift of Mr. and Mrs. Lee Hills (77.78)

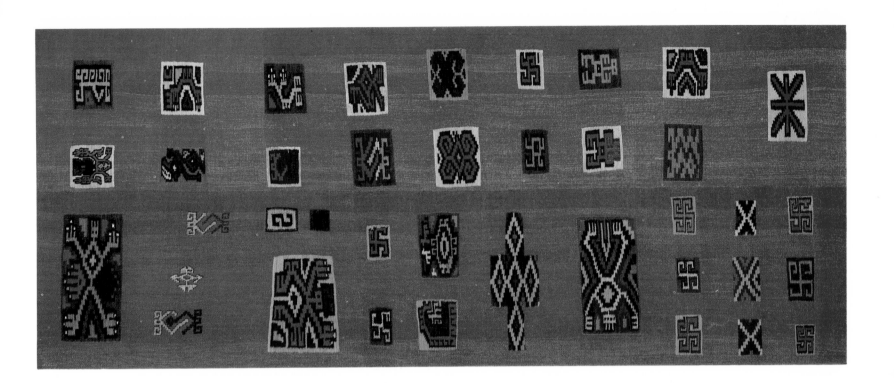

Ceremonial Textile

THE Maya *Embracing Couple* is a superb example of the figurines found buried in tombs on the mile-square island of Jaina in the Gulf of Mexico. This island, in the direction of the setting sun near the Maya world's end, was used as a cemetery and ceremonial center.

The Maya served a pantheon of deities whose activities and relationships were allegories for the forces and cycles of nature. The Detroit figurine may be compared with images in the *Dresden Codex*, an illustrated folding book of bark paper, dealing with Maya astronomy. A featured deity is Ix Chel, the goddess of the moon, earth, and water. Beautiful, serene, and amorous, she controlled procreation, licentiousness, healing, foretelling the future, bodies of water, and rainbows. She is shown in affectionate poses with elderly male deities associated with the sun, the heavens, and the Maya calendar. These embracing figures may represent lunar phases and conjunctions. The attraction of the moon goddess for these other heavenly deities insured that life on earth would continue, rain would fall, the heavenly bodies would continue on their appointed rounds, and life would come from death.

Maya philosophy placed great emphasis on the fertility of the earth and the recurring life cycles of man, earth, and the heavens. If this is the moon goddess, she may be represented as a Maya noblewoman graciously accepting Death's welcome to the underworld, for her ear ornaments and artificially elongated skull resemble those of the Maya elite buried at Jaina.

The Detroit figurine is composed of molded faces and body fronts and more simply modeled backs. Some of the ornaments were appliquéd and some incised, and the distinctive Maya blue paint was added to the woman's headdress, ear ornaments, and gown, while the man's body was painted earth red.

Figurines such as this one often were found buried on or near a corpse, indicating their importance as aids in the transition to another phase in the cycle of existence.

REFERENCE

Elizabeth P. Benson, "From the Island of Jaina: A Maya Figurine," *Bulletin of the Detroit Institute of Arts*, vol. 57 (1979), pp. 94–103.

Embracing Couple

Maya, ca. 700

Terra-cotta with traces of pigment; h. 24.8 cm. (9¾ in.)

Katharine Margaret Kay Estate and New Endowment Fund (77.49)

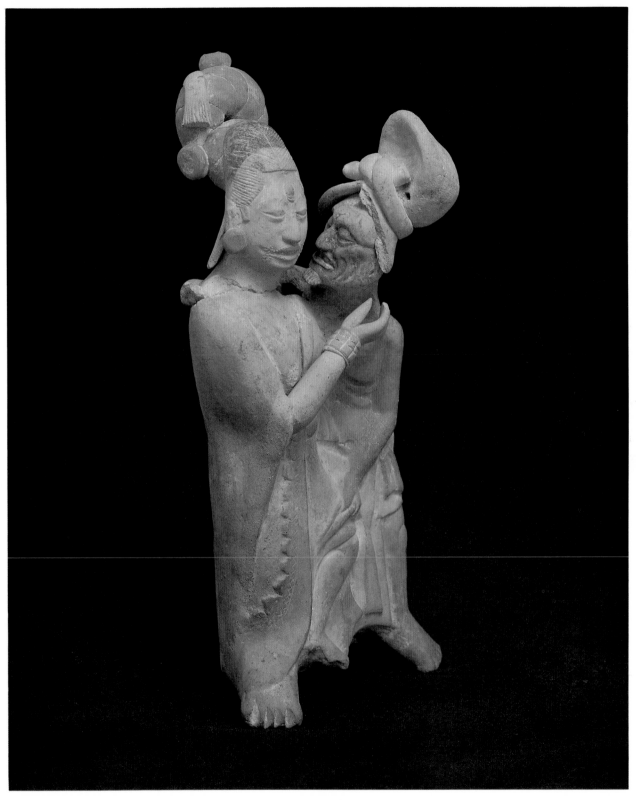

MAYA

Embracing Couple

THE term *palma* (palm leaf), in Mexican archaeology, refers to a large leaf-shaped stone sculpture most commonly associated with the classic period of the Vera Cruz coast of the Gulf of Mexico. The *palma* shape is also associated with the distinctive Mesoamerican ball game; relief carvings at the Vera Cruz site of El Tajín illustrate men wearing objects shaped like palm leaves tied to their waists while playing the game.

This *palma* is unusual in its comparatively graphic depiction of a sacrifice. A supernatural being with the head of a monkey and an elaborate headdress stands on the chest of a sacrificial victim. The palmate portion of the object behind the figure is carved with two maize stalks in low relief. The monkeylike deity, when combined with the ball game connotation of the *palma*, suggests that it can be identified as Ocomatli, a god of amusements, dancing, sports, success in games, and also as a manifestation of Xochipilli Centeotl, a variation of the Aztec maize god Centeotl, thus explaining the stalks.

The theme of sacrifice on the *palma* refers to the ritualistic and religious overtones of the ball game. The mythic origin of the game recounts how two brothers played against the Lord of the Underworld. Though they lost and were killed, they were miraculously resurrected and defeated the underworld god, thereby conquering death. Mesoamerican cosmology related death and resurrection to the seasonal growth and harvest of corn, their staple food. The Vera Cruz ball game in some ways reenacted the origin myth since the losing team was sacrificed, as is illustrated on the reliefs carved on the ball court at El Tajín. Sacrifice promised resurrection—not of the players, but of the next season's corn crop, which would emerge from the realm of the underworld and conquer death.

REFERENCE

A. S. Cavallo, "A Totonac Palmate Stone," *Bulletin of the Detroit Institute of Arts*, vol. 29 (1949–50), pp. 56–58.

Palma with Maize God Receiving a Human Sacrifice

Mexico, Vera Cruz Culture, 400–700

Basalt; h. 48.3 cm (19 in.)

City of Detroit Purchase (47.180)

African, Oceanic, and New World Cultures

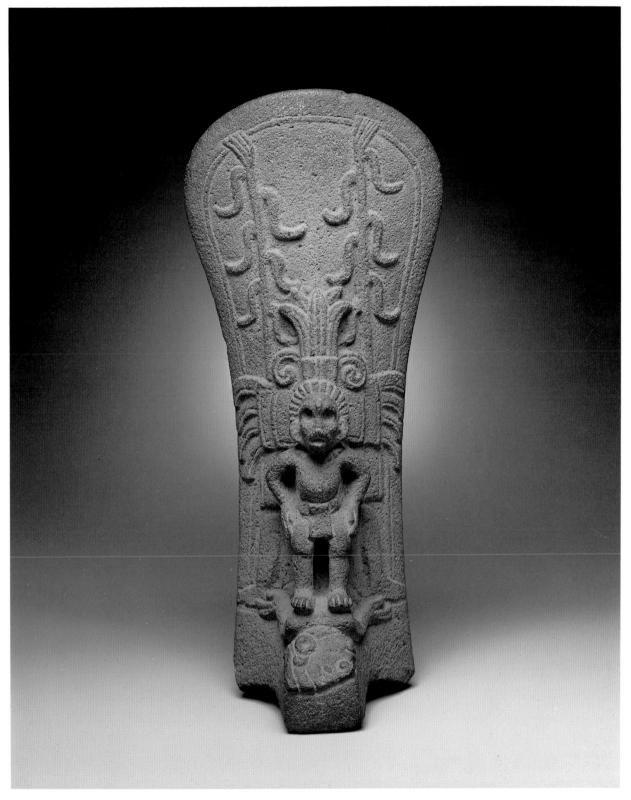

MEXICO, VERA CRUZ CULTURE

Palma with Maize God

THE heavily forested woodlands of the American Northeast once supported a dense Native American population. Many of the tribes combined cultivation of corn with seasonal periods of hunting and gathering. The arrival of Europeans permanently changed the life-style of the northeastern Indians as they turned away from traditional patterns of life to heavy dependence on the fur trade. The combined pressures of fur trade competition, European settlers, and, finally, administrative policies worked to move the eastern peoples steadily westward, so that by the nineteenth century many of the Great Lakes tribes were living on reservations in the prairie states.

The *Bear Claw Necklace* was made by a member of the Sauk and Fox tribe native to the Upper Great Lakes area. At the time of European contact in the seventeenth century, the two groups lived in what is now Wisconsin; they later fled to the prairies, where a few hundred still live today. The necklace is an example of personal adornment expressing the social importance of the owner. The bear was believed to be the most powerful and intelligent of animals. The wearing of such a necklace implied the sharing of these attributes, and a strong spiritual power derived from association with the animal. The claws came from the prairie grizzly bear, a subspecies that became extinct on the prairies in the early nineteenth century. These claws were prized because they grew especially long in the grassy environment. All of the claws used came from the forepaws of the animal, and a maximum of eight could be taken from a single bear.

A religious specialist was required to assemble the necklace and endow it with protective powers. The necklace is wrapped in otter fur, and a long otter tail (not shown) hangs as a pendant from the back. Large dotted beads, obtained by trade with Europeans, separate the claws, and various beaded panels and colorful rosettes embellish the necklace. Only the most esteemed chiefs and warriors would wear such an ornament.

Bear Claw Necklace

Native American, Sauk and Fox, 1835

Bear claws, fur, glass beads, ribbon, horsehair, and cloth; necklace: 44.4 × 36.8 cm (17½ × 14½ in.)

Founders Society Purchase (81.644)

African, Oceanic, and New World Cultures

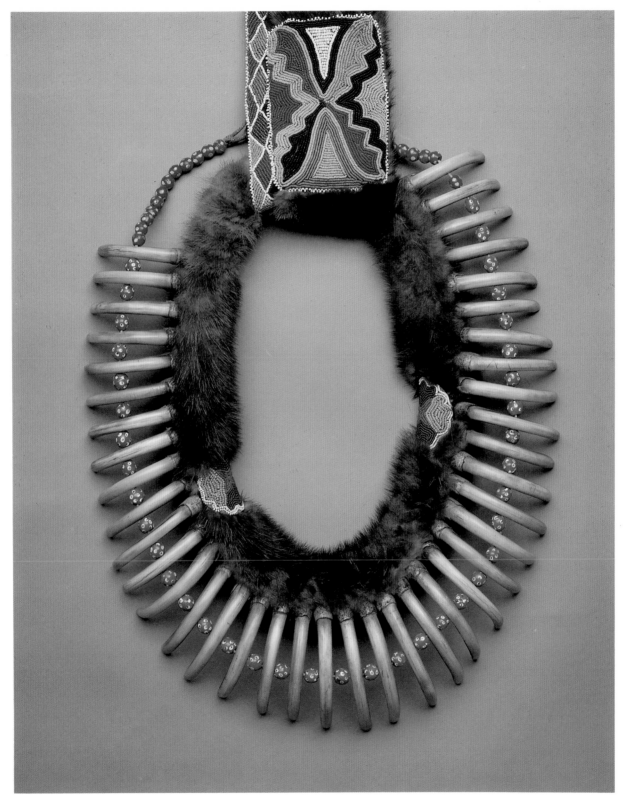

NATIVE AMERICAN, SAUK AND FOX

Bear Claw Necklace

This Cheyenne shield was a gift from General George Armstrong Custer to the Audubon Club of Detroit in 1869. It previously belonged to Little Rock, second-in-command to Chief Black Kettle. In violation of a treaty, Custer's Seventh Cavalry destroyed their Cheyenne camp. Little Rock died while defending the women and children, and his shield was taken as booty.

The Cheyenne were famed as buffalo hunters and warriors of the Great Plains; their territory ranged from Oklahoma to South Dakota. The products of the buffalo hunt were prepared with traditional ceremonies to provide the warrior with physical and spiritual protection. The shield's hard core of buffalo rawhide could stop arrows; its cover of tanned buckskin displays potent objects and painted symbols in a precisely planned schematic depiction of Little Rock's dream vision.

The thunderbird, referring to the sacred power of thunder, is accompanied by smaller birds that symbolize other sacred powers. The crescent shape represents the moon, and the cluster of seven circles signifies the constellation Pleiades. Grandmother Earth, who gave the Cheyenne their first corn and buffalo, is represented by the blue border.

Red, the most sacred color, symbolizes supernatural blessing and life. Black (the original color of the now-faded background) is a victory color, representing enemies killed and the dead coals of the extinguished camp. The objects attached at carefully selected points—bells, eagle and owl feathers, and corn husks—may refer to qualities of the wind, the birds, and Grandmother Earth. The blue-green color probably was made from the blue clay of Bear Butte, the Cheyenne sacred mountain accessible to them between 1830 and 1851.

REFERENCES

Evan Maurer, *The Native American Heritage,* Chicago, 1977, cat. no. 206.

Michael Kan and William Wierzbowski, "Notes on an Important Southern Cheyenne Shield," *Bulletin of the Detroit Institute of Arts,* vol. 57 (1979), pp. 125–33.

Michael Kan and William Wierzbowski, "The Native American Art Collection of the Detroit Institute of Arts," *American Indian Art,* vol. 4 (1979), no. 3, pp. 57–59.

Shield

Native American, Cheyenne, mid-nineteenth century

Buffalo rawhide, tanned buckskin, bells, feathers, corn husks, and natural pigments; diam. 49.5 cm (19½ in.)

Gift of General George Armstrong Custer (76.144)

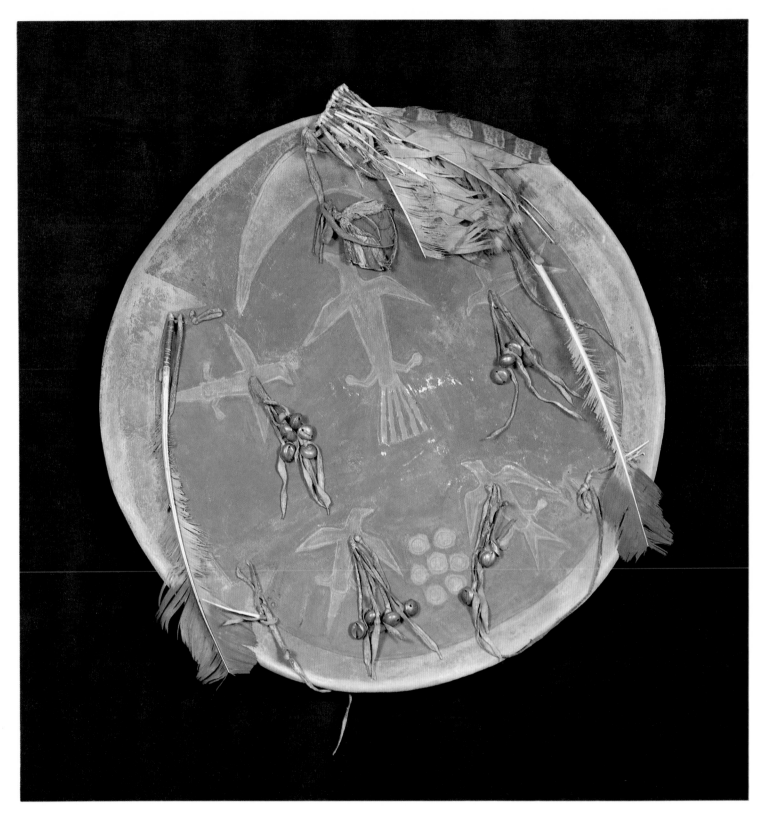

NATIVE AMERICAN, CHEYENNE

Shield

European Painting

DELICATE and precious in its execution and rich in its symbolism, this small panel painting attributed to Jan van Eyck depicts Saint Jerome reading in his study. He is identified by his attribute, the lion, from whose paw, according to legend, Jerome extracted a thorn. The books and other objects relate to the saint's intellectual pursuits and, in this context, take on symbolic meanings. The hourglass is traditionally equated with the passage of time and the mortality of man. The glass bottle is undisturbed by the light passing through it just as the virginity of Mary was undisturbed by the Holy Spirit when she conceived Jesus. The jar labeled *tyriaca* (an antidote for snakebite) surmounted by a pomegranate (a symbol of resurrection) refers to Christ as the Savior of mankind.

Based on the inscription on the folded letter on the table, Erwin Panofsky suggested that the figure of Saint Jerome is a disguised portrait of Cardinal Niccolò Albergati, titular head of the church of Santa Croce in Gerusalemme, Rome. The cardinal, a noted scholar and ascetic, visited Bruges in 1431 and was an important participant at the Congress of Arras in 1435, meeting with Jan van Eyck's patron, Philip the Good, on both occasions. A silverpoint drawing (formerly Kupferstichkabinett, Dresden) and a painting (Kunsthistorisches Museum, Vienna) attributed to the artist have also been identified as portraits of Cardinal Albergati, but the individuals portrayed bear little resemblance to the Detroit Saint Jerome.

Although a majority of scholars have agreed that Jan van Eyck probably executed most of the painting, much of the continuing controversy surrounding its authorship is based on the date *1442* on the wall above the saint. The date is not in the original paint layer but was added soon afterward. This fact has led to a supposition that the painting was incomplete at the time of Jan van Eyck's death and that his artistic heir, Petrus Christus, finished and dated it.

REFERENCES

Erwin Panofsky, "A Letter to St. Jerome: A Note on the Relationship between Petrus Christus and Jan van Eyck," *Studies in Art and Literature for Belle da Costa Greene*, ed. D. Miner, Princeton, 1954, pp. 102–8.

Edwin Hall, "Cardinal Albergati, St. Jerome and the Detroit Van Eyck," *Art Quarterly*, vol. 31 (1968), pp. 2–34.

Edwin Hall, "More about the Detroit Van Eyck: The Astrolabe, the Congress of Arras and Cardinal Albergati," *Art Quarterly*, vol. 34 (1971), pp. 180–201.

Jan van Eyck

Flemish, ca. 1390–1441

Saint Jerome in His Study, **inscribed 1442**

Oil on panel; 19.9 × 12.5 cm (7⅞ × 4⅞ in.)

City of Detroit Purchase (25.4)

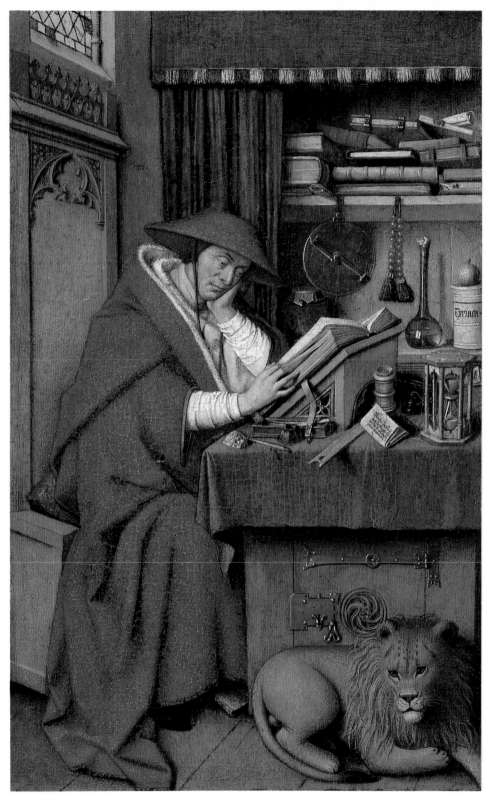

JAN VAN EYCK

Saint Jerome in His Study

THE exceptionally fine condition of the paint surface and gilding of Benozzo Gozzoli's *Madonna and Child with Angels* provides a wonderful example of the freshness and brilliance of Florentine Renaissance painting in the middle of the fifteenth century.

Benozzo is best known for his lively frescoes of the Journey of the Magi that decorate the chapel in the Palazzo Medici, Florence. These were painted in 1459, shortly before the Detroit picture was executed. Earlier, Benozzo had served as principal assistant to Fra Angelico in his work on frescoes for the chapel of Nicholas V in the Vatican, and then in the Cathedral at Orvieto.

Here the Virgin is sumptuously dressed in a cloak lined with ermine; the neckline and cuffs of her dress are ornamented with illusionistically painted precious jewels. The Child holds a naturalistically detailed goldfinch, a bird that prefers to eat thistles and other thorny plants and thus symbolizes the Passion of Christ. An otherworldly quality is imparted to this heavenly vision of the Madonna and Child by the clearly modeled surfaces and precise treatment of details and by the brilliantly colored red and blue angels who surround the holy figures. Each of these angels has six wings, identifying them as seraphim, the highest of the nine orders of angels. The seraphim provided Benozzo with an opportunity to create complex decorative patterns in their wings, delicately incised haloes, and alternating intense colors. The dense, unworldly, and decorative qualities of the painting are heightened by the fact that the panel has been cut down on all four sides from a larger composition.

REFERENCE

John Pope-Hennessy, "The Ford Italian Paintings," *Bulletin of the Detroit Institute of Arts,* vol. 57 (1979), no. 1, pp. 18–20.

Benozzo Gozzoli

Italian, 1420–1497

Madonna and Child with Angels, **ca. 1460**

Tempera and gold leaf on panel; 64.7 × 50.8 cm (25½ × 20 in.)

Bequest of Eleanor Clay Ford (77.2)

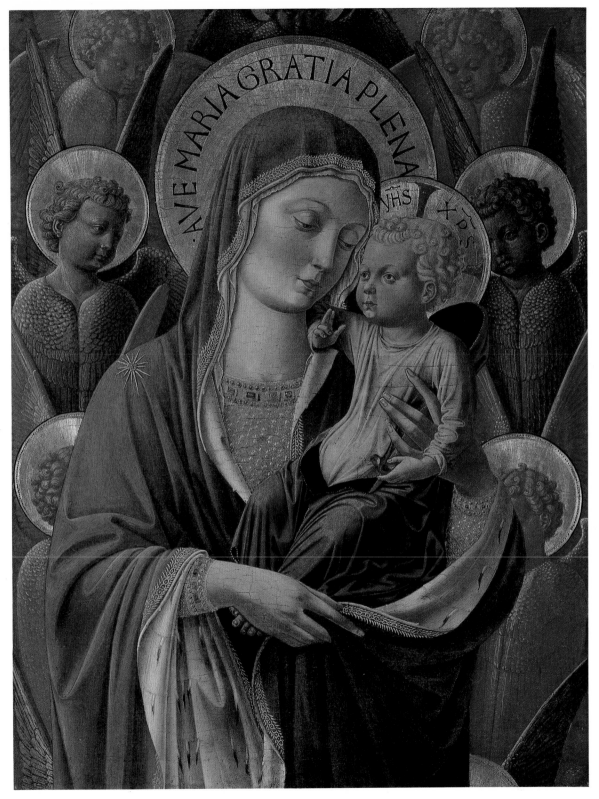

BENOZZO GOZZOLI

Madonna and Child with Angels

GIOVANNI BELLINI is the Venetian painter whose work most clearly reflects both the precision and purity of quattrocento Italian painting and the ideal beauty of High Renaissance art. He was about eighty years old when he signed and dated this composition *IOANNES BELLINVS/MDVIIII* on the book held by the Madonna. The essence of the artist's lifetime accomplishment may be perceived here in a characteristically serene vision of the Madonna and Child. The basic form is a traditional arrangement familiar from medieval times: the Virgin presents her son, who raises his hand in blessing; but the Renaissance artist constructs these figures with a beauty and perfection that are both human and divine and places them in a space that is at once earthly and sublime. Bellini was one of the first Italian artists to explore fully the new medium of oil paint, and his masterful use of its rich coloristic possibilities can be seen in the Detroit *Madonna and Child.*

The solemn figures are placed in front of a rich green curtain, which serves to heighten their immediacy. Balancing their graveness is the minutely detailed idyllic landscape, which is full of signs of both human and animal life. Bellini's natural world is beautiful, stable, and full of light and radiant air; his figures are confident, serene, and accepting. Like his contemporary Leonardo da Vinci, Bellini belonged to the last generation of artists who were untouched by the shock of the Protestant Reformation.

At the time of his death in 1516, Bellini was described by a contemporary as "the excellent painter whose fame is known throughout the whole world: despite his old age, he still painted most wonderfully."

REFERENCES

Rodolfo Pallucchini, *Giovanni Bellini,* Milan, 1959, p. 155.

Fritz Heinemann, *Giovanni Bellini e i Belliniani,* Venice, 1962, vol. 1, no. 62, p. 21; vol. 2, pp. 152–53.

Giovanni Bellini

Italian, ca. 1430–1516

***Madonna and Child,* 1509**

Oil on panel; 84.7 × 106 cm (33⅜ × 41¾ in.)

City of Detroit Purchase (28.115)

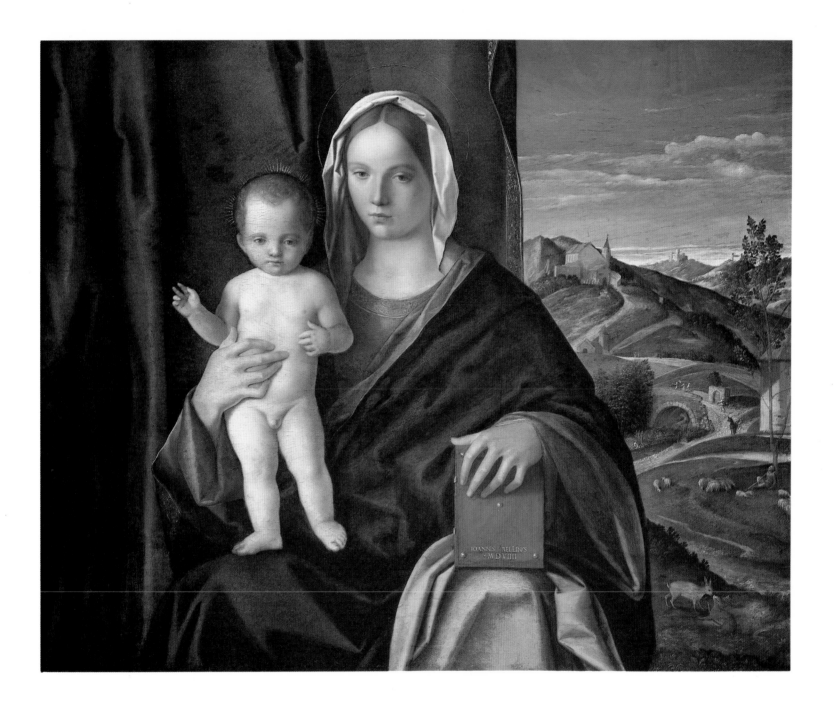

GIOVANNI BELLINI

Madonna and Child

ONE of the greatest achievements of the German Renaissance is in the art of portraiture, which was brought near perfection by Hans Holbein the Younger. Born in Augsburg, Holbein was active in Basel and, above all, in London. He was appointed a member of King Henry VIII's household, and one of his tasks there was to execute portraits of courtiers. A superb series of Holbein's drawings is kept at Windsor Castle and constitutes the most vivid description of Renaissance gentry that has come down to us.

The small, exquisitely detailed portrait in Detroit comes from the Lonsdale family at Lowther Castle, Cumberland. The early history of the painting is not known, but it probably was done in England and remained there until it was bought by Mr. and Mrs. Edsel Ford. The unknown woman in the portrait wears a typical English outfit of the period. The large beret over the frontlet and the folded neckerchief draped about her shoulders were fashionable at the time in England, as witnessed by other portraits executed by Holbein in the mid-thirties.

The startling economy of the portrait gives no clues to the identity of the sitter; even her age is uncertain. This is not unusual in portraits by Holbein, who concentrated on the sitter's personality rather than on informative attributes. The remoteness of expression also is a feature Holbein used occasionally to express the inner qualities of his subject, as in the penetrating portrait of his friend Thomas More (Frick Collection, New York).

REFERENCES

Paul Ganz, "A Note on a Holbein Portrait," *Art Quarterly,* vol. 1 (1938), pp. 59–60.

Katharine Baetjer, "A Portrait by Holbein the Younger," *Bulletin of the Detroit Institute of Arts,* vol. 57 (1979), no. 1, pp. 15–29.

Hans Holbein the Younger

German, 1497/98–1543

***Portrait of a Woman,* ca. 1532–35**

Oil and tempera on panel; 23.4 × 19.1 cm (9⅛ × 7½ in.)

Bequest of Eleanor Clay Ford through the generosity of Benson and Edith Ford, Benson Ford, Jr., and Lynn Ford Alandt (77.81)

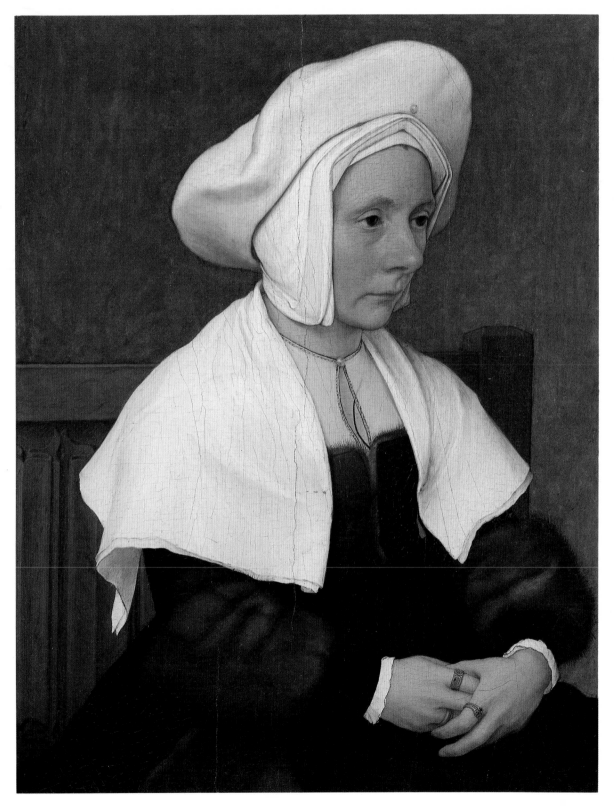

HANS HOLBEIN THE YOUNGER

Portrait of a Woman

THE WEDDING DANCE was discovered in England in 1930 by William R. Valentiner, at that time the director of the Detroit Institute of Arts. He recognized it as an original work by Pieter Bruegel the Elder and purchased it for the museum. A thorough cleaning in 1942 revealed the vibrancy of color that is typical of Bruegel.

While most of Bruegel's contemporaries in the Netherlands were imitating the themes and styles of Italian Renaissance painting, Bruegel found the source for his art in the life around him—in vast landscapes and especially in his adaptations of peasant life as a vehicle for his own "human comedy."

The Wedding Dance is a splendid example of his fascination with the people of his native land as an artistic source. It is documented that Bruegel attended peasant weddings in disguise, in order to study them. He might, in this sense, be compared to the quiet, isolated observer standing just behind the bagpipers, at the right side of the painting.

Though it is primarily an engaging genre picture that describes a wedding with accuracy and brilliance of color, the painting may also have an allegorical significance. The frenzied dance and the lustful behavior of some of the peasants may allude to the desacralization of marriage, which leads to sin and damnation. There seems to be in Bruegel's moralizing mind only a short step from this peasants' dance to the dance of death.

REFERENCES

Ernest Scheyer, "*The Wedding Dance* by Pieter Bruegel the Elder in the Detroit Institute of Arts: Its Relations and Derivations," *Art Quarterly,* vol. 28 (1965), pp. 167–93.

Fritz Grossman, *Bruegel: The Paintings,* London, 1966, pp. 200–201.

Pieter Bruegel the Elder

Flemish, 1525/30–1569

The Wedding Dance, **ca. 1566**

Oil on panel; 119.4 × 157.5 cm (47 × 62 in.)

City of Detroit Purchase (30.374)

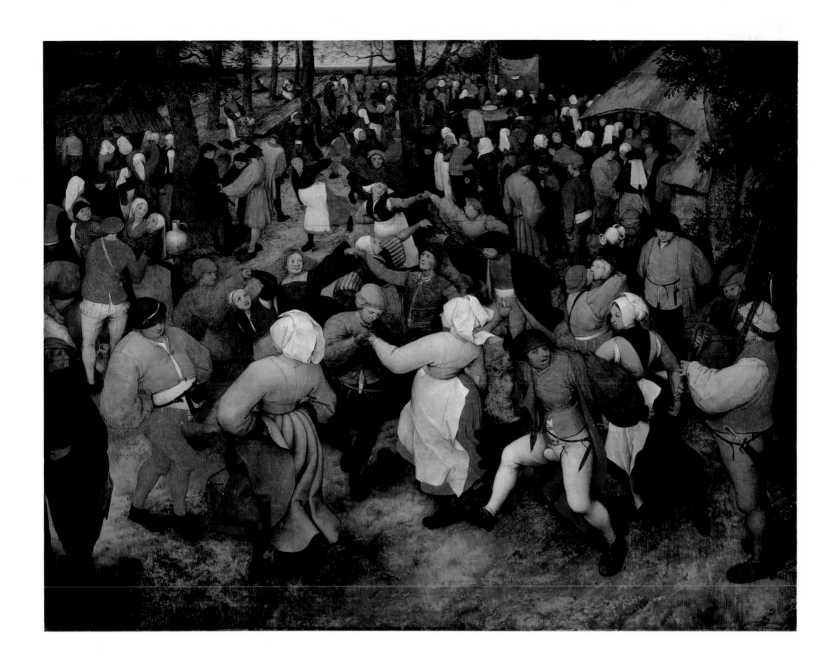

PIETER BRUEGEL THE ELDER

The Wedding Dance

W
HEN Rubens executed this large composition around 1625–30, he was at the height of his fame. Indisputably the most revered painter in Europe since Titian, he counted emperors, kings, and the Church among his regular patrons. For these and a host of less exalted individuals he indefatigably produced paintings, altarpieces, and portraits, and provided cartoons for tapestries and designs for engravings. Living in Antwerp in palatial surroundings, directing a factorylike studio, Rubens produced a volume of work that is—even considering the extensive help he received from pupils and apprentices—titanic.

What patrons found in Rubens was an artist capable of treating every possible subject, from religious compositions to mythological scenes and political allegories, with an ease that did not exclude refined allusions and obscure iconographic details. His style, too, befitted his patrons: generous, buoyant, colorful, theatrical, the quintessence of Northern Baroque.

The early history of this picture—one of the first major paintings to enter the Detroit Institute of Arts, in 1889—is unknown, though it can be traced back to the eighteenth century when it was in a French collection. The subject, taken from I Samuel 25:18–42, relates the story of Abigail, Nabal's wife, offering provisions to David, whose messengers had requested them from Nabal but had been dismissed empty-handed, thus provoking David's ire and his resolution to avenge himself by the sword. The rarely treated subject may have been executed as a commissioned political allegory to advocate cooperation with, rather than contempt for, an occupying force. Above all, the picture displays Rubens's astonishing skill at filling a huge canvas without being trite or dull. This he does not only by diversifying gestures, contrasting textures, and pairing a remarkable sense of drawing with an innate feeling for the expressive beauty of the paint film, but also by quoting from the antique (Rubens was a collector of ancient marbles), and by introducing a splendid note of poetry in the kneeling Abigail and the two maidens standing behind her.

REFERENCES

W. R. Valentiner, "Rubens and Van Dyck in the Detroit Museum," *Art in America,* vol. 10 (1922), pp. 203–4.

Julius S. Held, *The Collections of the Detroit Institute of Arts: Flemish and German Paintings of the 17th Century,* Detroit, 1982, pp. 87–90.

Peter Paul Rubens

Flemish, 1577–1640

The Meeting of David and Abigail, **1625–30**

Oil on canvas; 178.5 × 249 cm (70¼ × 98 in.)

Gift of James E. Scripps (1889.63)

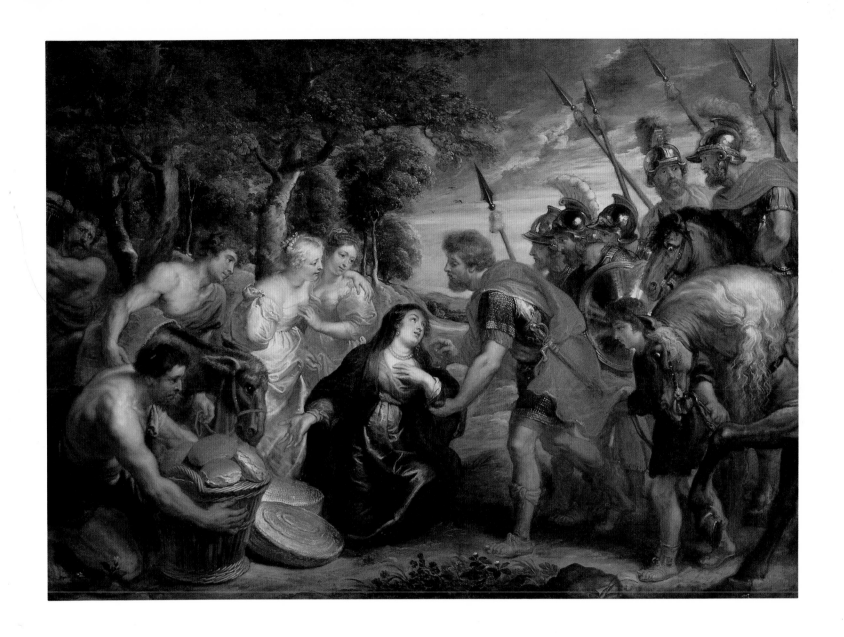

PETER PAUL RUBENS

The Meeting of David and Abigail

It is only apparently paradoxical that the greatest seventeenth-century French painter, Nicolas Poussin, spent his entire career in Rome. There, not subjected to the exacting demands of royal patronage, he was able to develop his art with the encouragement of an enlightened group of amateurs, which included Francesco Barberini, Cassiano dal Pozzo, Fréart de Chantelou, and Pointel. To these kindred spirits Poussin would deliver works ranging from austere religious images to elaborate mythological representations. The Detroit painting belonged, in the seventeenth century, to Cardinal Mazarin, whose political ambition was matched only by his fastidious taste and avid collecting.

In Rome, Poussin was never part of the flourishing art community. Although he was well known and respected by fellow artists, his works were occasionally met with indifference, and he may have been the object of intrigues that prevented him from obtaining lucrative commissions. The lack of official recognition was balanced, however, by the intellectual rewards he received from association with his distinguished friends. As a result Poussin's works, rather than participating in the development of the great Baroque tradition of Roman painting, reflect the interests, preoccupations, and discoveries of this small group of refined intellectuals.

Selene and Endymion shows the influence of the circle upon Poussin in the early 1630s, when the subject matter of his work often was based on Ovid's *Metamorphoses* and dealt with poetic and allegorical themes. The exact subject of this painting is the meeting of Selene (Diana) and her lover Endymion with whom she will spend the day away from the light of the sun. A winged figure is about to draw a curtain to protect the couple from Apollo who is seen departing on his chariot at dawn. The painting deals with love in a subtle manner that stresses the passing of time. It is typical of Poussin in the 1630s to play with the ambiguity of the moment represented: the meeting of the lovers can happen only if day alternates with night. It is this elegiac mood, paired with an extraordinary economy of narrative elements, that made contemporary artists like Bernini see in Poussin a painter of particularly elevated intellectual quality.

REFERENCES

Walter Friedlaender, *Nicolas Poussin,* New York, 1966, p. 120.

Anthony Blunt, *The Paintings of Nicolas Poussin,* London, 1966, no. 149, p. 107.

Jacques Thuillier, *L'Opera completa di Poussin,* Milan, 1974, p. 90, no. 42.

Nicolas Poussin

French, 1594–1665

***Selene and Endymion*, ca. 1630**

Oil on canvas; 121.9 × 168.9 cm (48 × 66½ in.)

Founders Society Purchase, General Membership and Donations Fund (36.11)

European Painting

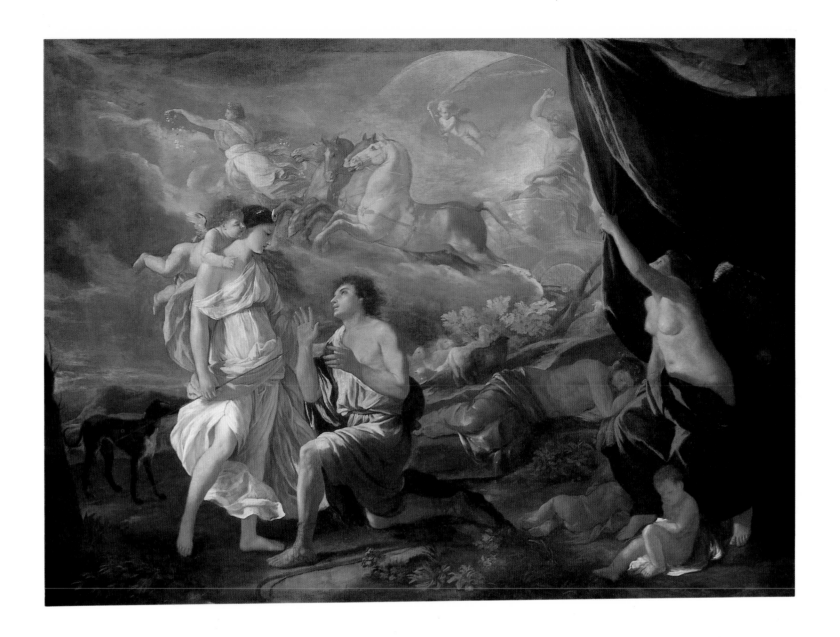

NICOLAS POUSSIN

Selene and Endymion

It is characteristic of the greatest painters to reach at the end of their lives a freedom of expression that is sometimes considered a loosening of constraints on their earlier style, while it is, in fact, a subtle apotheosis of their most personal qualities. The Bolognese Guido Reni does not differ in this respect from such masters as Titian and Picasso. For years the most articulate exponent of a rigorous classicism, the master par excellence of impeccably balanced composition, smoothly finished execution, and the coolest color harmonies, Reni ultimately relinquished this abstract elegance in order to create works that are less "perfect" in appearance but emotionally richer.

In his youth Reni could not escape the widespread fascination for Caravaggio's astonishing naturalism. Having occasionally tried his hand at it, he rejected this style to pursue a classical ideal. Yet the fascination remained, and in his late paintings, Reni finally resolved his response to Caravaggio's work by synthesizing the realist and the classical traditions in works that are remarkably loaded with emotion.

The remoteness of the figures typical in his early style is replaced in *The Angel Appearing to Saint Jerome* by the expression of an intense, if mute, communication between the saint and the angel. Surprise, awe, respect, and a subtle array of psychological states are expressed by a vigorous colorism and an eloquent display of gestures that are theatrical without being melodramatic. Ethereal in its intention yet immediate in its rendition, this painting maintains a remarkable aesthetic and emotional balance which Guido's followers and imitators through the centuries were seldom able to duplicate.

REFERENCES

D. Stephen Pepper, "*The Angel Appearing to Saint Jerome* by Guido Reni, a New Acquisition," *Bulletin of the Detroit Institute of Arts,* vol. 48 (1969), pp. 28–35.

D. Stephen Pepper, *Guido Reni.* Forthcoming.

Guido Reni

Italian, 1575–1642

The Angel Appearing to Saint Jerome, **ca. 1640**

Oil on canvas; 198.1 × 148.6 cm. (78 × 58½ in.)

Founders Society Purchase, Ralph H. Booth Fund, Mr. and Mrs. Benson Ford Fund, Henry Ford II Fund, and New Endowment Fund (69.6)

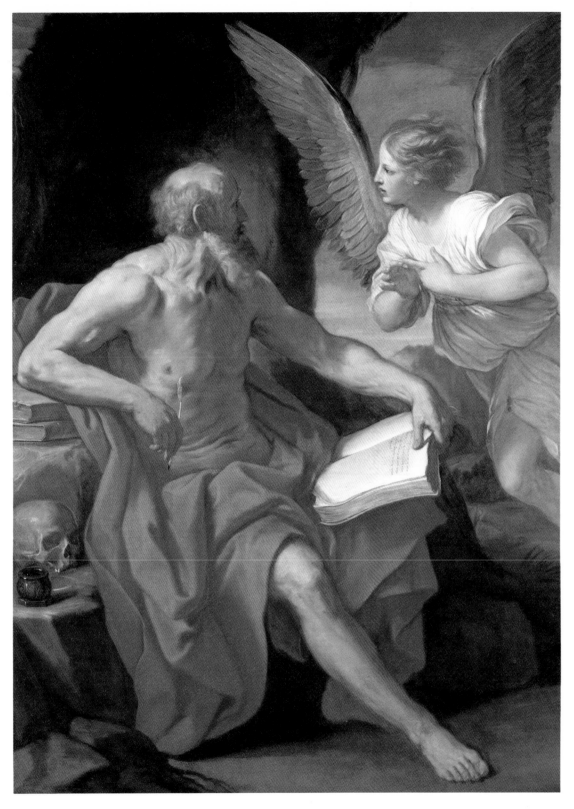

GUIDO RENI

The Angel Appearing to Saint Jerome

THE uniqueness of Rembrandt's *Visitation* resides both in the fact that it is the artist's only rendition of the subject and in its striking representation of the event. Everything in the picture acts to stress the emotional encounter of the two expectant women, Mary and her cousin Elizabeth. A supernatural golden light evenly bathes the composition, except for Elizabeth's face and to a lesser extent Mary's, which seem to glow in the semidarkness. This not only focuses attention on the center of the action, it is the only indication of the supernatural character of the encounter and symbolically reveals God's choice of the two women for participation in his miracle.

From Zacharias easing himself down the stairs, helped by a young boy, to Joseph climbing up the hill leading his donkey, the figures are linked by a series of gestures that add softness and fluidity to the composition while stressing the intimacy that binds the characters. Animals also play a symbolic role in the image. The dog provides another touch of informality and symbolizes the faithfulness of the couples. The peacock, a symbol of vanity, here seen watching over its chicks, contrasts with Elizabeth's profound joy and Mary's humble attitude as *ancilla Domini* (handmaiden of God).

This picture may also relate to Rembrandt's private life in the fact that Elizabeth's face seems patterned after that of Rembrandt's mother, who died in 1640 when his wife, Saskia, was about to deliver a child.

REFERENCES

Horst Gerson, *The Complete Edition of the Paintings of Rembrandt,* London, 1969, pp. 312–13.

Abraham Bredius, *Rembrandt,* London, 1969, no. 562, pp. 476, 607.

National Gallery of Art, Washington, D.C., *Gods, Saints, and Heroes: Dutch Paintings in the Age of Rembrandt,* 1980, p. 146, no. 27.

Rembrandt Harmensz. van Rijn

Dutch, 1606–1669

The Visitation, 1640

Oil on panel; 56.5 × 48.1 cm (22¼ × 18⅞ in.)

City of Detorit Purchase (27.200)

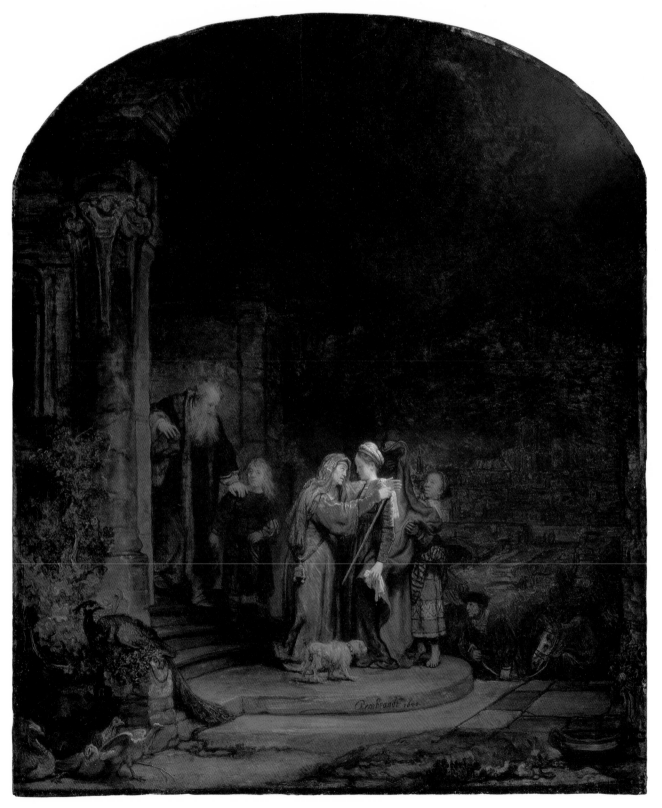

REMBRANDT HARMENSZ. VAN RIJN

The Visitation

THIS imposing landscape has never failed to startle commentators on Ruisdael's work and to defy their interpretation of it. Both the mystery surrounding its exact subject and its powerful evocation of a distinctive mood are major factors in the fascination it has exerted since its rediscovery in the early years of the nineteenth century.

The Detroit painting, which features tombs, ruins, broken tree trunks—as well as their symbolic hopeful counterparts, a pervasive light and a rainbow—is a rare example of an allegorical landscape in the oeuvre of Ruisdael. The theme of the painting relates broadly to the *Vanitas,* an allegory, popular among Dutch still-life painters of the same period, of the transience of things.

The landscape juxtaposes realistic elements and more fanciful ones: the tombs are those which can still be seen at Beth-Haim, the Jewish cemetery of the Portuguese-Jewish community at Ouderkerk, near Amsterdam; the imposing ruin looming in the background is a fantasy based on studies made by the artist of the Romanesque abbey of Egmond and of the Gothic Buurkerk at Egmond-Binnen. Neither the ruin nor the hilly ground are part of the topography of the actual cemetery at Ouderkerk.

The elegiac mood of the painting has brought forth various interpretations. Goethe, who saw a closely related version executed shortly after the Detroit one (Gemäldegalerie, Dresden), did not acknowledge the melancholy symbolism of the painting, saying that the work "puts us in a . . . touching mood" and "the trees, . . . grass and flowers make us forget that we are on burial ground." John Constable, referring probably to the Detroit version under the title *An Allegory of the Life of Man,* ranked it below the artist's other landscapes because it "attempted to tell that which is outside the reach of art." Ruisdael's ambitious composition clearly concerns itself with issues broader than personal devotion: history, a meditation on the transience of things, and ultimately an existential quest.

REFERENCES

Jakob Rosenberg, *Jacob van Ruisdael,* Berlin, 1928, no. 153.

Wolfgang Stechow, *Dutch Landscape Painting of the Seventeenth Century,* London, 1966, p. 488.

Seymour Slive, *Jacob van Ruisdael,* New York, 1981, no. 26, pp. 67–75.

Jacob van Ruisdael

Dutch, 1628/29–1682

The Cemetery, **1655–60**

Oil on canvas; 142.2 × 189.2 cm (56 × 74½ in.)

Gift of Julius H. Haass in memory of his brother Dr. Ernest W. Haass (26.3)

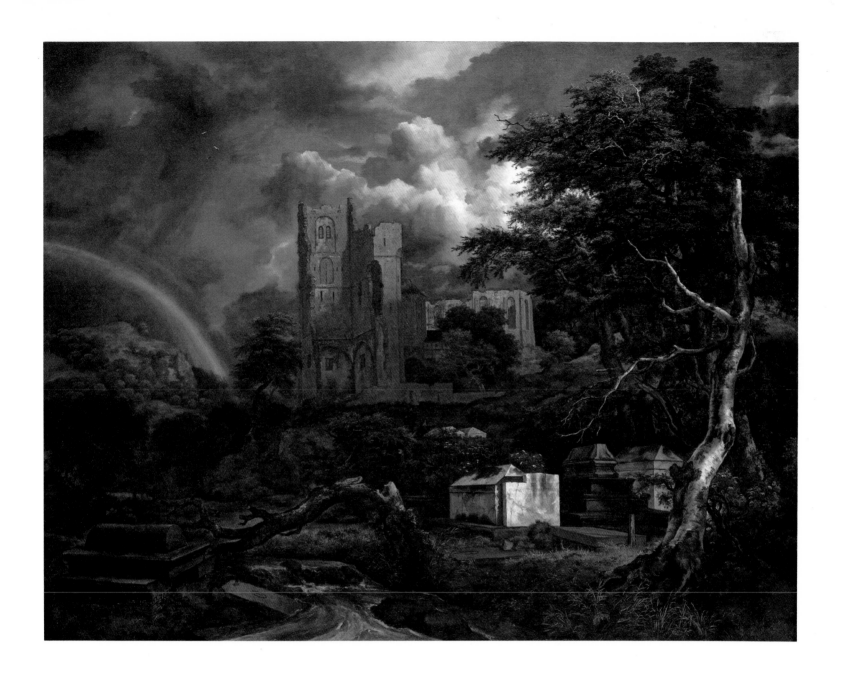

JACOB VAN RUISDAEL

The Cemetery

THIS rightly famous painting epitomizes the delicate art of Gerard Terborch. Executed around 1660, it is a mature work in which the artist displays his ability to manipulate the gestures, the placement of the figures, and the play of light in order to create an image as subtle in its narrative character as it is strong in its sureness of execution.

Terborch's paintings—and this one is no exception—are filled with mystery and reverie. Though they allude to precise scenes or subjects, these are never fully explained, and the spectator is left in a contemplative state, attempting to unravel their enigma.

In *A Lady at Her Toilet*, Terborch once again rearranges figures that belong to his stock repertoire: an elegant woman beginning to undress (she has removed the collar that should properly cover her shoulders), a page, a female servant, and a dog. Other elements give an idea of the lady's rank while introducing possibly moralizing elements. The mirror, in which her face is curiously reflected and enlarged, may be an allusion to the *Vanitas* theme, as the candles next to it could symbolize the transience of earthly things, but, at the same time, they might be only props. More important still is the lady's absent expression. Is she looking at someone outside the picture, or is she lost in her own reverie? The gesture of her hands is also mysterious: she seems to be removing her ring. Is she doing so just in the act of undressing or in a gesture of renouncing the world and its vanities? Terborch delicately plays with this ambiguity, delighting in the equivocality.

Seen in the context of Dutch genre painting, Terborch's approach was particularly original. His paintings, with their subtlety and avoidance of explicitness, became known as belonging to the "polite genre." This style, in turn, affected other artists, Jan Vermeer among them, who chose to focus on the representation of sentiments in all their complexity.

REFERENCES

Sturla J. Gudlaugsson, *Gerard Ter Borch*, The Hague, 1959–60, vol. 1, no. 165, p. 315; vol. 2, no. 165, p. 169.

Egbert Haverkamp-Begemann, "Terborch's Lady at Her Toilet," *Art News,* vol. 64 (1965), no. 8, pp. 38–41, 62.

Philadelphia Museum of Art, *Masters of Seventeenth Century Dutch Genre Painting,* 1984, no. 13.

Gerard Terborch

Dutch, 1617–1681

A Lady at Her Toilet, ca. 1660

Oil on canvas; 76.2 × 59.7 cm (30 × 23½ in.)

Founders Society Purchase, Eleanor Clay Ford Fund, General Membership Fund, Endowment Income Fund, and Special Activities Fund (65.10)

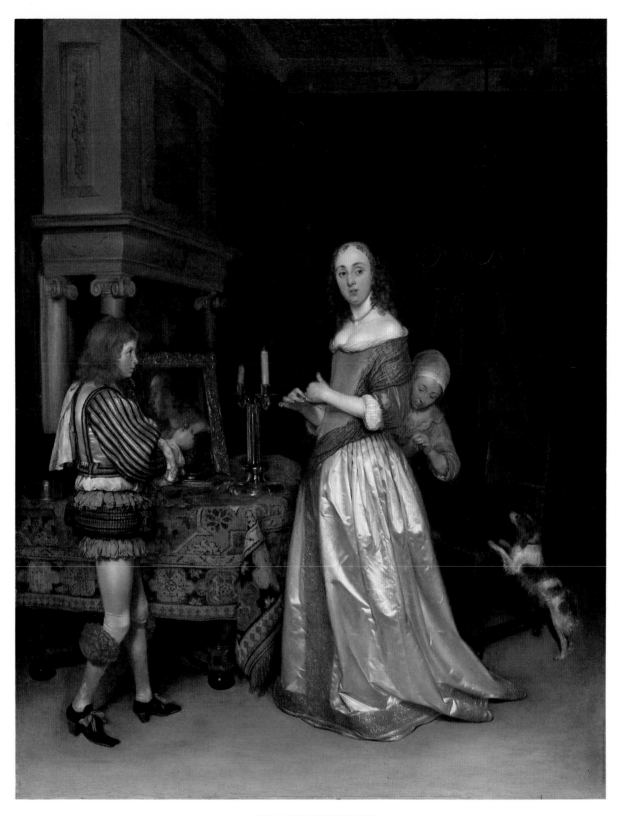

GERARD TERBORCH

A Lady at Her Toilet

The profound originality of Chardin's work, seen in the context of the official painting of his time, has never failed to surprise. Diderot avowed that "one didn't understand anything about this magic." Over the centuries critics have tried to make of this discreet artist a pioneer of modern attitudes toward aesthetic conceptions, if not a rebel against the official art of his time. This vision, though simplistic, nevertheless contains some truth. The originality of the composition in this small still life strikes one by its asceticism: a copper caldron, an earthenware dish, three eggs, a small leek, and a pepper shaker are the sole components of this richly painted image. Yet for all its "abstract" and "metaphysical" qualities, the painting is not timeless; it brings us into an earthly world and into the midst of the creative process of one of the greatest French artists of the eighteenth century.

Chardin was already famous and successful around 1730 when he began painting small still lifes of kitchen utensils, as opposed to the dead game and somewhat opulent objects he had previously favored. This series of compositions marks the apogee of his talent as a still-life painter: slight variations from one composition to another, a twist in the position of an object, the addition or suppression of a modest element, prove that for Chardin imagination is not a synonym for accumulation, but instead a constant paring.

Typically, Chardin would conceive a painting such as this kitchen still life as one of a pair. It has been advanced that the pendant of the Detroit picture is an equally sparse composition at the Musée Cognacq-Jay, Paris, where some of the elements of the Detroit picture reappear. Although an attempt at an interpretation of such compositions would be both futile and erroneous, one cannot escape the painter's vision of the real world—a vision draped in contemplative melancholy.

REFERENCES

Georges Wildenstein, *Chardin,* Greenwich, Connecticut, 1969, p. 165, no. 119.

Pierre Rosenberg, *Chardin, 1699–1779,* Cleveland, 1979, no. 50, p. 180.

Jean-Siméon Chardin

French, 1699–1779

Still Life, ca. 1732

Oil on canvas; 16.8 × 21 cm (6⅝ × 8¼ in.)

Bequest of Robert H. Tannahill (70.164)

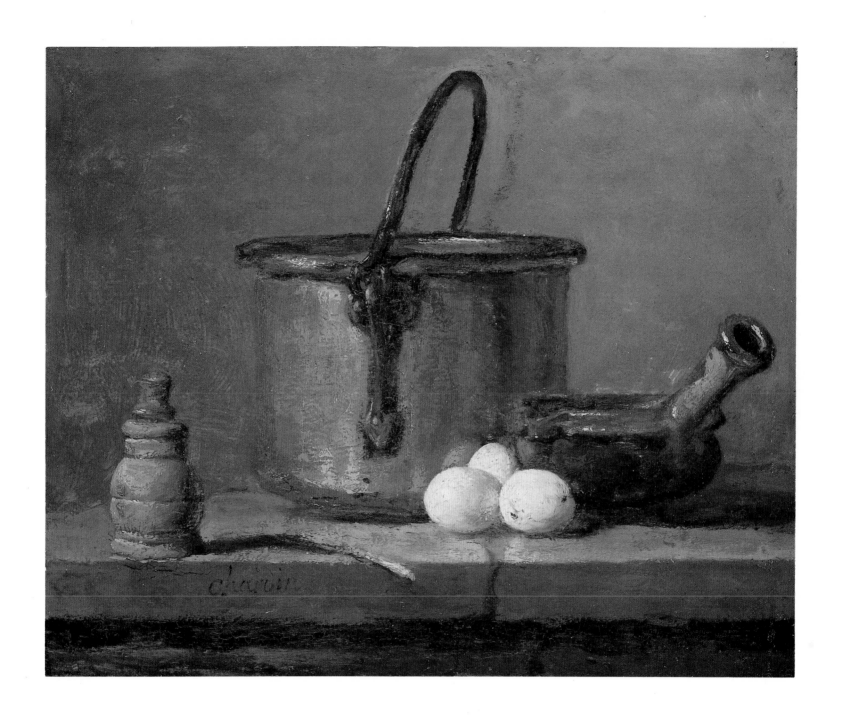

JEAN-SIMÉON CHARDIN

Still Life

SINCE its exhibition at the London Royal Academy in 1782, Henry Fuseli's *The Nightmare* has been considered the artist's supreme masterpiece, a work that established his reputation as a painter of dreams and demonic subjects and a painting whose greatness is equalled only by its ambiguity.

Because of its date the painting is often contrasted with an almost exactly contemporary work, Jacques-Louis David's *Oath of the Horatii* (Louvre, Paris), the latter being considered the manifesto of the Apollonian Neoclassic school while Fuseli's is thought to open the gates to the most Dionysiac aspects of Romanticism and beyond it to Symbolism and Surrealism. Yet to represent Fuseli as only a visionary, forward-looking artist is to ignore the extraordinary visual and literary culture of this artist of the Enlightenment, who chose his subjects from the Bible, Milton, Shakespeare, Ovid, Plutarch, Homer, and the Niebelungenlied.

Although *The Nightmare* cannot be linked to a precise literary source, the representation of a nightmare reflects contemporary philosophical preoccupations. In the Age of Reason, philosophers sought scientific explanation of dreams and nightmares. While the old creeds concerning them, linked to witchcraft or the presence of evil spirits, were easily dismissed, new scientific theories relating dreams to nutrition or bodily malfunctions were equally trivial and unsatisfactory. In their attempt to explain dreams, English philosophers such as Hume and Locke came close to a formulation of the role of the unconscious in human behavior.

Fuseli's *The Nightmare* is part of a long visual tradition of representations of dreams, dreamers, and sleeping figures, but beyond this universalism, a more personal element also can perhaps be perceived. In 1778–79 in Zurich, Fuseli had fallen passionately in love with a woman named Anna Landolt. He wanted to marry her but was turned down by her father. Returning to London, he became obsessed with her and in a letter of 1779 declared that in his dreams "Now she's mine and I am hers!" A connection with *The Nightmare,* suggested by the late H. W. Janson, may be reinforced by the fact that on the back of the canvas is a full figure of a young woman who bears the appearance of the sleeper and presumably is Anna Landolt.

REFERENCES

H. W. Janson, "Fuseli's *Nightmare*," *Arts and Sciences,* vol. 2 (1963), pp. 23–28.

Harold D. Kalman, "Füssli, Pope and the Nightmare," *Pantheon,* vol. 29 (1971), no. 3, pp. 226–36.

Nicolas Powell, *Fuseli: The Nightmare,* New York, 1973.

Henry Fuseli

Swiss, 1741–1825

The Nightmare, **1781**

Oil on canvas; 101.6 × 127 cm (40 × 50 in.)

Gift of Mr. and Mrs. Bert L. Smokler and Mr. and Mrs. Lawrence A. Fleischman (55.5)

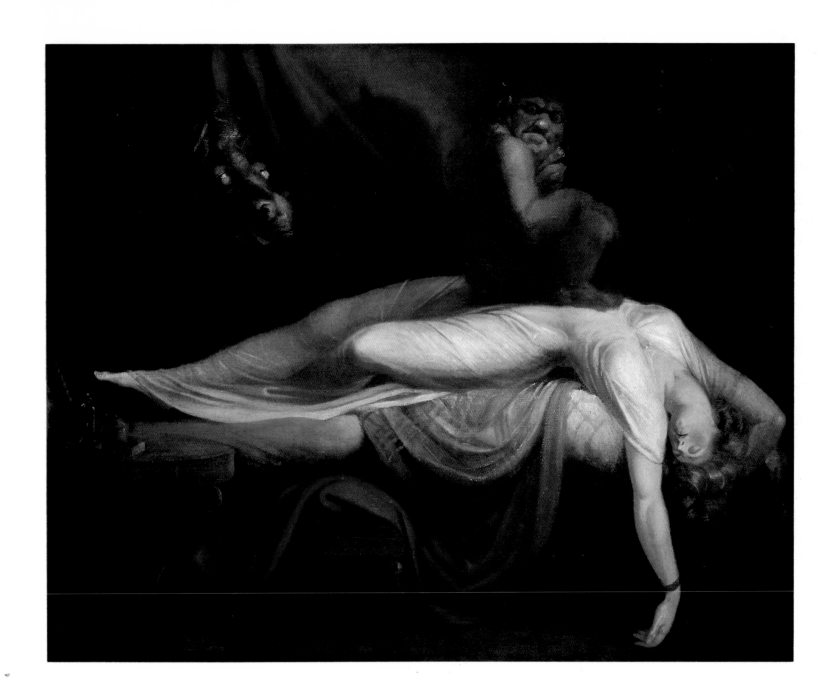

HENRY FUSELI

The Nightmare

Of all Impressionist painters, Degas is the one who devoted most attention to the human figure. He established a brilliant and impressive gallery of characters of his time, but mostly of his milieu, the *haute bourgeoisie* and aristocracy of the Second Empire and the Third Republic.

Music played an important part in the life of the Impressionists. Its popular form can be seen, for instance, in Pierre-Auguste Renoir's *Country Ball* (Museum of Fine Arts, Boston), and its more elegant variations in this picture. Although no musician was linked with the movement, the young Impressionists professed a profound admiration for Richard Wagner. His music, reduced for voice and piano, was often performed at Parisian musical soirees, such as the ones held at the home of Edouard Manet. The subject of this painting may in fact have been conceived during one of those musicales, which Degas often attended.

The two figures in the Detroit picture have not been identified. Beyond their identities as portraits, however, what matters is Degas's ability to differentiate their characters and roles through his composition and handling of paint. The slight turn of the woman's frothily painted body indicates that she is caught in action and reveals perhaps a slight apprehension, while the man is more sturdily brushed, tuning his violin with a concentrated but mildly absent expression.

Degas's elegant composition, bathed in a hazy sunlight, stresses psychological depth while avoiding narrative details. A mere indication of the setting (the mantelpiece and its mirror on the right), costumes, and attitudes are yet enough to allow us to participate in this untold story.

REFERENCES

Paul-André Lemoisne, *Degas et son oeuvre,* Paris, 1946, vol. 2, p. 134.

Jean S. Boggs, *Portraits by Degas,* Berkeley and Los Angeles, 1962, pl. 75.

Hilaire-Germain-Edgar Degas

French, 1834–1917

***Violinist and Young Woman,* ca. 1871**

Oil and pastel on canvas; 46.4 × 55.9 cm (18¼ × 22 in.)

Bequest of Robert H. Tannahill (70.167)

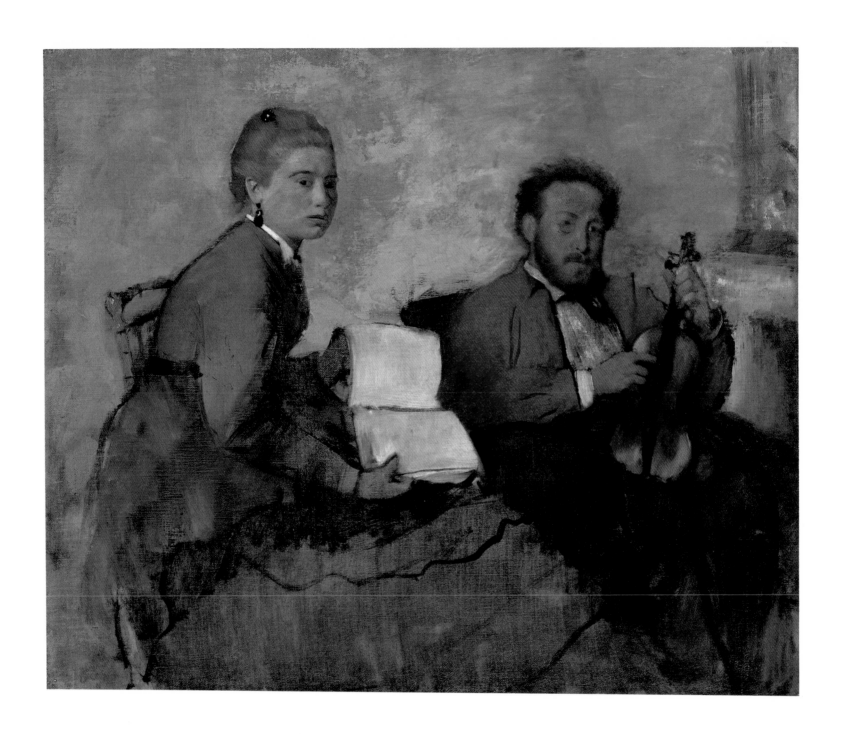

HILAIRE-GERMAIN-EDGAR DEGAS

Violinist and Young Woman

"For want of a better model," but also with obsessive attention, van Gogh repeatedly chose himself as the subject of his paintings. During the summer of 1887 he shared an apartment in Montmartre with his brother Theo. This Parisian period was a relatively happy one for the artist. His brother's protective intimacy as well as Vincent's introduction to the sophisticated Parisian world had a considerable impact on his work.

Seen as a group, the self-portraits of 1887 reveal this shift in the artist's life. Compared to later ones, they are remarkably sedate, yet their emotional and expressive impact still is considerable. All together, van Gogh's portraits constitute almost an analytical description of the artist's mental state, a poignant visual diary. Yet it is the individual qualities of each painting that prevail—their extraordinarily powerful expressiveness.

The Detroit portrait is a work of small dimensions—perhaps for the artist an almost routine recording of his own traits, an entry in his diary—in which the sitter wears the large straw hat he favored at the time. One of the most remarkable features of the Detroit portrait is the lightness of the palette. Van Gogh had considerably lightened his palette under the influence of the Impressionists but soon reserved the use of such light colors to express particular moods. Especially in the non-naturalistic coloration of his portraits, the choice of a dark or light palette was intentional. In the same period, for instance, van Gogh executed self-portraits in which his face is forcefully contrasted against a dark background. Here, instead, a sunny animated surface is common to both the artist's face and the colorful background. The emotional impact of the portrait is considerable: the eyes, deeply set in their sockets, are inquisitive, and the three-quarter pose of the head adds an immediacy to the self-presentation of the sitter. Knowing the tragic denouement of van Gogh's life causes us perhaps to project an added element of tragedy into this portrait, but it is only fair to look at this discrete masterpiece in the light of the artist's work and life at the time it was executed.

REFERENCES

Jean-Baptiste de La Faille, *L'Oeuvre de Vincent van Gogh,* Paris, 1928, no. 526.

Fritz Erpel, *Die Selbstbildnisse Vincent van Gogh,* Berlin, 1963, no. 14, p. 55.

Paolo Lecaldano, *L'Opera pittorica completa di van Gogh,* Milan, 1971, p. 185.

Vincent van Gogh

Dutch, 1853–1890

Self-Portrait, 1887

Oil on canvas; 34.9 × 26.7 cm (13¾ × 10½ in.)

City of Detroit Purchase (22.13)

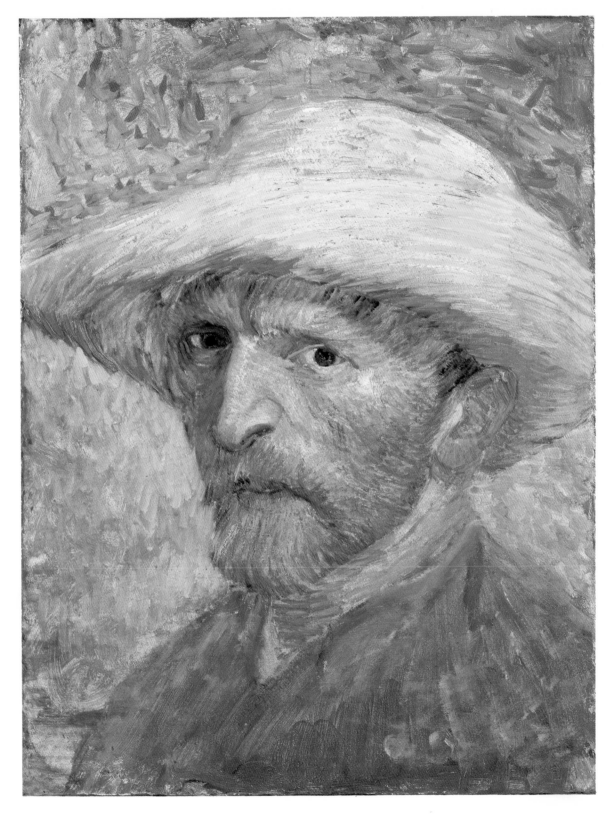

VINCENT VAN GOGH

Self-Portrait

It can be argued that Claude Monet's water lilies and Cézanne's late work are the most astonishing achievements of late-nineteenth-century French painting. Their impact upon generations of painters can still be sensed at the root of every major art movement of the twentieth century.

Cézanne, when speaking of his wife, Hortense, said that "she only likes Switzerland and lemonade." His emotional detachment from her, though surprising considering the many portraits he did of her, becomes less so when these portraits are placed in the context of his other works. Cézanne's portraits of his wife are no more about marital love than his skulls are about death or his apples about nature. Shapes, volumes, light, and the construction of an image independent from visual reality were Cézanne's preoccupations and led him to create a style as ground-breaking and original as the one Giotto had initiated in the century preceding the Italian Renaissance.

Madame Cézanne's rather plain features, severely parted hair, crossed hands, unimaginative dress, and conventional attitude make her appear almost lifeless in this picture. In contrast to the figure, the paint—the real subject of the work—flickers across the surface, animating it, creating moments of tension and calm, and guiding the eye at an unresting pace. Madame Cézanne is here reduced to being an object in space, a creation of paint and light, rather than an image of an actual human being. She belongs to the realm of the canvas more than to our own.

REFERENCES

Ambroise Vollard, *Cézanne,* Paris, 1914, pl. 45.

N. Javorskaia, *Paul Cézanne,* Milan, 1935, pl. 25.

Lionello Venturi, *Paul Cézanne,* Paris, 1936, vol. 1, p. 178; vol. 2, no. 528.

Paul Cézanne

French, 1839–1906

Portrait of Madame Cézanne, **ca. 1888**

Oil on canvas; 101 × 81.3 cm (39¾ × 32 in.)

Bequest of Robert H. Tannahill (70.160)

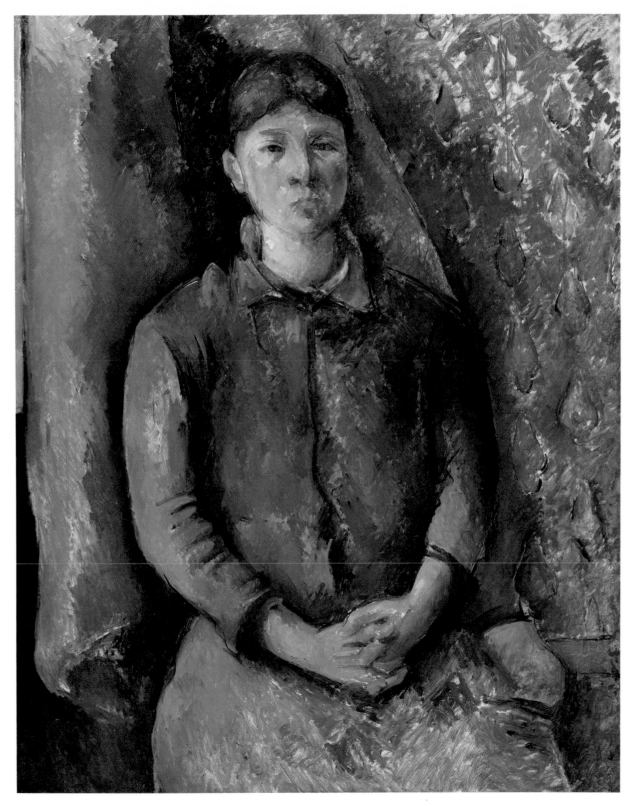

PAUL CÉZANNE

Portrait of Madame Cézanne

By the late 1880s, Impressionism had experienced a crisis that led many of its exponents to innovative approaches. Monet, for one, started painting in series, thus radicalizing his own creative process. Yet the task of taking Impressionism one step further was assumed by a younger generation who had been nurtured in its achievements. The diversity of their approaches prevents one from grouping them under a single name, but Paul Gauguin, Vincent van Gogh, Seurat, and Henri de Toulouse-Lautrec shared a common desire to use Impressionism as an expressive means rather than as an end in itself.

In this respect, the work of Seurat is particularly significant, being the most radical attempt to paint according to experimental rules; Seurat's technique, which he called "divisionist," was based on scientific research on the way the optical nerve transmits juxtaposed colors to the brain. His short career allowed him to paint only a few major works to prove the validity of his color theories, but several landscapes that at first glance appear to be dry and rationalized versions of Impressionism are in fact elegant systematizations of these theories.

This view of Le Crotoy, a village on the coast of Picardy, is characteristic of Seurat's approach to landscape painting and of his technique, which allows him to build an extraordinarily balanced landscape. Done to "wash his eye from the studio light," the painting is nevertheless a mathematical construction, built according to rules as much as to direct experience. Yet his method does not exclude expression of a mood —here calm and soothing, as recalled from the landscape backgrounds of Poussin's compositions.

One of the painting's striking and modern features is its double frame: the painted edge around the canvas and the actual wooden frame Seurat painted in his own technique. Based on optical science, his paintings do not allow the visual distraction of ordinary frames. In painting his own, Seurat helped define our field of vision and gradually prepare us to participate in the visual experience of his picture.

REFERENCES

Paul Signac, *D'Eugène Delacroix au néo-impressionisme,* Paris, 1921, pp. 74–86.

Henri Dorra and John Rewald, *Seurat,* Paris, 1959, pp. cviii–cxii.

Sarane Alexandrian, *Georges Seurat,* New York, 1980, pp. 78–85.

Georges Seurat

French, 1859–1891

***View of Le Crotoy, Upstream,* 1889**

Oil on canvas; 70 × 86.7 cm (27½ × 34⅛ in.)

Bequest of Robert H. Tannahill (70.183)

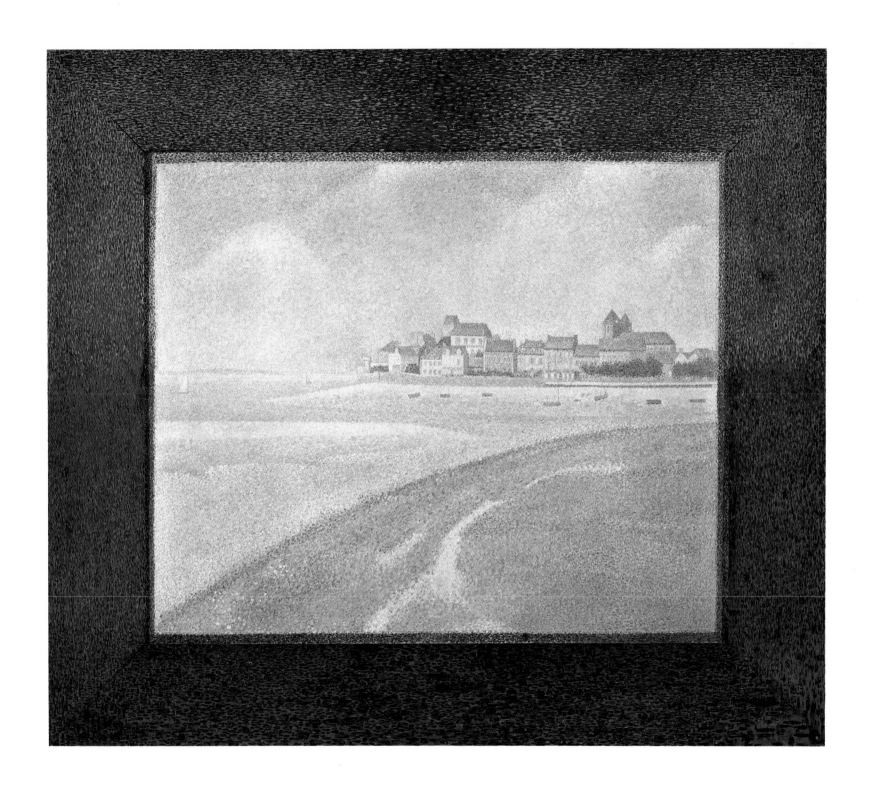

GEORGES SEURAT

View of Le Crotoy, Upstream

To the painters of the Pont-Aven school (Gauguin, Emile Bernard, Jacob Meyer de Haan, and their absent friend Vincent van Gogh) portraits and self-portraits fulfilled a specific function. Conceived as intimate statements, alluding to personal events, states of mind, or common aesthetic theories, they often were given or exchanged among the artists. In the case of Gauguin and van Gogh they may be considered to constitute something like the pages of a diary in which the artists often presented themselves as heroes, saints, or outcasts.

The date of the Detroit portrait is subject to speculation, a fact that influences its interpretation. Some authorities believe that it was painted before Gauguin's departure in 1891 for his first visit to the South Seas, but it is more likely that it was executed after his return from this trip in 1893. The artist here wears a Breton costume, which contemporaries said he sported even in Paris. His hair is long in a fashion also reminiscent of Breton peasants, and the total attitude of the artist is that of a rough and rugged man, as solid and direct as the colors he used to describe himself.

Gauguin executed another, similar portrait, usually dated 1893 (McNay Institute, San Antonio, Texas), in which he represented himself under the vigiliant eye of an oceanic idol. Here, in the upper right corner Gauguin has painted a representation of a sketch by Eugène Delacroix for a fresco in the Palais-Bourbon in Paris representing Adam and Eve expelled from Paradise. The choices of both artist and subject matter are relevant. On one hand, Gauguin pays homage to the great Romantic painter of the early nineteenth century; on the other, the choice of the image alludes to Gauguin's feelings at the time, expelled as he was from the paradise he had discovered in Tahiti.

The painting is executed in the broad and solid style referred to as Synthetist, a style that brought into immediate focus both intellectual ideas and visual reality. The signature *P.Go* at the lower left is the typical abbreviated signature of Gauguin's Synthetist works.

REFERENCES

Museum of Fine Arts, Houston, *Paul Gauguin, His Place in East and West,* 1954, no. 40.

K. Mittelstadt, *Paul Gauguin, Self-Portraits,* Oxford, 1968, p. 64.

Mark Roskill, *Van Gogh, Gauguin and the Impressionist Circle,* Greenwich, Connecticut, 1970, p. 55.

Paul Gauguin

French, 1848–1903

Self-Portrait, ca. 1893

Oil on canvas; 46.2 × 38.1 cm (18¼ × 15 in.)

Gift of Robert H. Tannahill (69.306)

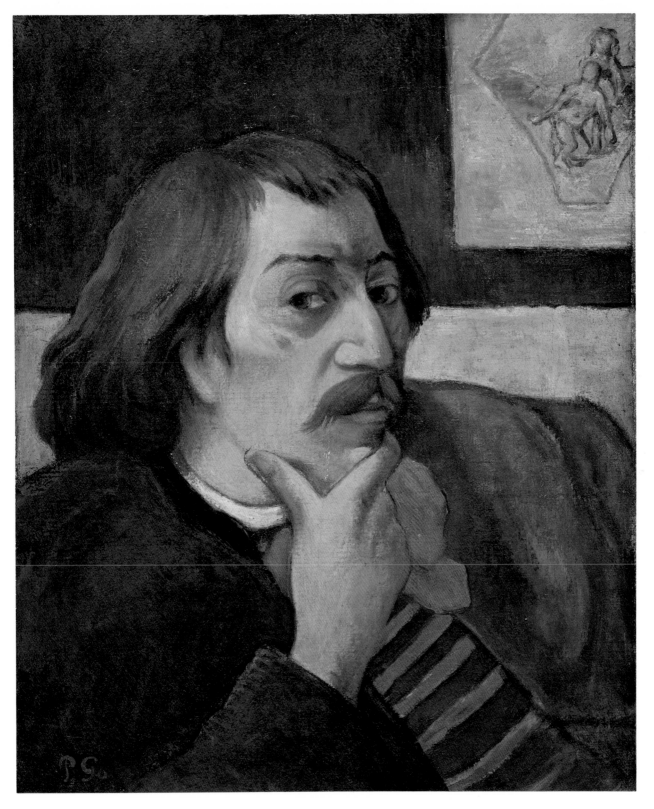

PAUL GAUGUIN

Self-Portrait

Renoir's late works are bold, masterfully executed, and remarkably unhampered by signs of the artist's old age; they serve as another example of the extraordinary renewal of vitality that often seizes artists of genius at the end of their lives. Like Titian, Nicolas Poussin, Pablo Picasso, or Henri Matisse, Renoir developed in his later years a style that is often too easily dismissed, a style in which the very qualities the artist had brought to perfection are willfully exaggerated. In this *Seated Bather* Renoir is no longer interested in the dissolution of forms in light. Instead he concentrates, with obsession and emotion, on the creation of a solid, heroically monumental figure. He achieves this not by stressing drawing, but by isolating the figure against an undefined background and by focusing the light to model his sculpturesque subject.

That sculpture was on Renoir's mind is attested to not only by his own contemporary three-dimensional works, but also by the gesture of the figure in *Seated Bather*. With her left hand she gently lifts her hair in a movement reminiscent of a Hellenistic Venus, thus reminding us also of the important part played by antique art in Renoir's background. A trip to Italy in 1881 had been particularly decisive in the artist's career, causing him not only to introduce classical themes into his work but also to shift away from the orthodox Impressionism he had helped to create.

Because of the fleshiness of his models Renoir has often been compared to Rubens, but in Detroit's *Bather* this comparison seems only superficial. The gentle languor of the figure and her remoteness from the spectator are in fact closer to Jean-Auguste-Dominique Ingres, the great Neoclassical master whom Renoir admired and to whom he came close in his so-called dry manner between 1882 and 1887. It is a credit to the aging artist's genius that he was able to retain both the spirit of Ingres and the light, feathery touch of his own finest Impressionist works to create this superb work.

REFERENCES

W. Gaunt, *Renoir,* London, 1952, pl. 80.

Musée Marmottan, Paris, *Chefs-d'oeuvre des Musées des Etats-Unis, de Giorgione à Picasso,* 1976, pl. 28.

Pierre-Auguste Renoir

French, 1841–1919

Seated Bather, 1903–6

Oil on canvas; 116.2 × 88.9 cm (45¾ × 35 in.)

Bequest of Robert H. Tannahill (70.177)

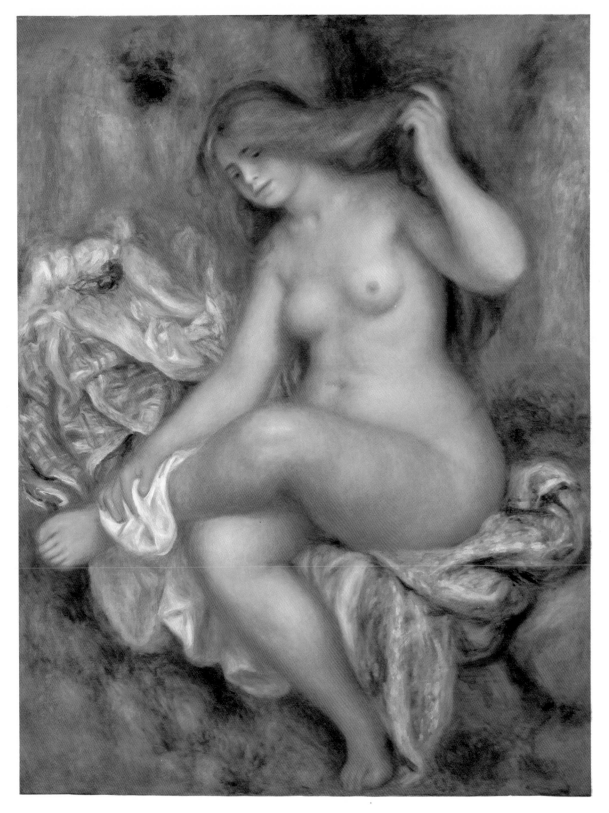

PIERRE-AUGUSTE RENOIR

Seated Bather

European Sculpture and
Decorative Arts

A crozier is carried in religious processions by a bishop or an abbot as a sign of office. While most Limoges croziers bear enameled flowers as their principal decoration, Saint Michael slaying the dragon is not an unusual subject on figural examples, as the image of the shield-bearing warrior thrusting his lance into the evil beast is an appropriate subject for an emblem of those charged with protecting others from evil.

The Limoges workshops in western France produced croziers and other enameled objects in great numbers during the twelfth and thirteenth centuries, supplying churches throughout Europe with liturgical vessels, reliquaries, and other richly decorated objects. This piece is one of three Limoges crozier heads depicted in a drawing by the nineteenth-century French artist Eugène Delacroix.

Champlevé (literally "raised field") was the preferred enamel technique in the High Middle Ages. In this method, the metal ground (usually copper or bronze) was carved away in the areas to be filled with enamel. On the stem of this crozier head, bright blue enamel forms the background for a gilt foliate design. Three serpents with their heads downward are affixed to this section of the piece, and turquoise enamel studs decorate their backs. The openwork of the knob is formed by finely cast intertwined dragons, and the rim of the knob is decorated with turquoise enamel studs. The crook of the crozier is in the form of the dragon and terminates in the head, which is turned back to confront the saint. A champlevé pattern of blue enamel forms the scales of the beast. The bright gilding covering the copper structure of the crozier gives it the rich surface characteristic of medieval treasury objects.

REFERENCES

J. J. Marquet de Vasselot, "Trois crosses limousines du XIII siècle dessinées par E. Delacroix," *Bulletin de la société de l'histoire de l'art français* (1936), pp. 138–46.

William D. Wixom, *Treasures from Medieval France,* Cleveland, Ohio, 1967, p. 20, cat. no. IV.

Robert G. Calkins, *A Medieval Treasury: An Exhibition of Medieval Art from the Third to the Sixteenth Century,* Ithaca, New York, 1968, cat. no. 40.

Crozier Head with Saint Michael and the Dragon

French, second quarter of the thirteenth century

Gilt copper and champlevé enamel; h. 31.6 cm (12½ in.)

Gift of Mr. and Mrs. Henry Ford II (59.297)

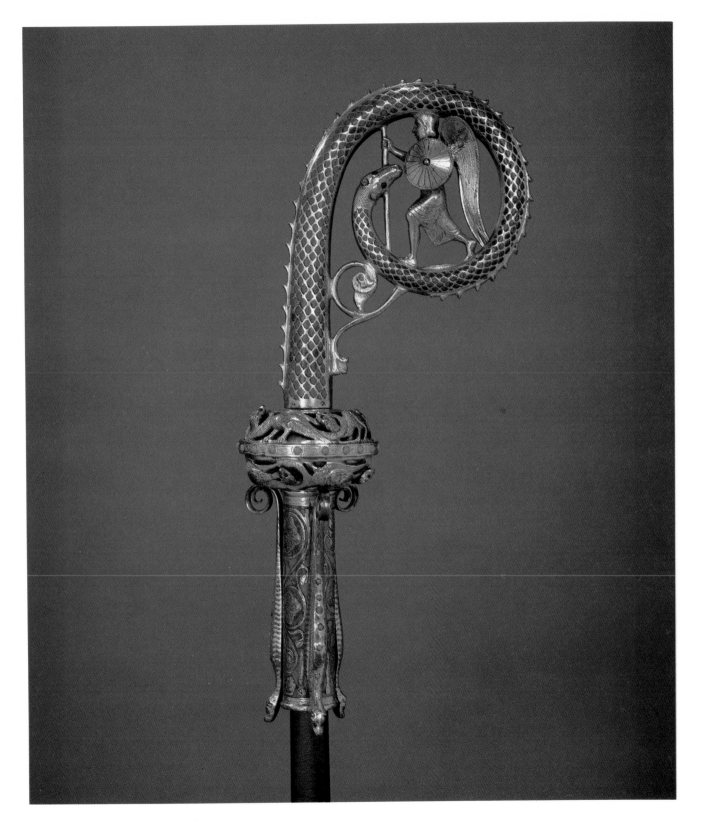

FRENCH

Crozier Head, Saint Michael and the Dragon

This marble statue of the *Madonna and Child* is an important piece in the group of Italian Gothic sculptures acquired for the Detroit museum during William Valentiner's tenure as director. It has been attributed at different times to Nino Pisano and to Nino's father, Andrea Pisano. Andrea is best known for his relief sculpture on the baptistry and campanile of Florence. Nino's work is less well documented, though we know that he succeeded his father as *capomaestro* at Orvieto in 1349 and that he was later active in Pisa, Florence, and Venice.

The styles of the father and son are closely related, but when the works of the two sculptors are carefully reviewed, it is apparent that the courtly elegance of this sculpture is entirely in keeping with Nino's style. Nino absorbed new ideas, such as the graceful Gothic pose seen in the Detroit *Madonna*, derived from French sculpture of the early fourteenth century. Furthermore, Nino's personal style can be recognized in the sweet smile of the Madonna, which conveys the intimate human relationship between Mary and her son. Nino's skill as a marble carver can be seen in the delicately rendered features of the Madonna's face, the lyrical series of folds in her drapery, and in the face and drapery of the Child.

REFERENCES

W. R. Valentiner, *Italian Gothic and Early Renaissance Sculpture,* Detroit, 1938, cat. no. 16.

W. R. Valentiner, "Andrea Pisano as Marble Sculptor," *Art Quarterly,* vol. 10 (1947), pp. 163–84.

Anita Moskowitz, "A Madonna and Child Statue: Reversing a Reattribution," *Bulletin of the Detroit Institute of Arts,* vol. 61 (1984), pp. 34–42.

Nino Pisano

Italian, active 1343–68

Madonna and Child, **ca. 1350–60**

Marble with traces of polychromy and gilding; h. 76.2 cm (30 in.)

Gift of Mr. and Mrs. Edsel B. Ford (27.150)

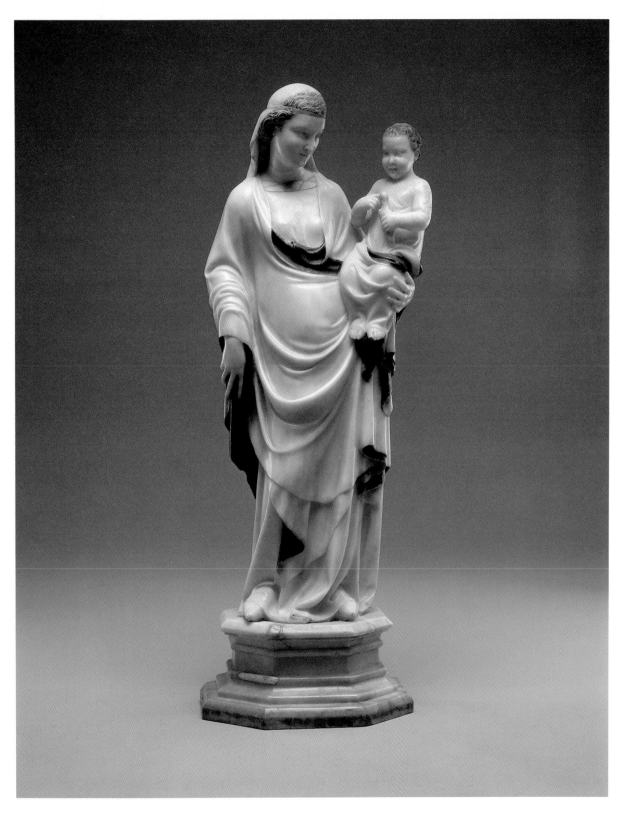

NINO PISANO

Madonna and Child

LUCA DELLA ROBBIA was one of the great sculptors of the early Italian Renaissance. Born in Florence, Luca was influenced by Nanni di Banco, Lorenzo Ghiberti, and Filippo Brunelleschi and worked in marble, bronze, and enameled terra-cotta. His earliest documented work is the monumental marble *cantoria* (1432–38), or singing gallery, for the cathedral of Florence.

Luca is best known today, however, as the originator, around 1440, of enameled terra-cotta, or tin-glazed earthenware, as a medium for sculpture and as the founder of a family line of sculptors working in this medium. His family name is commonly associated with these beautifully modeled and glazed ceramic reliefs of religious subjects set into circular, semicircular, or rectangular frames. After Luca's death, his nephew Andrea della Robbia and other members of the family continued producing reliefs of this type into the sixteenth century.

The Genoese Madonna is one of the most attractive of Luca's enameled terra-cotta Madonnas. His pure white figures, with gilding in their hair and halos and ornamenting their drapery, are set against a rich, celestial-blue background. The clear, serene composition creates a classic beauty and evokes a deep religious sentiment. The grace with which the Madonna bends toward the Christ Child and the childlike fashion in which he clings to her emphasize the simple humanity of their relationship and would cause us almost to forget their divine character were it not for the halos.

This is one of four versions of the so-called Genoese Madonna, each with slight differences in modeling and expression. The others are in the Kunsthistorisches Museum, Vienna, in the Staatliche Museen, Berlin-Dahlem, and in the Museo Nazionale, Florence. This group of Madonna and Child reliefs received the name "Genoese" from the Vienna piece, which stood for many years in a Gothic tabernacle in the Casa Serra in Genoa.

REFERENCES

J. Walther, "The Genoese Madonna by Luca della Robbia," *Bulletin of the Detroit Institute of Arts*, vol. 11 (1929), pp. 34–35.

W. R. Valentiner, *Italian Gothic and Renaissance Sculpture*, Detroit, 1938, cat. no. 33.

John Pope-Hennessy, *Luca della Robbia*, Ithaca, New York, 1980, pp. 65–66, 255–60, cat. no. 41.

Luca della Robbia

Italian, 1400–1482

***The Genoese Madonna*, 1450–55**

Enameled terra–cotta; h. 49.5 cm (19½ in.)

City of Detroit Purchase (29.355)

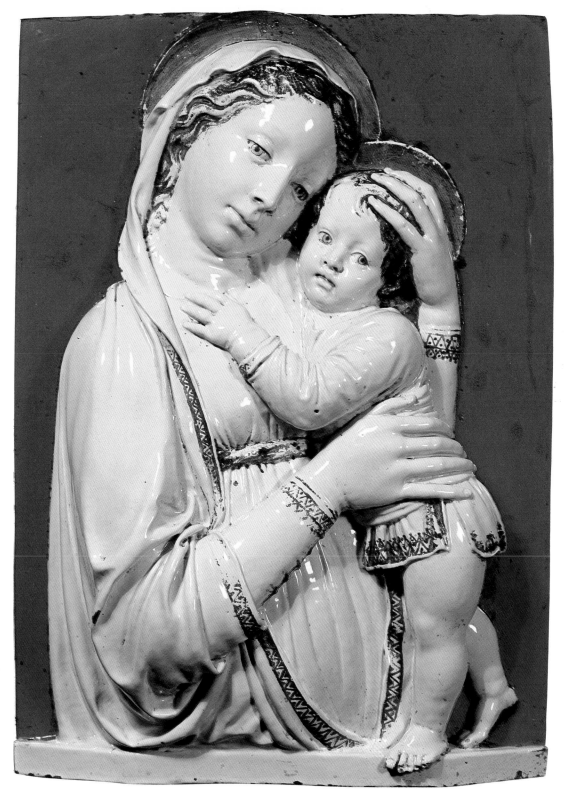

LUCA DELLA ROBBIA

The Genoese Madonna

THIS carved Lamentation group originally formed the central portion of a large altarpiece. The sculpture represents a moment not described in the narrative of Christ's Passion given in the Gospels. As the dead body of Christ is carried to the sepulcher for entombment by Joseph of Arimathea, assisted by Nicodemus, the Virgin reaches out to embrace her son for the last time, and the Magdalen, on the right, bends to weep at his feet. The richly detailed scene is charged with emotion conveyed by the dramatic attitudes of the figures and the complex folds of the voluminous drapery. The finely detailed surface reveals tears on the faces of Nicodemus and the Virgin.

A drawing now in the Louvre provides additional information about this Lamentation group. It shows that a frame, decorated with Gothic tracery, surrounded the group and that there were additional figures. Angels carrying the instruments of the Passion originally appeared above, and there were two additional figures behind the Magdalen.

This sculpture, sometimes referred to as the "Arenberg Lamentation," after a previous owner, bears the circular mark of the Brussels sculpture guild. The style of the carving and the design show the unmistakable impact of the great painter Rogier van der Weyden (1399?–1464). While there is no evidence that Rogier or his workshop actually carved wood sculpture, we know that Rogier himself collaborated on sculptural projects, probably polychroming figures and backgrounds and possibly providing working drawings for sculptors.

REFERENCES

Nicole Verhaegen, "The Arenberg 'Lamentation' in the Detroit Institute of Arts," *Art Quarterly,* vol. 25 (1962), pp. 294–312.

Theodor Müller, *Sculpture in the Netherlands, Germany, France and Spain: 1400 to 1500,* Harmondsworth, Middlesex, 1966, pp. 90, 96.

Circle of Rogier van der Weyden

Flemish

***The Lamentation,* ca. 1460–70**

Oak; 87.6 × 139.7 cm (34½ × 55 in.)

Gift of Mrs. Edsel B. Ford (61.164)

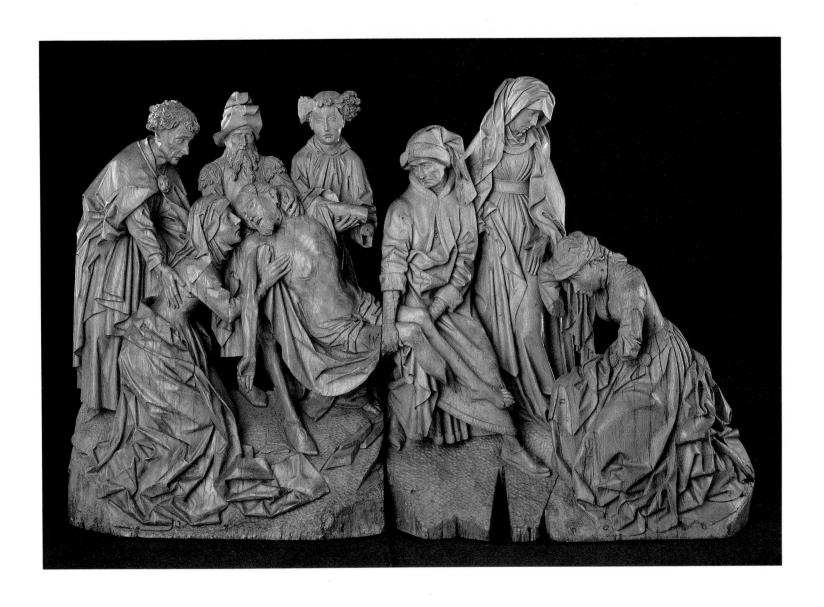

CIRCLE OF ROGIER VAN DER WEYDEN

The Lamentation

HEBE, the Greek goddess of immortal youth and beauty and the daughter of Zeus and Hera, is represented in this statuette by the Dutch Mannerist sculptor Hubert Gerhard. Like many other northern European artists, Gerhard felt that his education was not complete without a period of study in sixteenth-century Italy, and he went to Florence in the 1560s to study in the workshop of Giambologna, the most important sculptor in Italy after the death of Michelangelo. By 1581 Gerhard had moved to Germany to execute an important bronze altar for the Fugger banking family in Augsburg. From the late 1580s until his death he continued to work in Bavaria, dividing his time between commissions from the Fuggers and from the aristocracy of Munich and Innsbruck.

Although formerly attributed to Adriaen de Vries, *Hebe* probably was one of two female figures made for the perimeter of the monumental Augustus Fountain that Gerhard created in Augsburg between 1589 and 1594. The work is typically Mannerist: the spiraling, balanced figure is a demonstration of the concept of the *figura serpentinata*, first developed by Michelangelo, while the elegant contrapposto rhythms of the raised arm offset by the thrust of the hip attest to the artist's association with Giambologna. The fine craftsmanship characteristic of Renaissance metalwork is also apparent in the highly polished and modeled surface. The exquisitely executed drapery, diadem, and coiffure, the elongated torso with its small head, and the flowing silhouette all express the Mannerist ideal of beauty. Designed to be seen from all angles, the work was intended to be a source of visual delight and pleasure, appealing to the taste of sophisticated patrons at the end of the sixteenth century.

REFERENCES

Paul L. Grigaut, "Hebe, Goddess of Immortal Youth by Adriaen de Vries," *Bulletin of the Detroit Institute of Arts,* vol. 39 (1959–60), pp. 8–10.

Hans R. Weirhauch, *Europäische Bronzestatuetten: 15.–18. Jahrhundert,* Braunschweig, 1967, p. 346.

Augsburg, Rathaus, Zeughaus, *Welt im Umbruch: Augsburg zwischen Renaissance und Barock* (exh. cat.), 1980, pp. 174–75, cat. no. 534.

Hubert Gerhard

Dutch, 1540/50–1620

Hebe, **ca. 1590**

Bronze; h. 76 cm (30 in.)

Gift of Mr. and Mrs. Henry Ford II (59.123)

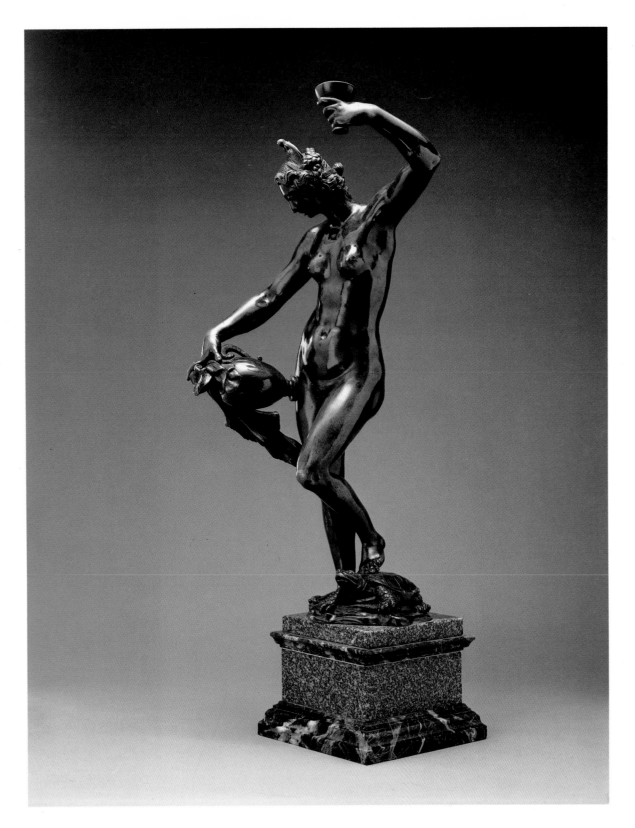

HUBERT GERHARD

Hebe

THIS terra-cotta model is the only surviving sculptural sketch for the *Chair of Saint Peter,* the great Baroque monument that is the focal point of the apse of Saint Peter's in Rome. Bernini designed the magnificent gilded bronze throne as a shrine to encase the most venerated relic in the basilica, the simple oak chair from which by tradition Saint Peter himself had preached. The project, one of the most ambitious and complex undertaken by Bernini, represents the crowning achievement of his career.

The reliefs on this model refer to the most significant moments in the life of Saint Peter: on the back is Jesus' charge to Peter, "Feed my sheep" (John 21:16–17); on the left side, the giving of the keys to Peter (Matthew 16:19); on the right, the washing of the disciples' feet (John 13:5–17); and below the seat, the miraculous draught of fishes (John 21:1–14). Flanking the seat of the throne are two angels made of stucco except for their terra-cotta feet and wings.

This model provides a glimpse of Bernini's working methods. Bernini made numerous sketches and three-dimensional models to show his patron, Pope Alexander VII, the progress of his project. In April 1658, according to a recently discovered document in the Chigi archives, Bernini brought what probably was the Detroit model to the pontiff; in form, it is very close to the final design.

REFERENCES

Detroit Institute of Arts, *Art in Italy, 1600–1700,* 1965, p. 43.

Michael P. Mezzatesta, *The Art of Gian Lorenzo Bernini: Selected Sculpture,* Fort Worth, Texas, 1982, cat. no. 7.

Olga Raggio, "Bernini and the Collection of Cardinal Flavio Chigi," *Apollo,* vol. 117 (1983), pp. 368–79.

Giovanni Lorenzo Bernini

Italian, 1598–1680

***Model for the Chair of Saint Peter,* 1658**

Terra-cotta and stucco; h. 58.4 cm (23 in.)

Ralph Harman Booth Bequest Fund (52.220)

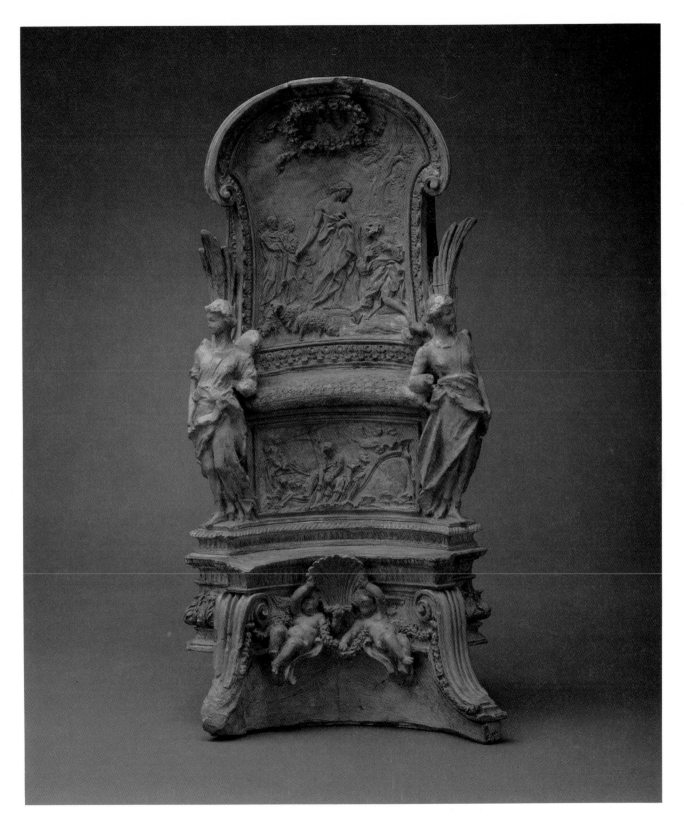

GIOVANNI LORENZO BERNINI

Model for the Chair of Saint Peter

This French pedestal clock may be the most outstanding of the five known Clocks of the Four Continents, so-named because of the four Atlantes surrounding the face who represent Africa, Europe, Asia, and America. The case and pedestal are attributed to André-Charles Boulle, the most celebrated of all the furniture designers who worked for Louis XIV.

The clock is veneered with engraved brass on tortoiseshell, which has come to be known as Boulle marquetry. The brass is inlaid in a pattern of scrolls, tendrils, and floral arabesques; the pedestal is supported on four lion-paw feet. Set in the upper part of the face of the pedestal is a circular gilt bronze plaque showing Hercules relieving Atlas of the weight of the world. Below the clock face hangs a plaque inscribed *Julien le*

Roy, the royal horologist who made the oval dial that features a rare self-lengthening hour hand that becomes longer when it reaches the top and bottom of the dial and gradually shortens as it proceeds to the sides. Only two other Clocks of the Four Continents have their original faces with lengthening hands.

Like Boulle's other works, this case and pedestal are typified by the overall unity of the shapes, the masterful bronzes, and the elaborate design of the marquetry. Since Boulle often worked with Baroque sculptural designs by Gilles-Marie Oppenort, it is possible that this represents a collaboration between the two masters. Recent research suggests that the five clocks may have been commissioned by the five directors of the French East India Company, a firm active in Paris until its bankruptcy in 1721. This hypothesis would account for the theme of the Four Continents and some of the other decorative motifs on these sumptuous clocks.

REFERENCES

F. J. B. Watson, "Furniture," *Wallace Collection Catalogue,* London, 1956, pp. 19–20.

Geoffrey de Bellaigue, "Furniture, Clocks, and Gilt Bronzes," *The James A. de Rothschild Collection at Waddesdon Manor, Catalogue,* vol. 1, London, 1974, no. 3, pp. 51–55.

Gillian Wilson, *French Eighteenth Century Clocks in the J. Paul Getty Museum,* Malibu, California, 1976, pp. 12–17, cat. no. 2.

Attributed to André-Charles Boulle

French, 1642–1732

Clock of the Four Continents, ca. 1710–20

Oak, tortoiseshell, brass, and gilt bronze; h. 2.8 m (9 ft. 2½ in.)

Founders Society Purchase, Mr. and Mrs. Horace E. Dodge Memorial Fund, Josephine and Ernest K. Kanzler Founders Fund, J. Lawrence Buell, Jr., Fund (F1984.7)

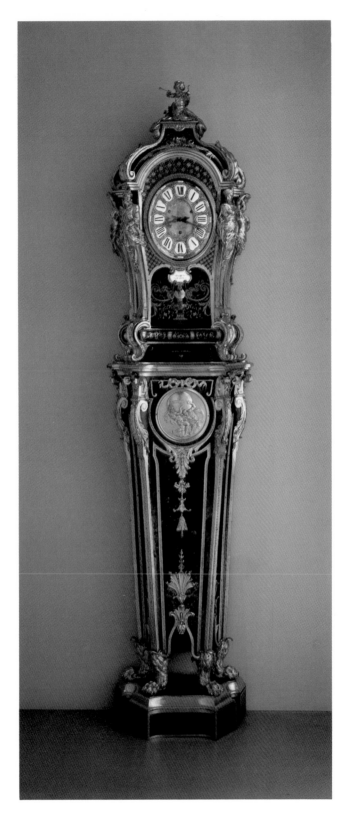

ANDRÉ-CHARLES BOULLE

Clock of the Four Continents

IN 1710 a German chemist, Johann Friedrich Böttger, discovered the secret of the Chinese process of making porcelain, and under the patronage of Augustus the Strong, Elector of Saxony and King of Poland, a factory was built at Meissen near Dresden. In order to furnish his Japanese-style palace with a steady supply of the luxurious "smoky" white porcelain, Augustus himself commissioned most of the pieces made by the factory and employed Johann Gottlob Kirchner for the specific purpose of modeling large animals and other extravagant decorative objects for the palace. Kirchner's understanding of his material led him to experiment with possibilities of utilizing porcelain as a sculptural medium. Saxon court jester Fröhlich wears a comic outfit composed of a Tyrolean hat and outmoded ruff. Known for his fearless skepticism, he pauses and glances left for a moment, perhaps ready to deliver a verbal charge.

Johann Joachim Kändler, considered by many to have been the greatest artisan ever employed at the factory, succeeded Kirchner at Meissen. Kändler, trained as a sculptor in Dresden, from 1736 onward was mainly engaged in modeling smaller figures. His style is readily visible in the life-size bust of Saxon court jester "Postmaster" Schmiedel, executed in 1739. Softly and more delicately modeled than the Fröhlich bust, Schmiedel's face exhibits a comic drollery and Rococo spirit of playful capriciousness, which superbly exploits the plasticity of the porcelain and the reflectivity of the glaze. Schmiedel wears his badge of office, a foppish tricornered hat, and a horn. The frivolity of the portrayal lies in the two frisky rodents on the hat and shoulder of Schmiedel, who was well known at court for his fear of mice.

Only one other pair of these magnificent and very fragile busts is known to have survived, and they remain in the Staatliche Porzellansammlung, Dresden.

REFERENCES

The Metropolitan Museum of Art, New York, *Masterpieces of European Porcelain,* 1949, no. 232.

W. B. Honey, *Dresden China,* London, 1954, p. 84.

Rainer Ruckert, "Der Hofnarr Joseph Fröhlich," *Kunst & Antiquitäten,* 1980, no. 5, pp. 42–55; 1980, no. 6, pp. 56–70; 1981, no. 1, pp. 57–73.

Johann Gottlob Kirchner

German, active as Chief Modeler at Meissen 1730–33

Court Jester Joseph Fröhlich, 1730

Porcelain; h. 51 cm (20 in.)

Gift of Mr. and Mrs. Henry Ford II (59.295)

Johann Joachim Kändler

German, active as Chief Modeler at Meissen, 1733–75

Court Jester "Postmaster" Schmiedel, 1739

Porcelain; h. 48.5 cm (19 in.)

Gift of Mr. and Mrs. Henry Ford II (59.296)

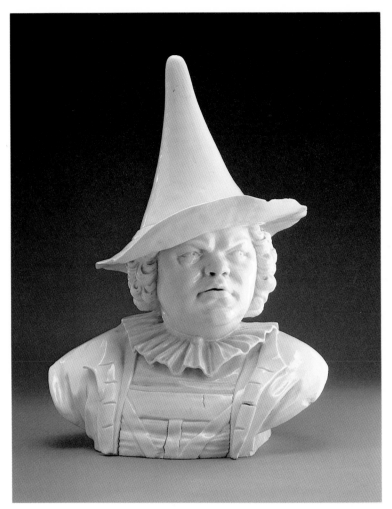

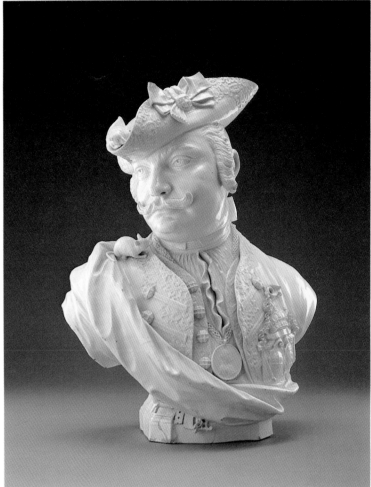

JOHANN GOTTLOB KIRCHNER

Court Jester Joseph Fröhlich

JOHANN JOACHIM KÄNDLER

Court Jester "Postmaster" Schmiedel

CHRIST AT THE COLUMN by Franz Ignaz Günther is one of this artist's most important mature sculptures; it depicts a scene from the Passion of Christ, the poignant moment after the Flagellation when Christ was still bound to the column. This German Rococo sculpture, signed with the artist's initials and dated 1754, is impressive for its power of expression and its shimmering pearlescent painted surface.

Günther rose to prominence when he was appointed court sculptor of the Bavarian Electorate in Munich in 1754. Known for his large, complex figure groups of saints and angels created for the ornate Rococo churches of Bavaria, Günther developed a personal style that combined graceful compositions with the expression of fervent religious emotion. He rendered the drapery of his elegant figures in small elongated planes that create a flickering pattern of reflected light across the surfaces.

Christ at the Column depicts Christ standing on a mound of earth, wearing a cloth that furls out behind him. His arms are manacled to a short pillar painted to resemble marble. The manacles, made of parchment to appear like leather, are connected to the pillar by carved wooden chains.

A meticulous cleaning of the surface has revealed Günther's masterful hand in the carving and painting of the rippling musculature, exaggerated contrapposto, and bleeding wounds of Christ. The sensitive carving of Christ's open mouth, thin lips, and wisp of a beard, and the glistening of the porcelain-white flesh, whose surface has been polished smooth with an agate, are qualities that testify to the skills that made Günther the greatest sculptor in eighteenth-century Bavaria.

REFERENCES

Heinrich Decker, "Ein Unbekanntes Frühwerk Ignaz Günthers," *Kunst und Die Schöne Heimat,* vol. 53 (1955), pp. 332–33.

Gerhard Woeckel, *Franz Ignaz Günther,* Regensburg, 1977, p. 61, no. 32, pp. 100–101.

Franz Ignaz Günther

German, 1725–1775

Christ at the Column, 1754

Linden wood with polychromy; h. 74.45 cm (29⅜ in.)

Founders Society Purchase, Acquisitions Fund (1983.13)

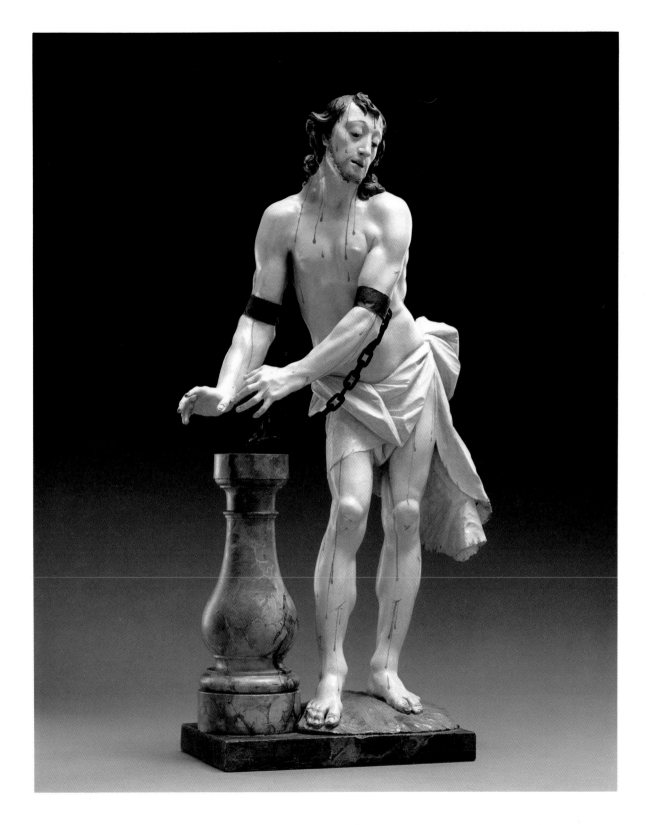

FRANZ IGNAZ GÜNTHER

Christ at the Column

DURING the eighteenth century in France, the furniture dealers of Paris were great patrons of the cabinetmakers, the *ébénistes,* challenging these craftsmen to create some of the most luxurious furniture the world has ever known. The cabinetmakers enriched the surfaces of their pieces with veneers of many types of precious woods, gilt bronze, and fragile plaques of soft-paste porcelain. This *coffre à bijoux* (jewel cabinet) was created by Martin Carlin, cabinetmaker to Louis XVI, and is one of only seven such cabinets known to exist today.

A furniture maker of great skill, Carlin is noted for his small-scale works of delicate proportions that incorporate Sèvres porcelain plaques, a practice that became popular for furniture after 1760. Fitted with a strong lock and once furnished with a velvet-covered writing slide and compartments for writing materials, this cabinet probably served dual functions as both a receptacle for jewels and a writing table, since it was common for eighteenth-century furniture to serve more than one purpose. The graceful elegance of the piece is indicative of the feminine style of much art from this period when women such as Madame de Pompadour and Madame du Barry were important patrons of the arts and commissioned many pieces of furniture.

The refined and delicate lines of the cabinet are enhanced by the veneers of tulipwood with stringings of natural and dark-stained holly wood in a geometric pattern. The Detroit cabinet is exceptional in its ornamentation of plaques painted with sprays of pink roses. The beauty of line and color and the variety of rich woods skillfully employed by Martin Carlin give this piece great elegance.

REFERENCES

Pierre Verlet, *French Furniture and Interior Decoration of the 18th Century,* London, 1967, p. 276, cat. no. 146.

F. J. B. Watson, *The Wrightsman Collection,* vol. 1, New York, 1966, cat. no. 90.

R. L. Winokur, "The Mr. and Mrs. Horace E. Dodge Memorial Collection," *Bulletin of the Detroit Institute of Arts,* vol. 50 (1971), no. 3, p. 45.

Martin Carlin

French, 1730–1785

Jewel Cabinet, ca. 1774

Tulipwood, holly wood, oak, Sèvres porcelain, and ormolu; 90.2 × 54.6 × 36.8 cm (35½ × 21½ × 14½ in.)

Bequest of Mrs. Horace E. Dodge in memory of her husband (71.196)

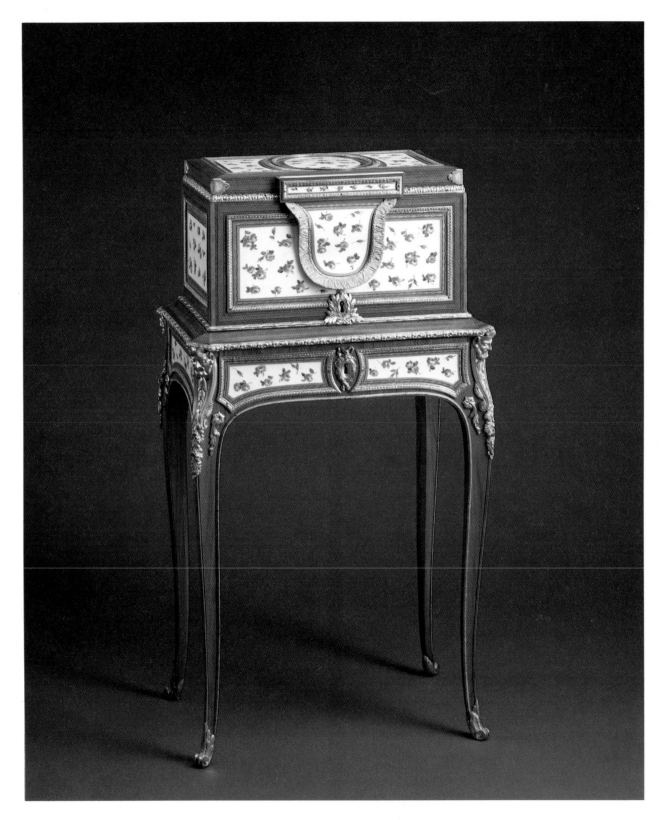

MARTIN CARLIN

Jewel Cabinet

Le Génie de la Danse consists of the central figure and putto modified from the monumental relief sculpture *La Danse* created for the Théâtre de l'Opéra in Paris by Jean-Baptiste Carpeaux, one of the leading and most innovative French artists of the nineteenth century. When *La Danse* was unveiled in 1869, the Parisian public was shocked, saying it violated contemporary standards of decency. Rather than symbolizing the art of dance with idealized figures or illustrating a sedate dance, Carpeaux created a circle of ecstactic women whirling around the *génie* (or creative spirit) of the dance. *La Danse* quickly became one of the most famous public monuments in France.

Plagued by financial difficulties near the end of his life, Carpeaux began to mine successful sculptural concepts from his earlier public monuments in order to generate independent works to be sold to the public. *Le Génie de la Danse* from about 1872 is a fascinating demonstration of this process. *La Danse* had been designed as a relief sculpture; *Le Génie de la Danse* is intended to be seen in the round, and Carpeaux successfully developed the overall surface and the back to create a powerful freestanding sculpture. This plaster model depicts the figure leaping exuberantly, arms stretched upward waving a tambourine. At his feet, Cupid (l'Amour) holds arrows and a theatrical puppet.

Le Génie de la Danse is an unusual original plaster in that there is considerable evidence of the artist's modeling in the wet plaster after the bulk of the form was cast. This can be seen in the many individual combing marks and the treatment of the back of the sculpture, all of which indicate Carpeaux's direct involvement. Evidence of nails embedded in the surface of the sculpture suggests that this plaster model was used for the "pointing" mechanical process of making sculptural editions and was the original source of smaller versions in bronze, terra-cotta, and marble.

REFERENCES

Victor Beyer and Annie Braunwald, *Sur les traces de Jean-Baptiste Carpeaux,* Paris, 1975, pp. 284-329.

Jeanne L. Wasserman, ed., *Metamorphoses in Nineteenth Century Sculpture,* Cambridge, Massachusetts, 1975, pp. 132–40.

Peter Fusco and H. W. Janson, eds., *The Romantics to Rodin,* Los Angeles and New York, 1980, pp. 153–54.

Jean-Baptiste Carpeaux

French, 1827–1875

***Le Génie de la Danse,* ca. 1872**

Plaster; h. 2.2 m (7 ft. 2 in.)

Gift of Mr. and Mrs. Allan Shelden III Fund (1983.16)

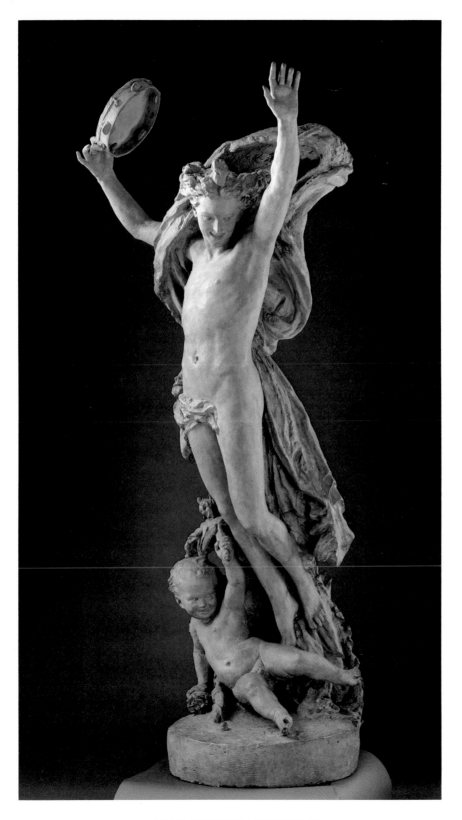

JEAN-BAPTISTE CARPEAUX

Le Génie de la Danse

Graphic Arts

SINCE the sixteenth century, connoisseurs have repeatedly singled out this print as proof of Albrecht Dürer's virtuosity in the engraving medium. The perpetual fame of his *Adam and Eve* is due to "the splendor of a technique which does equal justice to the warm glow of human skin, to the chilly slipperiness of a snake, to the metallic undulations of locks and tresses, to the smooth, shaggy, downy or bristly quality of animals' coats, and to the twilight of a primeval forest" (Panofsky, p. 84). Dürer is the supreme master in suggesting the visual appearance of textures in graphic art, as can be seen in this magnificent early impression of the print.

Dürer used the biblical story of the Fall of Man as a pretext to demonstrate his knowledge of the canon of human proportion. The ideally constructed nude figures of Adam and Eve embody Dürer's notion of classical beauty as defined in antiquity. As their strict frontality and self-contained poses were necessary to display the rational, almost geometric, theory of proportion, Dürer introduced symbolic details to enliven the biblical context and to explain the fall from grace in humanistic terms. For example, the cat, elk, rabbit, and ox each denotes one of the four humors or temperaments (choleric, melancholic, sanguine, and phlegmatic, respectively) that were believed to account for the human constitution. Before the Fall, the humors had been in equilibrium, but afterwards one or another predominated in each individual and caused the mortality and particular ills of every person. Also, the parrot, a symbol of the Virgin Birth of Christ, is perched on a branch of the Tree of Life, in opposition to the serpent entwined around the Tree of Knowledge (see Andersson and Talbot, p. 254).

This early impression (taken before Dürer added a cleft in the tree trunk between Adam's torso and left arm, visible in later states of the print) is a particularly prized example of *Adam and Eve*. None of the engraved lines is worn, and the silvery-black inking is remarkably fresh, enhancing the rippling and bulging effect of Adam's muscles while complementing Eve's soft, sensuously feminine body as seen against the backdrop of foliage.

REFERENCES

Joseph Meder, *Dürer-Katalog: Ein Handbuch über Albrecht Dürers Stiche, Radierungen, Holzschnitte, deren Zustände, Ausgaben und Wasserzeichen*, Vienna, 1932, no. 1.

Erwin Panofsky, *Albrecht Dürer*, 3rd ed., Princeton, 1948, vol. 1, pp. 84–87; vol. 2, no. 108.

Christiane Andersson and Charles Talbot, *From a Mighty Fortress: Prints, Drawings and Books in the Age of Luther 1483–1546*, Detroit, 1983, pp. 254–55, cat. no. 138.

Albrecht Dürer

German, 1471–1528

Adam and Eve, **1504**

Engraving; 25.1 × 19.5 cm (9⅞ × 7⅝ in.)

Founders Society Purchase, New Endowment Fund (F76.14)

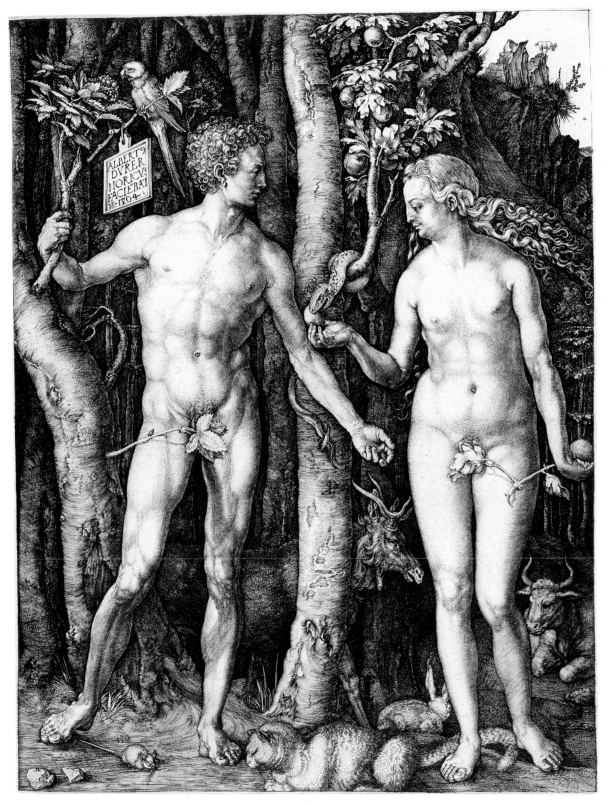

ALBRECHT DÜRER

Adam and Eve

This sheet of sketches by Michelangelo for the ceiling of the Sistine Chapel is a unique record of an intermediate stage in his evolving concept for the organization of the fresco. It documents the great Renaissance artist at work on his masterly overall design for the surface of the imposing vault, and also on various details of the many figures with which he would fill the ceiling.

Here we see his scheme for the decoration of the ceiling transformed from an earlier concept (recorded in a drawing in the British Museum) and in transition to the tour de force ultimately realized in the Sistine Chapel itself. The scheme in the Detroit drawing is oriented to the view continuing up from a side wall, rather than to the length of the ceiling with its sequence of Genesis scenes, the dominant axis of the ceiling decoration as finally executed. The winged putti seen here standing on pilasters and flanking an oval frame would finally evolve into the nude youths flanking the medallions on either side of the smaller Genesis scenes. The architectural niches between the pilasters would eventually be filled with Prophets and Sibyls.

Most striking of the detail studies randomly added to this sheet is the elegant chalk study of a forearm and hand which has sometimes been associated with that of Adam in the Sistine *Creation of Adam*, but which cannot be securely connected with any specific figure. The torso drawn in chalk is a study for the figure astride the ram in the right foreground of the *Sacrifice of Noah*, one of the smaller Genesis scenes.

Slight sketches on the verso of the sheet for arched niches are related to the evolving design and apparently were done in the same ink, as is the preliminary design for a Sibyl, also on the verso.

REFERENCES

Johannes Wilde, *Italian Drawings in the Department of Prints and Drawings in the British Museum: Michelangelo and His Studio,* London, 1953, pp. 17–20.

Frederick Hartt, *Michelangelo Drawings,* New York, 1971, p. 79, cat. no. 63; p. 82, cat. no. 81.

J. A. Gere and Nicholas Turner, *Drawings by Michelangelo from the British Museum,* New York, 1979, pp. 28–33.

Michelangelo Buonarroti

Italian, 1475–1564

Scheme for the Decoration of the Sistine Chapel Ceiling; Study of a Male Torso; Study of an Arm and Hand, 1508–12

Pen and brown ink, black chalk on paper; 37 × 25.4 cm (14⅝ × 10 in.)

City of Detroit Purchase (27.2)

Graphic Arts

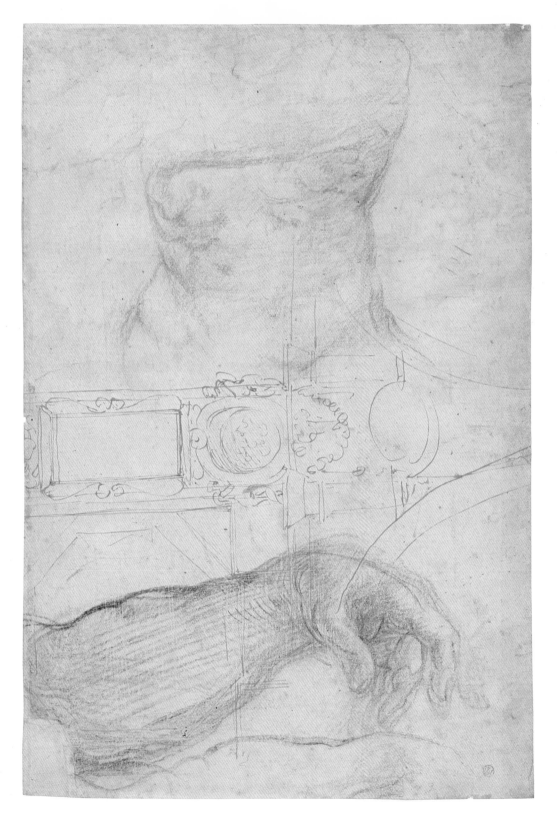

MICHELANGELO BUONARROTI

Scheme for the Sistine Chapel Ceiling

As indicated in the signature at the lower left, this portrait was created in Rome in 1813. During his first stay in Rome (1806–20) when he was a *pensionnaire* at the French Academy, Ingres made numerous pencil portraits of foreign officials and visitors. Marie Marcoz was the mistress of the Vicomte de Senonnes, a French nobleman, collector, and student of antiquity then living in Rome. She and the Vicomte were later married in Paris after the fall of the Empire, when the Vicomte became secretary-general of French museums. It is as Madame de Senonnes that she is best known to students of Ingres, for he painted her portrait in 1814 (now in the Musée des Beaux-Arts, Nantes).

Ingres's skill in capturing a likeness was immediately recognized by his contemporaries. What was perhaps not so readily apparent was his skillful use of mundane materials—the graphite pencil and smooth English-made white paper—to create incomparably sensitive and penetrating portraits.

In this portrait, the artist seems to delight in using a precise, delicate line to trace the oval curve of the brim of the bonnet to focus attention on his sitter's face. Ingres always carefully modeled the face of his subject by employing a stipple technique that is visible only under magnification. The brim of the bonnet casts a slight shadow that does not obscure the face but rather serves to convey the pensive mood of the sitter, whose lips are curved in a slight melancholy smile. In contrast, the rest of her figure, bonnet, dress, and cape are freely outlined with a sharply pointed pencil in fluid, lively strokes. The artist occasionally made sharp quick accents as in the folds of her cape falling across the arm of the chair.

The viewer may respond to this portrait on more than one level: tactilely to the movement and rhythm of the line and emotionally to the revelation of character that the great portrait artist achieves.

REFERENCES

Fogg Art Museum, Cambridge, Massachusetts, *Ingres Centennial Exhibition, 1867–1967: Drawings, Watercolors and Oil Sketches from American Collections,* 1967, no. 24.

Hans Naef, *Die Bildniszeichnungen von J.-A.-D. Ingres,* Bern, 1977, vol. 4, no. 95, p. 176.

Jean-Auguste-Dominique Ingres

French, 1780–1867

Portrait of Marie Marcoz, later Vicomtesse Alexandre de Senonnes, **1813**

Pencil; 27 × 20.1 cm (10⅝ × 7⅞ in.)

Bequest of Robert H. Tannahill (70.289)

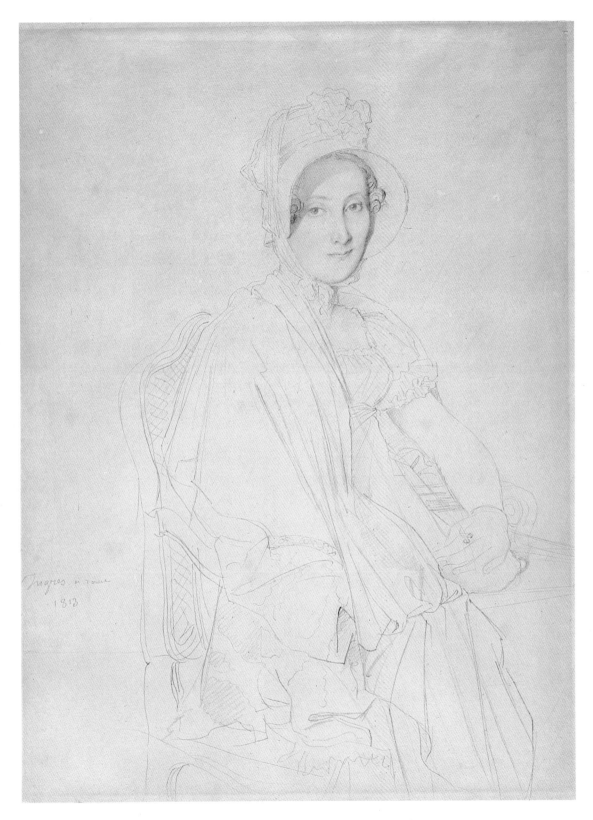

JEAN-AUGUSTE-DOMINIQUE INGRES

Portrait of Marie Marcoz

In Edinburgh between 1843 and 1847, D. O. Hill, a painter, and Robert Adamson, who had been trained in photographic techniques, created the first artistic calotypes. These were photographs in which the composition and subject matter were similar to those in contemporary paintings, and which were executed by a process producing an image quality in harmony with that of current painting. Because the texture of the paper negatives was to some extent visible in the prints, detail was minimized and the total image unified. Contrast between rich darker tones and highlights was emphasized.

Though Hill and Adamson also photographed architecture, landscape, and genre subjects, the major portion of their work was portraiture. Of Elizabeth Rigby (1809–1893), an author then living in Edinburgh, they made an imaginative variety of over twenty photographs. Hill in particular had a gift for making sitting for a portrait a pleasant experience. In this photograph Elizabeth Rigby may have assumed the identity of a fictional character, and an ethereal touch is provided by a small star above the sitter's head. This was added in wash on the negative. While books are frequently included in Hill and Adamson photographs, the presence of one here is particularly consistent with the premise that the woman has put down a book to lapse into "A Reverie," as Sara Stevenson noted that this image had been called.

In later years Elizabeth Rigby continued to write articles and books. As Lady Eastlake, wife of Sir Charles Eastlake, President of the Royal Academy, Director of the National Gallery, and President of the Photographic Society, she was acquainted with Queen Victoria and Prince Albert, and she noted that a calotype of herself, apparently of this image by Hill and Adamson, was "the first specimen of the photographic art that the Prince Consort saw, and excited his interest and curiosity."

REFERENCES

Colin Ford, ed., *An Early Victorian Album,* New York, 1976, pp. 3–4, 54, 105–19.

Sara Stevenson, *David Octavius Hill and Robert Adamson,* Edinburgh, 1981, pp. 23, 134–35.

David Octavius Hill

Scottish, 1802–1870

and

Robert Adamson

Scottish, 1821–1848

Miss Elizabeth Rigby, **1843–47**

Calotype; 20 × 14 cm (7⅞ × 5½ in.)

Founders Society Purchase, Robert H. Tannahill Foundation Fund (F81.57)

Graphic Arts

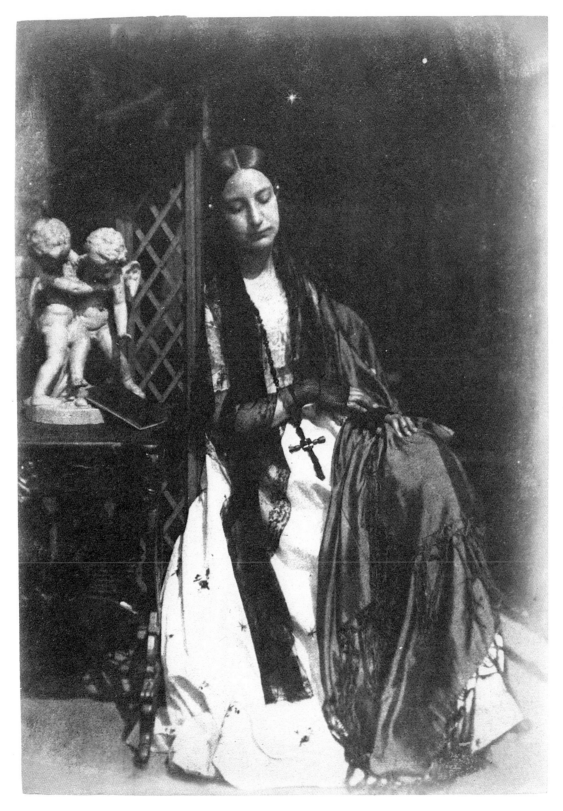

DAVID OCTAVIUS HILL AND ROBERT ADAMSON

Miss Elizabeth Rigby

AFTER his return to Paris from New Orleans in 1873, Degas began his intensive study of ballerinas and the dance, subjects that were to occupy him for the next thirty years. Degas watched rehearsals at the old opera house and then, from 1875, in the new building designed by Charles Garnier. He had free access to all parts of the enormous building.

Degas delighted in capturing dancers in informal, relaxed poses, as in this drawing which is a study for a figure in the painting *The Dance Class of Monsieur Perrot* (1875–76, Musée d'Orsay, Galerie du Jeu de Paume, Paris). With incisive, sure strokes Degas portrays the strength of the dancer's body, its capacity for speed combined with grace and balance. In contrast, the texture of the light tarlatan of her tutu is captured with a few delicate lines of the pencil. Touches of white chalk suggest the satin of her bodice and slippers and provide accents for the composition.

Although the dancer is not involved in the movements of the dance, the drawing is not static. The pentimenti of the drawing of the legs convey an impression of movement. Her feet have naturally taken a conventional ballet position even in repose; we sense that she is ready at any moment to begin the rehearsal.

REFERENCES

Lillian Browse, *Degas Dancers,* New York, 1949, cat. no. 19.

Theodore Reff, "Works by Degas in the Detroit Institute of Arts," *Bulletin of the Detroit Institute of Arts,* vol. 53 (1974), no. 1, pp. 34–35.

George T. M. Shackelford, *Degas: The Dancers,* Washington, D.C., 1984, p. 55.

Hilaire-Germain-Edgar Degas

French, 1834–1917

***Ballet Dancer Adjusting Her Costume,* 1875–76**

Pencil and chalk on paper; 39.4 × 26 cm (15½ × 10¼ in.)

Bequest of John S. Newberry (65.145)

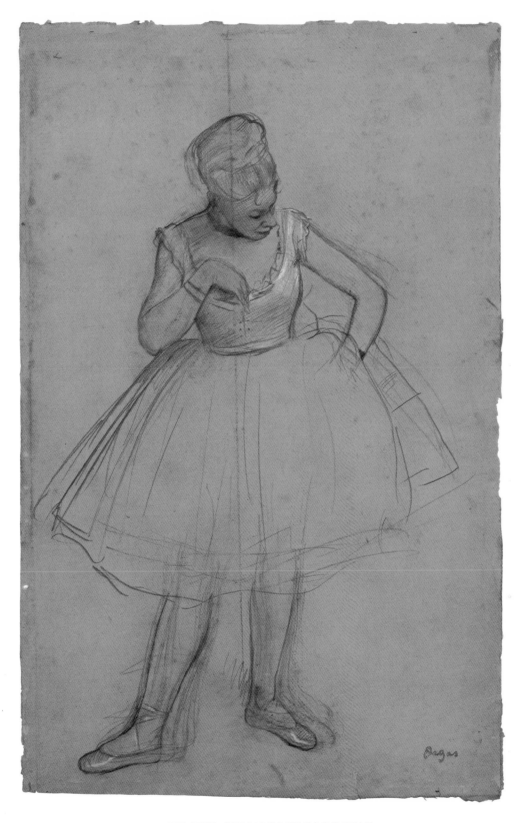

HILAIRE-GERMAIN-EDGAR DEGAS

Ballet Dancer Adjusting Her Costume

THOMAS EAKINS, painter, sculptor, and teacher, had regularly worked from nude models during his studies in Paris, and he advocated the same opportunity for his students at the Pennsylvania Academy of the Fine Arts, where he taught from 1876 to 1886. In Philadelphia this was a controversial practice and was to be a major factor in the ultimate dismissal of Eakins from the academy. But Eakins did have the loyal support of students who formed the Philadelphia Arts Students' League under him in order to continue their work.

Eakins apparently began photographing in 1880, using a four-by-five-inch camera and the newly available gelatin dry plates. He occasionally made photographs, apparently posed under his direction, to record motifs he wanted to include in paintings, and he made many photographs of nude models at the Pennsylvania Academy of the Fine Arts. Counterparts of *Three Female Nudes, Pennsylvania Academy of the Fine Arts,* but more typical of these photographs, are two portraying three male nudes supported by similar cubical boxes but with the paraphernalia of the studio visually prominent, rather than, as here, obscured in a shadowy background. Eakins's "Naked Series" includes twenty-six known sets of seven photographs, each set showing one model in seven carefully chosen poses. These were apparently made to serve as visual resources and teaching aids. A Pennsylvania Academy of the Fine Arts publication of 1883, intended to attract students, refers to the gradual accumulation of photographs for their use, with those of life-class models being of particular interest.

Three Female Nudes, Pennsylvania Academy of the Fine Arts is both a record and a work of art. It records the human body in the form of three unidentified models in different positions placed at different angles to the camera. Their poses are graceful, and the contours of each body are sensitively related to those of the others as well as to their inanimate and obscured surroundings.

REFERENCES

Gordon Hendricks, *The Photographs of Thomas Eakins,* New York, 1972.

Ronald J. Onorato, "Photography and Teaching: Eakins at the Academy," *American Art Review,* vol. 3 (1976), no. 4, pp. 127–40.

Lloyd Goodrich, *Thomas Eakins,* vol. 1, Washington, D.C., 1982, pp. 244–51.

Thomas Eakins

American, 1844–1916

***Three Female Nudes, Pennsylvania Academy of the Fine Arts,* ca. 1883**

Albumen print; 12.2 × 9.2 cm (4⅞ × 3⅝ in.)

Founders Society Purchase, Robert H. Tannahill Foundation Fund (F77.104)

Graphic Arts

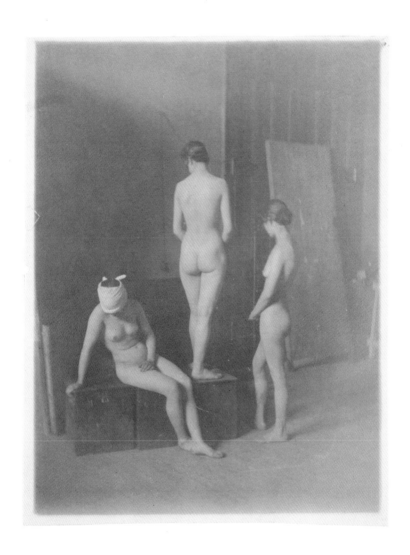

THOMAS EAKINS

Three Female Nudes

FROM 1918 to 1920, Matisse did many drawings in Nice of a young model named Antoinette. This sheet is one of a series of almost fifty variations Matisse executed showing her wearing a magnificently beribboned and plumed hat, which the artist fashioned directly on Antoinette's head, pinning the ostrich feathers and loops of black ribbon to the straw foundation. In a 1919 interview with Ragner Hoppe, Matisse explained that the first drawings of *The Plumed Hat* series were meticulously detailed, while later drawings were simplified into an arrangement of sweeping lines inherent in the composition (*Dessins et sculpture,* p. 102). Detroit's drawing is the most finished and celebrated one in the series. Here the sinuous curves of Antoinette's cascading hair, the streamlined brim of the hat with its plumed decoration, and the swirls of her voluminous gown create a harmonious arabesque, which is exactly what Matisse sought.

Of the four paintings of Antoinette wearing Matisse's millinery creation, the one most closely related to the Detroit drawing is the 1919 canvas *White Plumes* in the Minneapolis Institute of Arts.

REFERENCES

Victor I. Carlson, *Matisse as a Draughtsman,* Baltimore, 1971, pp. 94–95, cat. no. 37.

Musée National d'Art Moderne, Paris, *Henri Matisse, Dessins et sculpture,* 1975, pp. 101–2, no. 57.

Henri Matisse

French, 1889–1954

***The Plumed Hat,* 1919**

Pencil on paper; 53 × 36.5 cm (20⅞ × 14⅜ in.)

Bequest of John S. Newberry (65.162)

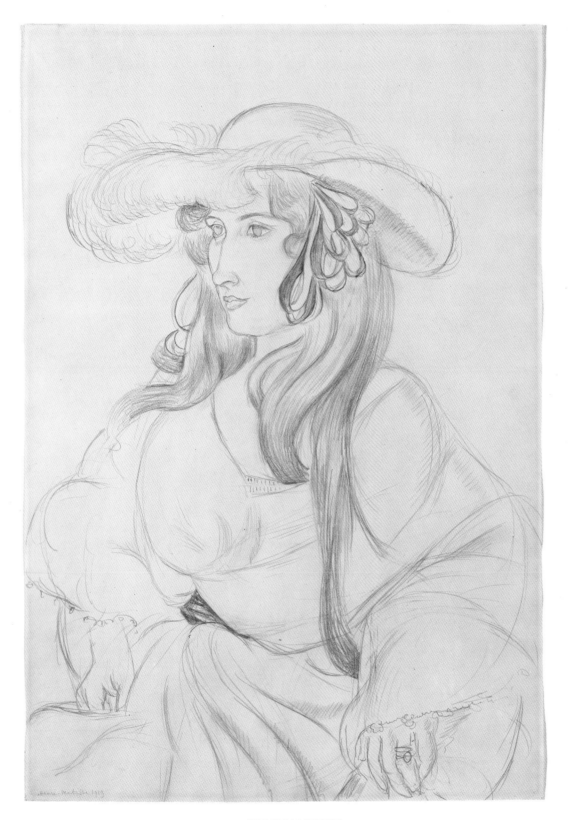

HENRI MATISSE

The Plumed Hat

On the basis of his watercolors, Charles Demuth was considered by critics as early as 1927 to be one of the most important figures in contemporary American painting. The themes that he chose to represent in this medium included architectural views, landscapes, scenes of the vaudeville theater, and still lifes of flowers and fruit. The latter are among the most beautiful and appealing twentieth-century works in this genre.

Signed and inscribed by the artist *Lancaster/Pa./1925,* this watercolor is one of a series of exuberant, virtuoso studies of fruit and vegetables that Demuth executed in 1925 and 1926. Lancaster was Demuth's place of birth and, although he studied art in Philadelphia and throughout his career made frequent trips to New York and Paris, it remained his home and one of his principal sources of inspiration. Lancaster is located in the heart of the Pennsylvania Dutch and Amish farming communities, and its farmers' markets are renowned for the quality of their produce and their handsome displays. The vegetables and fruits that Demuth's mother purchased at the markets near their home often became subjects for his watercolors.

Demuth studied in Philadelphia at the Drexel Institute and at the Pennsylvania Academy of the Fine Arts, where his teachers included Thomas Anshutz and William Merritt Chase. Most significant in the development of his art, however, were his contacts with French modernism through his visits to Paris in 1907 and 1912–14 and his association with Alfred Stieglitz and Gallery "291" in New York.

In both Paris and New York, Demuth saw exhibitions of the work of Paul Cézanne and undoubtedly was influenced by the French artist's subtle handling of the medium in transparent, faceted washes and with broad areas of the paper left white to create light and space. Particularly striking in this watercolor are Demuth's rich palette of reds and yellows, his fluid washes which are given texture through skillful manipulation of a blotter, and his way of combining pencil and watercolor to delineate form.

REFERENCES

Theodore Stebbins, Jr., *American Master Drawings and Watercolors: A History of Works on Paper from Colonial Times to the Present,* New York, 1976, p. 317.

Thomas E. Norton, ed., *Homage to Charles Demuth, Still Life Painter of Lancaster,* Ephrata, Pennsylvania, 1978, pp. 106–7.

Charles Demuth

American, 1883–1935

***Still Life: Apples and Bananas,* 1925**

Watercolor and pencil on paper; 30.2 × 45.7 cm (11⅞ × 18 in.)

Bequest of Robert H. Tannahill (70.253)

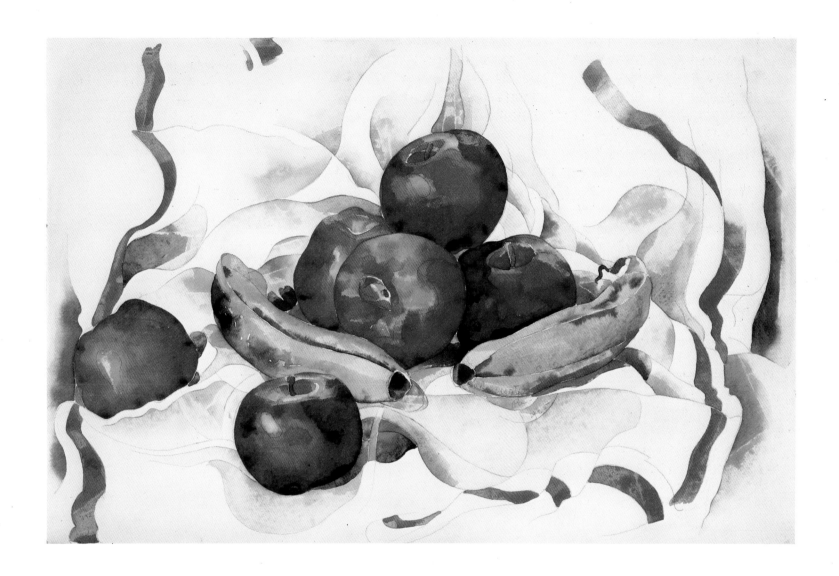

CHARLES DEMUTH

Still Life: Apples and Bananas

PORTRAITS, particularly self-portraits, are unusual in Nolde's oeuvre. It is not known how many self-portraits Nolde executed in drawing and watercolor, but only four were painted in oil, each one seemingly intended to record a special moment in his life. This is in marked contrast to Nolde's copious autobiographical writings, the first volume of which was published in 1931. Thus, this double portrait of the artist with his wife, Ada, is a rare record of the artist as he saw himself in maturity. It also serves as an important testimony to the relationship of a long-married and devoted couple. Nolde himself attached considerable significance to this work, as it was included as one of the few illustrations in *Jahre der Kämpfe (Years of Struggle),* the second volume of his autobiography, published in Berlin in 1934.

In this watercolor Nolde employed various pictorial means to underscore, while simultaneously bridging, the elemental gulf between man and woman. For example, the distinctive outline of Nolde's head is clearly defined as separate, and yet it is "joined" to Ada's head like an inset puzzle piece. Color also serves to differentiate and unite the two individuals: Ada is set against a field of a saturated warm red, while Nolde has cast himself in cool blue tones. With characteristic virtuosity, Nolde allowed the two primary colors of blue and red to flow into each other.

The harmony and spiritual accord of the couple are further suggested by their similar profile poses and serene expressions. Clearly the artist intended this portrait to transcend specific appearance and to convey instead the invisible realm of Emil's and Ada's inner beings.

REFERENCES

Emil Nolde, *Jahre der Kämpfe,* Berlin, 1934, p. 260.

The Detroit Institute of Arts, *The Robert Hudson Tannahill Bequest,* 1970, pp. 56–57, 59, 76.

Emil Nolde

German, 1867–1956

***Portrait of the Artist and His Wife,* ca. 1932**

Watercolor; 52.5 × 35.8 cm (20¾ × 14⅛ in.)

Bequest of Robert H. Tannahill (70.323)

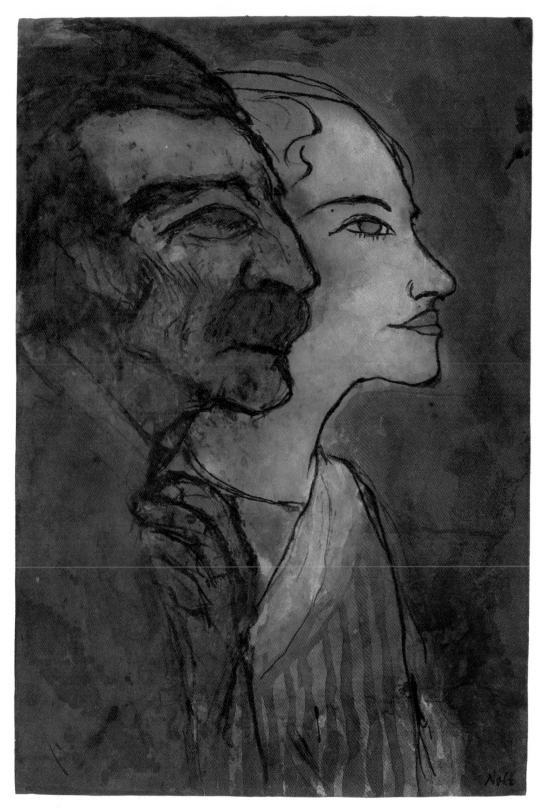

EMIL NOLDE

Portrait of the Artist and His Wife

Throughout his career Picasso drew artistic inspiration from each of his close female companions, who acted variously as mistresses, models, and muses. In early 1936, the Surrealist poet Paul Eluard introduced Picasso to the stunningly attractive photographer Dora Maar, whom he saw again in August of that year while vacationing on the Riviera. Shortly thereafter Dora Maar became his mistress and subsequently the subject of many of his paintings, drawings, and prints, until 1945, when Françoise Gilot assumed precedence in Picasso's affections. The monumental painting *Guernica* was the most important work Picasso produced in the decade he was with Dora Maar. During the painting of *Guernica* in May 1937, Maar photographed the stages of its creation, thereby providing important documentation.

Picasso and Dora Maar usually spent their summers on the Riviera, and in July 1939 they travelled to Antibes, where they rented the apartment of the artist Man Ray. They would spend their mornings on the beach, and Picasso would paint in the afternoons. *Bather by the Sea (Dora Maar),* specifically dated July 20, serves as a visual diary for that day, no doubt inspired by a fresh memory of Dora Maar donning a sunhat on the seashore. Taking characteristic liberties with human anatomy, Picasso has reconstructed her body into new configurations. In spite of the distortions and the double-face device (where the head can be "read" simultaneously frontally and in profile), the face is unquestionably Dora Maar's—the handsome, well-formed red mouth, the elegant, straight, pointed nose with flaring nostrils, the dazzling eyes, and the sleek shoulder-length coiffure. Although this work is full of personal associations with Picasso's life and art, it transcends the individual and takes its place in the grand tradition of the nude bather in art.

REFERENCE

C. Zervos, *Pablo Picasso, Oeuvres de 1937 à 1939,* Paris, 1958–59, vol. 9, pp. 152, 190, cat. no. 318.

Pablo Ruiz y Picasso

Spanish, 1881–1973

***Bather by the Sea (Dora Maar),* 1939**

Gouache; 64.1 × 47 cm (25¼ × 18½ in.)

Bequest of Robert H. Tannahill (70.339)

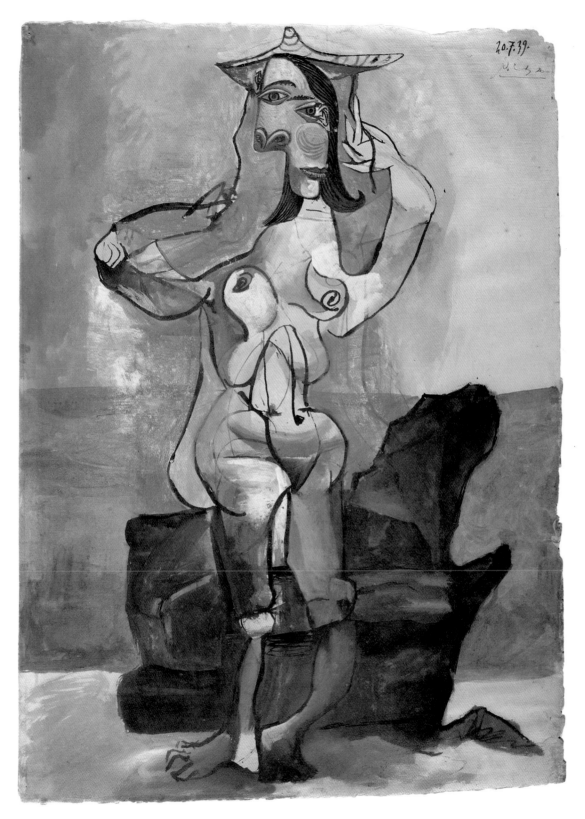

PABLO RUIZ Y PICASSO

Bather by the Sea (Dora Maar)

THIS is one of a series of industrial photographs that Sheeler made in 1939 in preparation for a group of six paintings on the theme of Power commissioned by *Fortune* magazine. (The related painting, *Rolling Power,* is in the collection of Smith College, Northampton, Massachusetts.) It depicts the wheels and a disk driver of a Model J3A Hudson Thoroughbred locomotive, one of the ten streamlined versions of the engine designed to pull the legendary Twentieth Century Limited. This engine, designed by Henry Dreyfuss and built in 1937, was regarded by railroad enthusiasts as the most beautiful steam locomotive for a passenger train in America.

Charles Sheeler was greatly admired by his peers in photography, such as Alfred Stieglitz, Edward Steichen, Paul Strand, and Edward Weston, not only for his straightforward camera technique, but also for his ability to refine everyday subjects and invest them with emotional power. Steichen said, "Sheeler was objective before the rest of us ever were" (Millard, p. 85).

Focusing on the wheels of a great locomotive, Sheeler created in *Drive Wheels* an image that epitomizes the power and speed of the engine and the elegance of its design. As is characteristic of Sheeler's photographs, there are no stark white and black contrasts, but rather there is a warm, subtle range of tones and a satisfying balance of light and shadow. Especially masterful are the graduations of tone in the wheel at the left and in the puff of steam with a trail of vapor which energizes and enlivens the compositon at the lower right.

That Sheeler himself valued this image is shown by the fact that he chose *Drive Wheels* when Edward Weston asked him for an example of his photographic work to be included in an article on the art of photography which Weston wrote for the 1941 edition of the *Encyclopaedia Britannica*.

REFERENCES

Charles Millard, "The Photography of Charles Sheeler," *Charles Sheeler,* Washington, D.C., 1969, pp. 85–86.

Van Deren Coke, *The Painter and the Photograph,* Albuquerque, 1972, p. 217, no. 445.

Rick Stewart, "Charles Sheeler, William Carlos Williams, and Precisionism: A Redefinition," *Arts,* vol. 58 (1983), no. 3, p. 106.

Charles Sheeler

American, 1883–1965

***Drive Wheels,* 1939**

Gelatin-silver print; 15.9 × 24.2 cm (6¼ × 9½ in.)

Founders Society Purchase, John S. Newberry Fund, and J. Lawrence Buell, Jr., Fund (F1983.124)

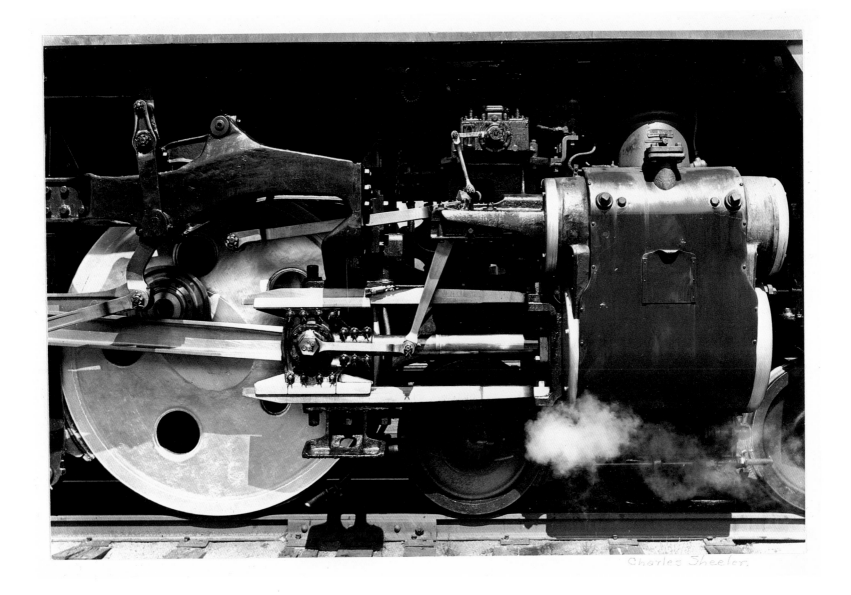

CHARLES SHEELER

Drive Wheels

American Art

HANNAH LORING married Boston merchant Joshua Winslow in 1763, the year this painting was executed; he died shortly before the Revolution. His widow, being a Loyalist, fled to Canada with their six children when the British evacuated Boston in 1776. Her property was eventually confiscated by the Americans, and Hannah Loring Winslow was never able to return to this country. She ended her days under circumstances vastly reduced from those she had enjoyed when she posed for this beautiful portrait.

Hannah Loring exemplifies the stylish elegance of John Singleton Copley's work of the early 1760s, in which fashionably dressed female sitters gaze out at the viewer with disarming directness. The subdued tones of the background depict a garden, which emphasizes the subject's privileged station in life, as does the elegance of her lace-trimmed gown and the pristine creaminess of her complexion. A half-smile plays on the lips of this assured young Bostonian who, like most members of her class, enjoyed the air of nobility with which Copley imbued them.

Although Hannah Loring's pose, with her gloved right hand tucked back on her hip and her left hand clasping a rose, has affinities with several other portraits of young women painted by Copley in 1763, the artist was careful never to repeat the same composition exactly. Most effective here is the use of oval motifs to suggest the abundance of young womanhood. Copley's sure coloristic sense is evidenced in the cool greens, grays, and blues of the gown, and the pink and blue color accents.

REFERENCES

Jules David Prown, *John Singleton Copley,* Cambridge, Massachusetts, 1966, pp. 38, 110.

Graham Hood, "American Paintings Acquired during the Last Decade," *Bulletin of the Detroit Institute of Arts,* vol. 55 (1977), pp. 69–70.

John Singleton Copley

American, 1738–1815

Hannah Loring, 1763

Oil on canvas; 126.4 × 99.7 cm (49¾ × 39¼ in.)

Gift of Mrs. Edsel B. Ford in memory of Robert H. Tannahill (70.900)

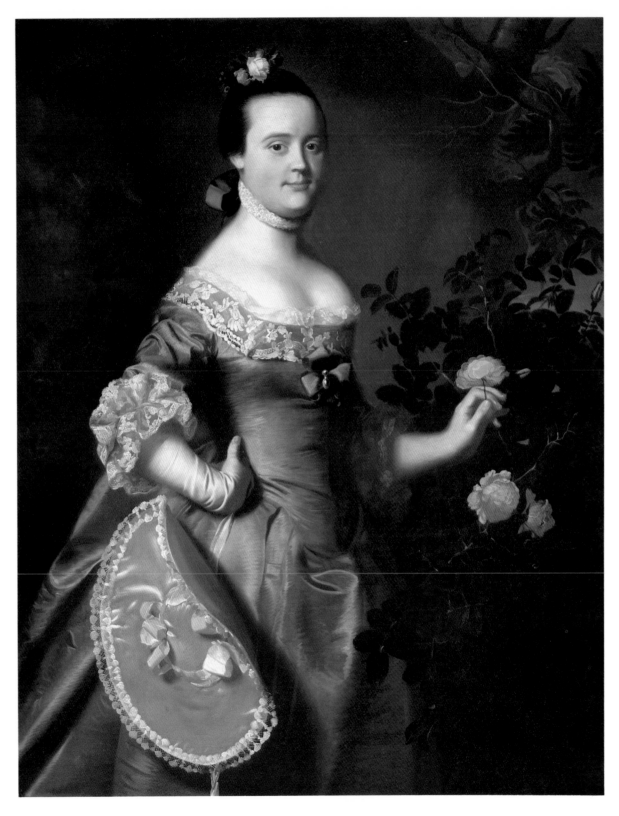

JOHN SINGLETON COPLEY

Hannah Loring

THE design of this superb desk and bookcase incorporates features, such as the hairy paw feet, the floral carving, and the eagle finial, that are associated with the most sophisticated Boston furniture in the Rococo style. The conservative nature of New England Rococo taste is disclosed by the design's combination of Rococo decorative elements with earlier Baroque forms.

The blocking, or convex-concave-convex shaping, of the desk section is based on English and Continental prototypes of the late seventeenth and early eighteenth centuries. In America, the blockfront seems to have originated in Boston and then spread to Salem and other North Shore towns, as well as to Rhode Island and Connecticut.

This Baroque form remained popular in New England long after it had gone out of fashion in Europe.

The bookcase section derives its form from English Baroque architecture. Designs for doorways were often adapted for use in large case pieces to insure that the furniture would harmonize with the paneling of a room. Bounded by fluted pilasters with Corinthian capitals, the bookcase is surmounted by the cabinetmaker's version of the architectural forms of architrave, frieze, and broken scroll pediment. That the desk is a product of the Rococo period is revealed in the delicacy of the carved moldings, the rosettes with trailing flowers and leaves, the elegance of the swan's neck pediment, and the graceful shape of the mirrors. As a crowning touch of elegance, the mirror moldings, corkscrew finials, and eagle are gilded.

REFERENCES

Richard H. Randall, Jr., *American Furniture in the Museum of Fine Arts, Boston,* Boston, 1965, p. 91.

The Detroit Institute of Arts, *American Decorative Arts from the Pilgrims to the Revolution* (exh. cat.), 1967, p. 30, no. 50.

Desk and Bookcase

American, 1770–85

Mahogany and pine; 260.3 × 107.9 × 61 cm (102½ × 42½ × 24 in.)

Founders Society Purchase, Robert H. Tannahill Fund, Gibbs-Williams Fund, and Louis Hamburger Fund (66.131)

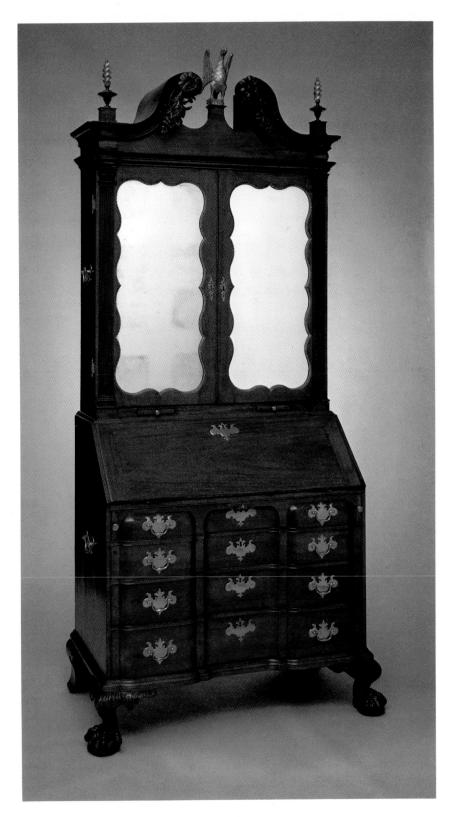

AMERICAN

Desk and Bookcase

THIS chest-on-chest is one of very few pieces of American eighteenth-century furniture to be signed by its maker—in this case, Nathan Bowen of Marblehead, Massachusetts. On the bottom of the lower case is incised N · B 1774. The existence of another chest-on-chest signed by Bowen adds a further dimension to the circumstances surrounding the creation of the Detroit piece. In addition to Bowen's inscription, the second chest-on-chest (Museum of Fine Arts, Boston) bears also the initials EM and the name Martin for the elder Ebenezer Martin (1730s–1800). According to Richard Randall, Martin and Bowen are known to have worked together on at least one other project. Coupled with the fact that the double chests are so similar, this raises the possibility that the Detroit piece is also the result of a rare collaboration between two master cabinetmakers.

The Detroit chest-on-chest is an excellent example of Massachusetts blockfront furniture. Here the blocking is not used as mere ornament but is integrated into the design of the whole chest. The distinct separation of each blocked portion produces a vertical emphasis that harmonizes with the upward thrust of the fluted pilasters and corkscrew finials. The crisp corners of the blocking echo the sharp edges of the cornice. The robustly curved legs, the columnar blocking, and the sensitive proportions of the upper and lower cases are equally important in supporting, both visually and structurally, a tall, imposing piece of furniture. Displaying a quiet majesty achieved through subtleties of design and superb execution, this chest-on-chest ranks with the finest examples of American furniture.

REFERENCES

Wallace Nutting, *Furniture Treasury,* Framingham, Massachusetts, 1928, vol. 1, no. 315.

Richard H. Randall, Jr., "An Eighteenth-Century Partnership," *Art Quarterly,* vol. 23 (1960), pp. 153–61.

Nathan Bowen

American, 1752–1837

Chest-on-Chest, **1774**

Mahogany and pine; 236.2 × 115.6 × 59.7 cm (93 × 45½ × 23½ in.)

Founders Society Purchase, Gibbs-Williams Fund (48.274)

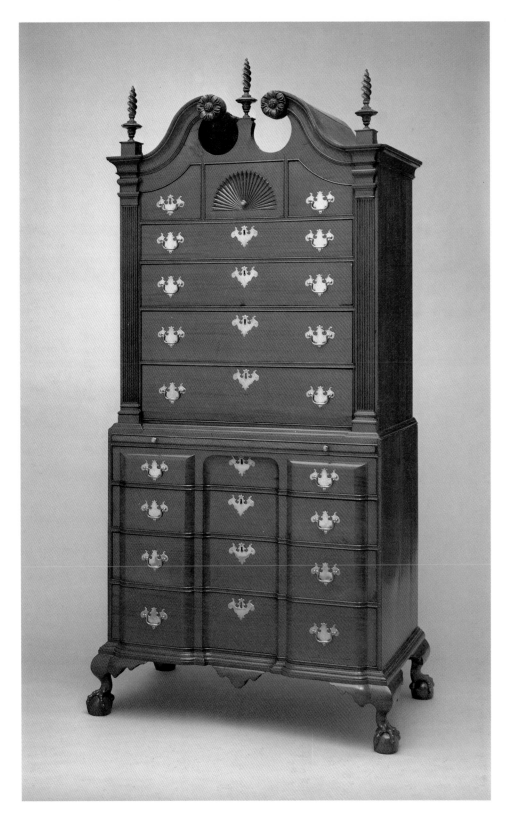

NATHAN BOWEN

Chest-on-Chest

This clock was originally owned by Elias Brown, a wealthy merchant in Preston, Connecticut. Although most clock faces are engraved with the clockmaker's name, this one has a more unusual inscription: *Abishai Woodward/Harland/Norwich*. Thomas Harland is recorded as a clockmaker in Norwich, Connecticut. Abishai Woodward was a woodworker living in Preston until 1788 and thus probably was responsible for making the clock's case.

Characteristics of both urban and rural furniture design are skillfully blended in the design and execution of this imposing clock.

The use of the shell on a blocked section is derived from the furniture of Newport, Rhode Island, whereas the addition of fanciful scrolls on the apron is an obvious indication of the clock's Connecticut origin, as are the rope-twist columns. The lower part of each column is embellished with ivory. The capitals and bases are of ivory and brass. The terminals of the vigorously curved swan's neck pediment are decorated with carved flower heads. The rural cabinetmaker's tendency toward profuse ornamentation is countered by the careful distribution of the ornament over the excellent proportions of the case. With expertly engraved but naïvely drawn images of the four seasons in the spandrels and a band of Rococo and classical motifs above the painted moondial, the clockface continues the delightful balance between sophisticated and provincial elements.

REFERENCES

Ada R. Chase and Houghton Bulkeley, "Thomas Harland's Clock—Whose Case?," *Antiques,* vol. 87 (1965), pp. 700–701.

Minor Myers, Jr., and Edgar deN. Mayhew, *New London County Furniture,* New London, Connecticut, 1974, pp. 57, 130, cat. no. 62.

Wendy A. Cooper, *In Praise of America: Masterworks of American Decorative Arts, 1650–1830, A Guide to the Exhibition,* Washington, D.C., 1980, pp. 22, 29–30, cat. no. 26.

Thomas Harland (clockmaker)

American, 1735–1807

and

Attributed to Abishai Woodward (cabinetmaker)

American, 1752–1809

Tall Case Clock, **1775–88**

Mahogany, pine, ivory, and brass; 222.2 × 46.4 × 28.6 cm (87½ × 18¼ × 11¼ in.)

Gift of Mrs. Alger Shelden, Mrs. Susan Kjellberg, Mrs. Lyman White, Alesander Muir Duffield, and Mrs. Oliver Pendar in memory of Helen Pitts Parker (59.149)

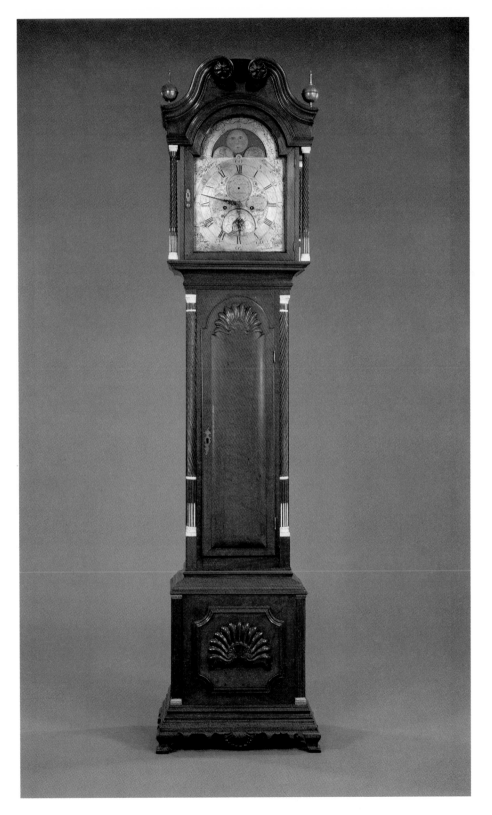

THOMAS HARLAND AND ABISHAI WOODWARD

Tall Case Clock

TRAINED by his father as a metalsmith, the American hero Paul Revere began his career during the 1750s at the beginning of the Rococo period. After the Revolution, when the Neoclassical style began to supplant the earlier florid mode, Revere was quick to adapt. The new style with its emphasis on refined geometric forms and delicate surface patterns is splendidly represented by this teapot. Influenced by the technological innovation of the sheet-rolling of silver as well as by ancient Greek and Roman styles, the form of the teapot superimposes fluting, like that of a classical column, upon a basic oval shape. The tapered oval spout and the round sockets for the wooden handle continue the geometric theme. The bright-cut engraving of drapery swags and of a stylized foliate border perfectly complements the fluted sides of the pot.

An inscription on the base of the pot reveals that its first owner was William Coombs, an exact contemporary of Revere. As several other teapots of this form, considered by scholars to be one of Revere's most successful Neoclassical designs, are known to have matching pieces such as sugar bowls and cream pitchers, it is possible that Mr. Coombs's magnificent teapot was originally ordered as a part of a complete tea and coffee service.

REFERENCE

Robert H. Tannahill, "The Growth of the Collection of Early American Silver," *Bulletin of the Detroit Institute of Arts,* vol. 18 (1939), pp. 4–7.

Paul Revere II

American, 1735–1818

Teapot, **1790–95**

Silver and ebony; h. 14.6 cm (5¾ in.)

Founders Society Purchase, Gibbs-Williams Fund (37.92)

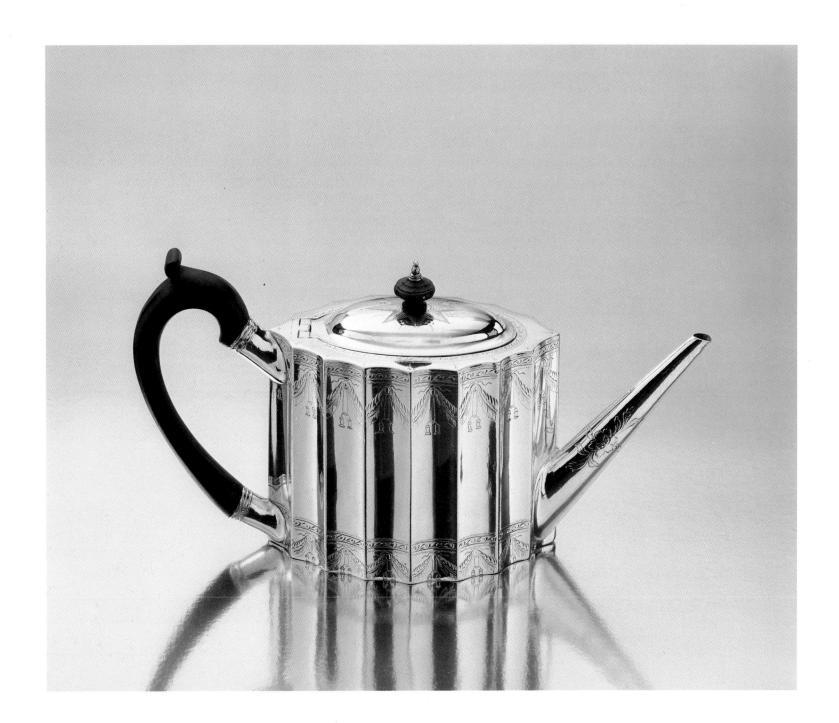

PAUL REVERE II

Teapot

This painting is Benjamin West's first preparatory oil sketch for a larger version of the apocalyptic theme that shows the holocaust following the opening of the four seals as described in the book of Revelation: 6. This canvas, though intended as a study for a larger work destined for King George III's Chapel of Revealed Religion at Windsor Castle, is the one example of West's work that the artist took to Paris and exhibited in the Salon of 1802, where it astounded the French and became the object of much critical discussion. The visionary character of the subject, which recounts the allegorical redemption of mankind, together with the vivid and dynamic manner of its execution, makes this one of the earliest paintings to express the spirit of Romanticism. The Detroit *Death on the Pale Horse* is one of West's most emotional works and one of his finest in terms of color.

The painting depicts the biblical passage fairly literally. The central figure is Death, who appears upon the opening of the fourth seal. Monstrous creatures from Hell follow him, and before him and to the left are scenes of killing by the sword, by famine, by pestilence, and by wild beasts. To the right are the riders on white, red, and black horses who are seen following the opening of the first three seals.

The Detroit painting is the second of three versions of the subject executed by the artist: the first is a large drawing done in 1783 (Royal Academy of Art, London); the third is the final, monumental painting (Pennsylvania Academy of the Fine Arts, Philadelphia) completed in 1816 and exhibited in 1817, in which West changed the rider on the white horse from a fierce warrior to a figure of Christ.

REFERENCES

John Dillenberger, *Benjamin West: The Context of His Life's Work, with Particular Attention to Paintings with Religious Subject Matter,* San Antonio, Texas, 1977, pp. 89–93.

Dorinda Evans, *Benjamin West and His American Students,* Washington, D.C., 1980, pp. 19, 68, 134.

Allen Staley, "West's Death on the Pale Horse," *Bulletin of the Detroit Institute of Arts,* vol. 58 (1980), pp. 137–49.

Benjamin West

American, 1738–1820

Death on the Pale Horse, **1796**

Oil on canvas; 59.5 × 128.5 cm (23½ × 50½ in.)

Robert H. Tannahill Foundation Fund (79.33)

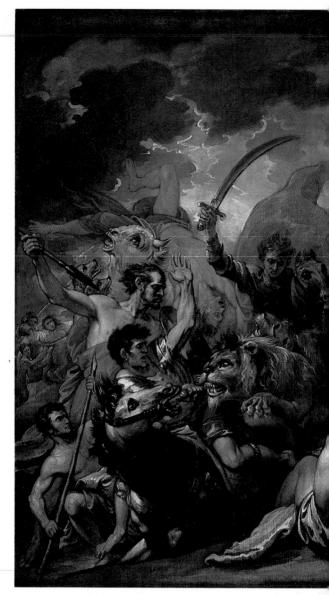

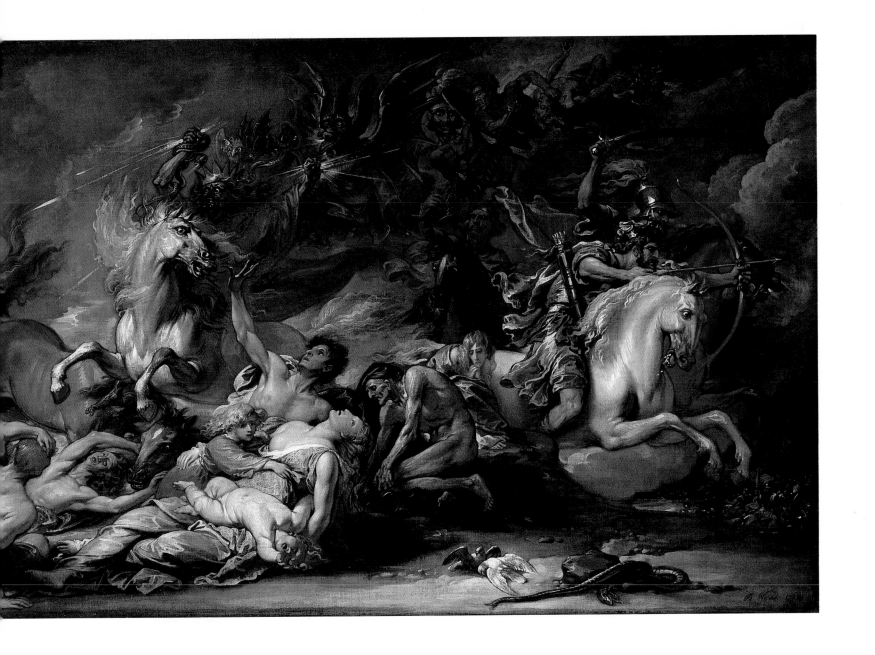

BENJAMIN WEST

Death on the Pale Horse

IN 1822 Charles Willson Peale was asked by the trustees of the Peale Museum in Philadelphia to paint a full-length portrait of himself to be installed in the museum of art and science that he had founded, the first scientific museum in the United States and one of the first such institutions in the world. The result is the famous *The Artist in His Museum* (Pennsylvania Academy of the Fine Arts). In the same year, to avoid "standing alone before posterity on the Museum walls" (as Charles Coleman Sellers observed), Peale produced this more intimate and subtle portrait of his younger brother, James. The picture presents the aging miniaturist and still life painter in a dimly lit interior, gazing fondly at a miniature painted by his daughter, Anna, of Rembrandt Peale's eldest daughter, Rosalba. This miniature is also in the collection of the Detroit Institute of Arts.

The Lamplight Portrait shows that Peale, who was then in his eighty-first year, retained great expressiveness in his style even late in his life. His interest in light puts him in the forefront of the art of the time. Employing only the warm glow of the lamp to illuminate the figure, he focuses attention on the gentle face of the elderly man and the miniature before him, making the whole canvas a study in subtle gradations of light. The reddish tonalities of the clothing and the background add to the mood of quiet contemplation.

REFERENCES

Charles Coleman Sellers, *Charles Willson Peale,* Philadelphia, 1947, vol. 2, p. 352.

Edgar P. Richardson, "A Portrait of James Peale, the Minature Painter (the 'Lamplight Portrait') by Charles Willson Peale," *Bulletin of the Detroit Institute of Arts,* vol. 30 (1950–51), pp. 8–11.

Edgar P. Richardson, Brooke Hindle, and Lillian B. Miller, *Charles Willson Peale and His World,* Washington, D.C., 1982, pp. 99, 104, 251.

Charles Willson Peale

American, 1741–1827

James Peale (The Lamplight Portrait), 1822

Oil on canvas; 62.2 × 91.4 cm (24½ × 36 in.)

Gift of Dexter M. Ferry, Jr. (50.58)

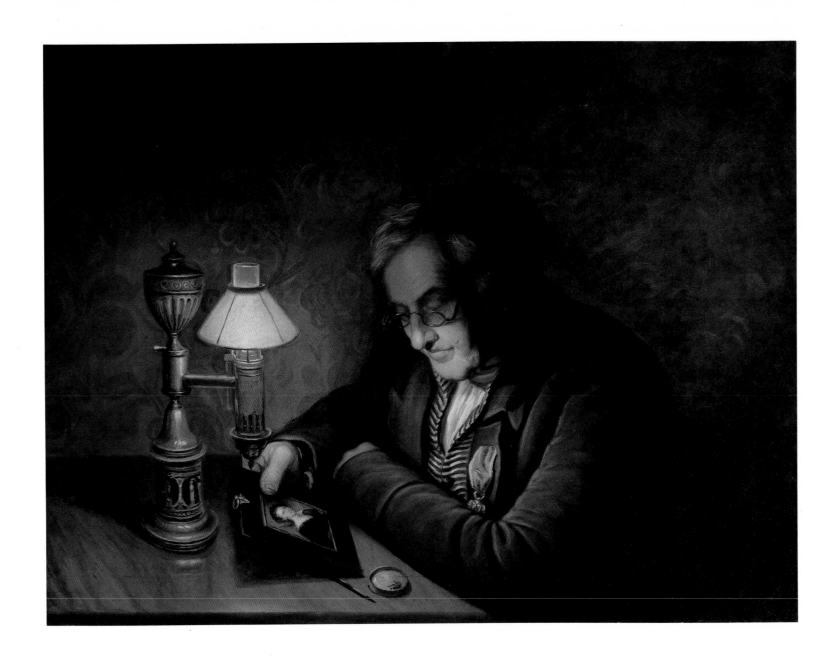

CHARLES WILLSON PEALE

James Peale (The Lamplight Portrait)

As Charles Willson Peale's second surviving and most talented son, Rembrandt Peale handled the paints and brushes of his father's studio almost from infancy. Gifted and energetic like his father, Peale founded the Peale Museum at Baltimore, established the first illuminating gas company in America, was one of the country's earliest lithographers, and painted the portraits of many of the nation's leaders. Shortly before leaving for an extended tour of Florence and Rome, the fifty-year-old artist painted this direct and expressive *Self-Portrait* for his wife, Eleanor.

Peale painted this portrait in Boston, where he had established a reputation for producing "valuable likenesses." He found opportunities there despite competition from Gilbert Stuart, an artist whose work he greatly admired. Though Peale's penchant was for linear clarity, detail, and surface polish, occasionally he conveyed a painterly flair reminiscent of Stuart, notable here in the ill-defined, broadly brushed clothing.

The Detroit painting was the first self-portrait Peale had executed since early in his career, though he would paint several more in the 1840s and 1850s. Most of the later self-portraits were public images. This one, however, shows the artist, his small eyes keenly observant behind the spectacles he had begun to use in 1818, as he appeared to his own searching and unflattering gaze. In its frontality and sober objectivity, the painting recalls Peale's Neoclassical style at the turn of the century, but its intensity and forceful lighting suggest more than a casual debt to his namesake, Rembrandt van Rijn.

REFERENCES

Edgar P. Richardson, "Self Portrait by Rembrandt Peale," *Bulletin of the Detroit Institute of Arts,* vol. 25 (1946), pp. 53–54.

William Oedel in *American Paintings in the Detroit Institute of Arts,* vol. 1, forthcoming.

Rembrandt Peale

American, 1778–1860

Self-Portrait, **1828**

Oil on canvas; 48.3 × 36.8 cm (19 × 14½ in.)

Dexter M. Ferry, Jr., Fund (45.469)

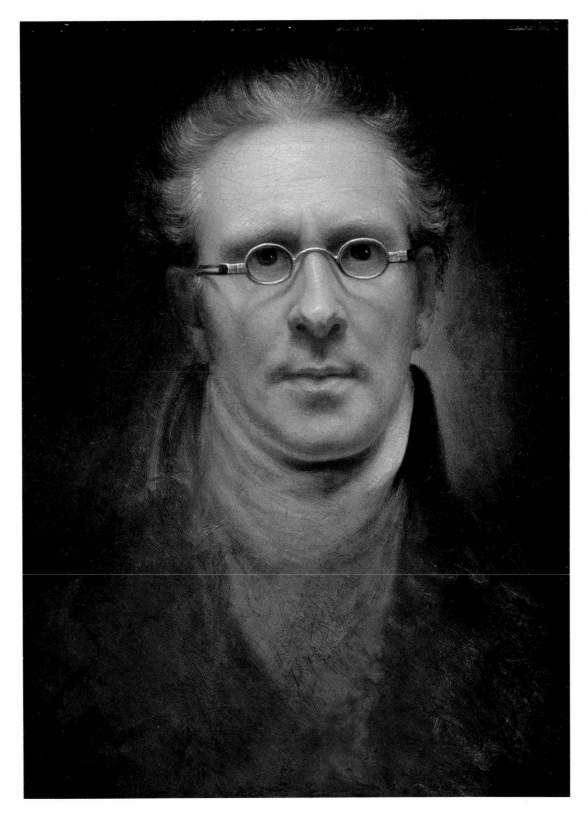

REMBRANDT PEALE

Self-Portrait

The TRAPPERS' RETURN is the second version of a painting George Caleb Bingham executed in 1845, *Fur Traders Descending the Missouri* (Metropolitan Museum of Art, New York), which is generally considered to be the artist's finest work in the genre idiom. Both pictures present a dugout moving slowly downstream with an old French trader paddling in the stern and his son amidships. Here, a bear cub has been chained to the bow; in the earlier version, the small black animal has been variously identified as a bear cub, a fox, and even a cat.

Bingham was a conscientious craftsman and made many preliminary studies for his compositions. These drawings often served as models for transposition into other compositions or for variations on a theme. In *The Trappers' Return,* Bingham has varied the figures only slightly in characterization and detail from the earlier version, but he has altered his emphasis by moving them forward so that the viewer more nearly participates in the action. The artist's understanding of light and shadow, textures, and color has also developed further since his first treatment of the subject. The general mood is similar in both paintings, and Bingham invests them with a sense of timelessness all the more striking for the specificity of the scenes depicted.

Bingham's impressions of river life on the Missouri and Mississippi remain the most enduring subjects of his art. E. Maurice Bloch has suggested that the artist's interest in the fur trader motif may have been inspired by Washington Irving's *Astoria,* a novel based on the records of the American Fur Company that had been recently published. The book describes at length the lives of the French traders at Saint Louis, particularly those who had intermarried with the Indians. When the first version of the painting was sent to the Art Union for consideration in 1845, it was titled *French Trader and His Half-Breed Son.*

REFERENCES

E. Maurice Bloch, *George Caleb Bingham: The Evolution of an Artist,* Los Angeles, 1967, pp. 79–84.

Albert Christ-Janer, *George Caleb Bingham: Frontier Painter of Missouri,* New York, 1975, p. 49.

George Caleb Bingham

American, 1811–1879

The Trappers' Return, **1851**

Oil on canvas; 66.7 × 92.1 cm (26¼ × 36¼ in.)

Gift of Dexter M. Ferry, Jr. (50.138)

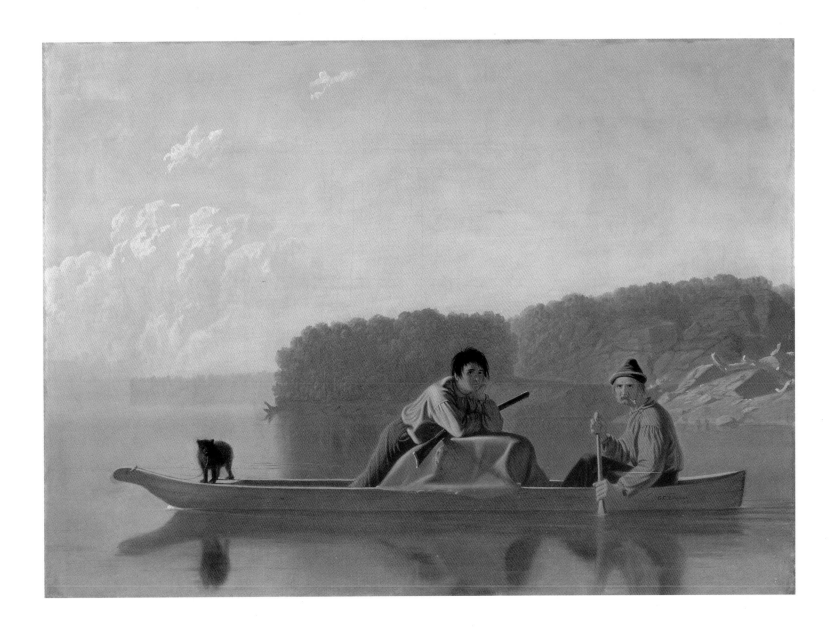

GEORGE CALEB BINGHAM

The Trappers' Return

COTOPAXI, an active volcano in the Andes Mountains, provided the quintessential nineteenth-century vision of nature's sublime and terrifying power. Frederic Church's painting of the mountain was executed on commission for James Lenox, a well-known book collector and philanthropist, when Church was at the height of his fame. The Detroit *Cotopaxi,* the third and the most monumental of the artist's four versions of the subject, is a compelling example of Church's ability to capture the atmosphere of a particular moment in imagery that is a metaphor for a deeper reality. The painting made a tremendous impact in 1863 on the American public, who perceived it as a geological parable of the Civil War, then in progress.

Church had been a student of Thomas Cole, the principal figure of the Hudson River School. An added intellectual source for Church was the German naturalist Alexander von Humboldt, who believed that there were bonds between natural science and poetry and artistic feeling. Inspired by Humboldt's passion for the tropics, Church made two trips to Ecuador: the first in 1853, when he made numerous sketches of Cotopaxi and the surrounding area; the second in 1857, when he studied the subject intensively.

Like all of Church's major canvases, *Cotopaxi* is not a specific view, but a naturalistic and symbolic characterization of a particular region of the earth. The viewer's attention is focused on the burning disk of the rising sun in its contest with the smoldering volcano. The colors radiate with fiery intensity — vivid pinks, oranges, and greens contrast with the rosy tints of early morning and the sooty grays of smoke—against a low, pearlescent skyline. In this cosmic drama of light dispelling darkness, Church reflects the contemporary tragedy of war and offers hope for its resolution through the suggestion of a cross formed by the sun's reflection on the lake. While other Hudson River School painters also dealt with the theme of hope during the dark hours of the Civil War, no other representation so effectively summarized American ideals at this critical point in the national history. Today *Cotopaxi* is recognized as one of Church's finest paintings and as an icon for nineteenth-century America.

REFERENCES

David Huntington, *The Landscapes of Frederic Edwin Church: Vision of an American Era,* New York, 1966, pp. 11–20.

Nancy Rivard, "Notes on the Collection: *Cotopaxi,*" *Bulletin of the Detroit Institute of Arts,* vol. 56 (1978), pp. 193–96.

John Wilmerding, *American Light: The Luminist Movement, 1850–1875, Paintings, Drawings, Photographs,* Washington, D.C., 1980, pp. 155–89.

Frederic Edwin Church

American, 1826–1900

Cotopaxi, **1862**

Oil on canvas; 121.9 × 215.9 cm (48 × 85 in.)

Founders Society Purchase, Robert H. Tannahill Foundation Fund, Gibbs-Williams Fund, Dexter M. Ferry, Jr., Fund, Merrill Fund, Beatrice W. Rogers Fund, and Richard A. Manoogian Fund (76.89)

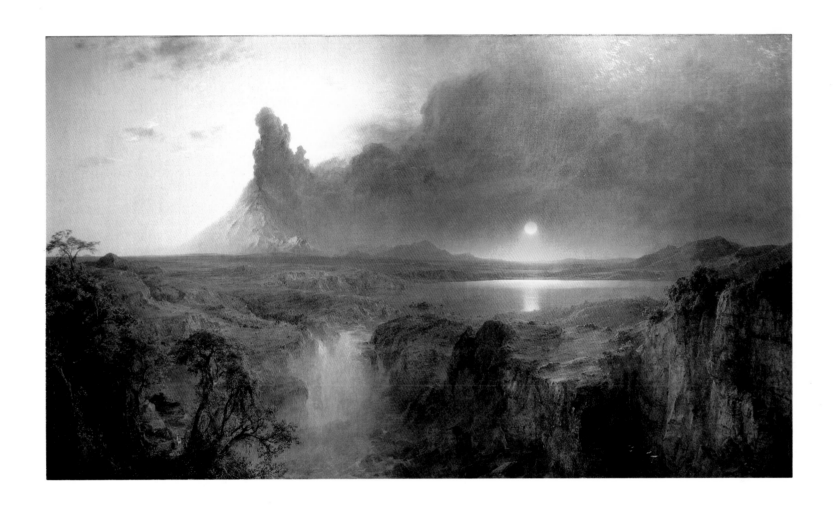

FREDERIC EDWIN CHURCH

Cotopaxi

This self-portrait was executed during a decade in which James Abbott McNeill Whistler produced many of his finest paintings. Although it has been linked compositionally to the well-known profile picture of his mother, *Arrangement in Gray and Black No. 1* (Louvre, Paris), the painting is more closely allied by the monumental triangular form of the half-length figure to the tradition of Renaissance and Baroque portraiture, especially to works by Raphael, Titian, Rembrandt, and Velázquez.

Whistler's surviving self-portraits in chalk and in oil attest to the artist's absorption with his own image. Like Rembrandt's self-portraits, *Arrangement in Gray* was for Whistler an exploration of his psyche as well as of problems in composition and technique. In this painting the artist turns, with a touch of disdain and a self-confidence perhaps buoyed by the completion of several important works, to confront the viewer with a cool, appraising gaze. The closeness of the figure to the picture plane combined with the lively handling of the face gives the image a startling immediacy.

Whistler's debt to Japanese prints is revealed in the flattened forms of the body and the hat, the subtle gradations of gray, and the asymmetrical composition that incorporates the artist's cipher, the butterfly. In addition to being a powerful self-portrait, *Arrangement in Gray* is a masterful example of Whistler's unique synthesis of Eastern and Western artistic traditions.

REFERENCES

D. Sutton, *James McNeill Whistler: Paintings, Etchings, Pastels and Watercolours,* London, 1966, p. 190.

Albright-Knox Art Gallery, Buffalo, New York, *Heritage and Horizon,* 1976, no. 29.

Andrew McLaren Young, Margaret MacDonald, and Robin Spencer, *The Paintings of James McNeill Whistler,* New Haven and London, 1980, vol. 1, pp. 74–75, no. 122.

James Abbott McNeill Whistler

American, 1834–1903

***Arrangement in Gray: Portrait of the Painter,* ca. 1872**

Oil on canvas; 74.9 × 53.3 cm (29½ × 21 in.)

Bequest of Henry Glover Stevens in memory of Ellen P. Stevens and Mary M. Stevens (34.27)

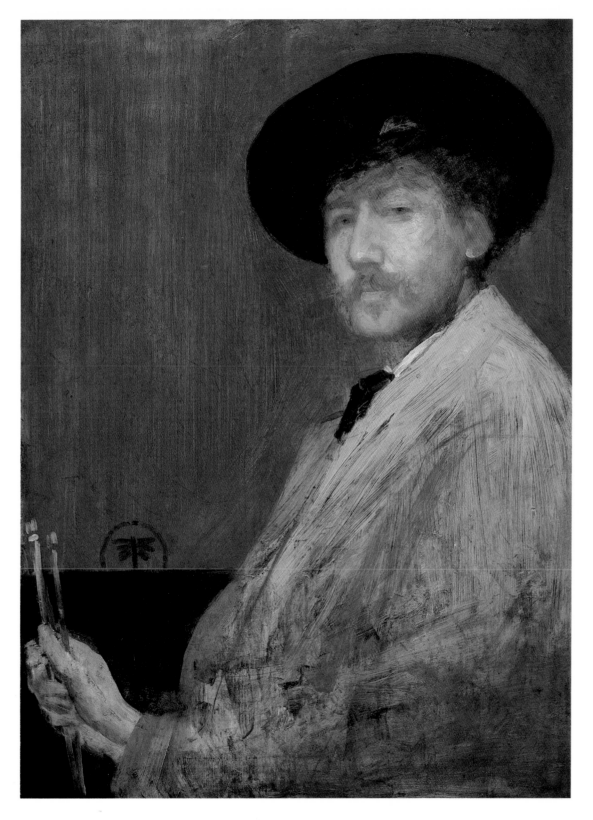

JAMES ABBOTT McNEILL WHISTLER

Arrangement in Gray: Portrait of the Painter

THE FALLING ROCKET has been immortalized as the painting that provoked art critic John Ruskin to attack its abstraction and, indirectly, its lack of a morally purposeful subject. In 1877 Ruskin stated that he "never expected to hear a coxcomb ask two hundred guineas for flinging a pot of paint in the public's face." The painter, James Abbott McNeill Whistler, replied by suing Ruskin for libel. Whistler won his case but was given only a token award of one farthing for damages. His ultimate vindication came in 1892 when he sold the painting for over four times the amount he had asked for it prior to the trial.

Whistler's Nocturnes, most of which were painted in the 1870s, were meant to be poetic evocations of the artist's visual experience of and emotional response to his subjects. During the trial, Whistler emphasized that the rapid execution of *The Falling Rocket,* criticized by Ruskin, was absolutely necessary to achieve the effect he wanted. The showers of sparks, the flames, and the smoke from the launching platform rise against the inky sky with an explosiveness that illustrates Whistler's description of his working method. The highly charged atmosphere derives not only from the colors, execution, and asymmetrical composition, but also from the subject itself. By achieving the perfect blend of technique, aesthetics, and the theme of fireworks, Whistler endowed *The Falling Rocket* with all the excitement and mystery he perceived in the scene.

REFERENCES

Andrew McLaren Young, Margaret MacDonald, and Robin Spencer, *The Paintings of James McNeill Whistler,* New Haven and London, 1980, vol. 1, pp. 97–99, no. 170.

The Detroit Institute of Arts, *The Quest for Unity: American Art between World's Fairs 1876–1893,* 1983, p. 250, no. 159.

David Park Curry, *James McNeill Whistler at the Freer Gallery of Art,* Washington, D.C., 1984, pp. 71–87.

James Abbott McNeill Whistler

American, 1834–1903

***Nocturne in Black and Gold: The Falling Rocket,* ca. 1875**

Oil on oak panel; 60.2 × 46.7 cm (23¾ × 18⅜ in.)

Gift of Dexter M. Ferry, Jr. (46.309)

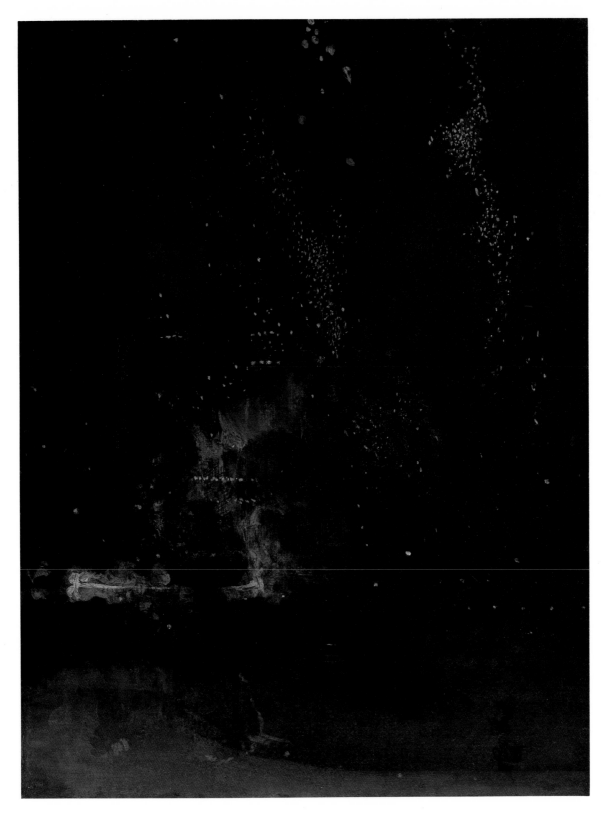

JAMES ABBOTT McNEILL WHISTLER

Nocturne in Black and Gold: The Falling Rocket

THE portrait of Madame Paul Poirson was one of the last works John Singer Sargent painted before he left France to settle in England. Although Sargent had already established some English connections, his move seems to have been precipitated by a lack of commissions following the scandal at the 1884 Salon concerning his painting of the notorious beauty Madame Gautreau, *Madame X* (Metropolitan Museum of Art, New York). The sophisticated Monsieur Poirson, who was on close terms with noted musicians and artists, apparently was undaunted by the furor surrounding Sargent, for he commissioned not only the portrait of his wife but also that of their daughter Suzanne.

The composition of *Madame Paul Poirson* follows that of Sargent's other three-quarter-length portraits of 1884, such as *Edith, Lady Playfair* (Museum of Fine Arts, Boston). The figure is placed at a three-quarter angle, the head faces outward, and the eyes engage the viewer directly. A new aspect of this pose is the long loop of Madame Poirson's bare arms, which is echoed by the rows of beaded trim on the bodice and skirt of her gown. Rejecting the sharp tonal contrasts in many of his earlier works, Sargent creates a subtle harmony of blues and silvers punctuated by the carefully placed accents of the black ribbon around the lady's neck and the blue and purple floral ornaments on the bustle and bodice and in her dark-gray hair.

Sargent's virtuosity in handling paint, often disparaged by contemporary critics as being merely clever, was a potent means of expression. It is his elegance of touch as much as his capturing of a personality that makes Sargent's portrait of Madame Poirson so fresh and alive.

REFERENCES

C. M. Mount, "New Discoveries," *Art Quarterly,* vol. 20 (1957), pp. 304–16.

Larry J. Curry, *"Madame Paul Poirson*: An Early Portrait by Sargent," *Bulletin of the Detroit Institute of Arts,* vol. 51 (1972), pp. 97–104.

James Lomax and Richard Ormond, *John Singer Sargent and the Edwardian Age,* Leeds. 1979, p. 36, cat. no. 18.

John Singer Sargent

American, 1856–1925

Madame Paul Poirson, **1885**

Oil on canvas; 149.9 × 85.1 cm (59 × 33½ in.)

Founders Society Purchase, Mr. and Mrs. Richard A. Manoogian Fund, Beatrice Rogers Bequest Fund, Gibbs-Williams Fund, and Ralph Harman Booth Bequest Fund (73.41)

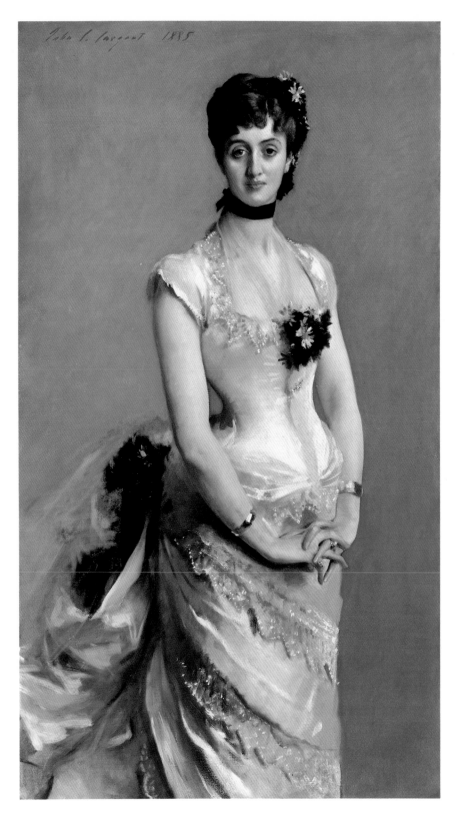

JOHN SINGER SARGENT

Madame Paul Poirson

THE international fame that Mary Cassatt achieved during her lifetime was based primarily on her depictions of motherhood. Her first mother and child picture appeared about 1880, and from 1890 on, her work focused almost entirely on this subject. Cassatt generally preferred natural poses, and the maternal preoccupations of her family and friends provided convenient material for her drawing skills. Caught in fresh and often startling compositions—such as cropped overhead views or intimate close-ups—mothers are shown performing the traditional tasks of bathing, caressing, or displaying a child.

In *Women Admiring a Child* the mother holds the child upright in her arms so that the child's head is on a level with hers, allowing for a formal and psychological interplay between the two. Their interdependence is further emphasized by their slight separation in the composition from the pair of admiring women. The viewer enters the open space in the circle, becoming a fifth participant in the scene.

In her pastels of this period, Cassatt partially abandoned the discipline of line that marked her earlier work. The chalk is applied loosely in large, broken strokes that activate the surface but do not describe the forms. The skillful blending of the flesh tones provides an interesting contrast to the free execution of the background and clothing in vertical and diagonal strokes of unblended color. The sketchy nature of this work, with its brown paper showing here and there as another color, illustrates Cassatt's technique. First she quickly drew in the general outlines of the composition in dark chalk. These lines were then covered with different layers of pastel, which were usually more thickly applied in the face. Finally, Cassatt went back over the design with dark chalk and reinforced and strengthened the major contours in the composition.

REFERENCES

Adelyn Dohne Breeskin, *Mary Cassatt: A Catalogue Raisonné of the Pastels, Watercolors, and Drawings,* Washington, D.C., 1970, cat. no. 272.

Nancy Mowll Mathews, "Mary Cassatt and the Modern Madonna of the Nineteenth Century," Ph.D. dissertation, New York University, 1980.

Mary Cassatt

American, 1844–1926

Women Admiring a Child, **1897**

Pastel on paper; 66 × 81.3 cm (26 × 32 in.)

Gift of Edward Chandler Walker (08.8)

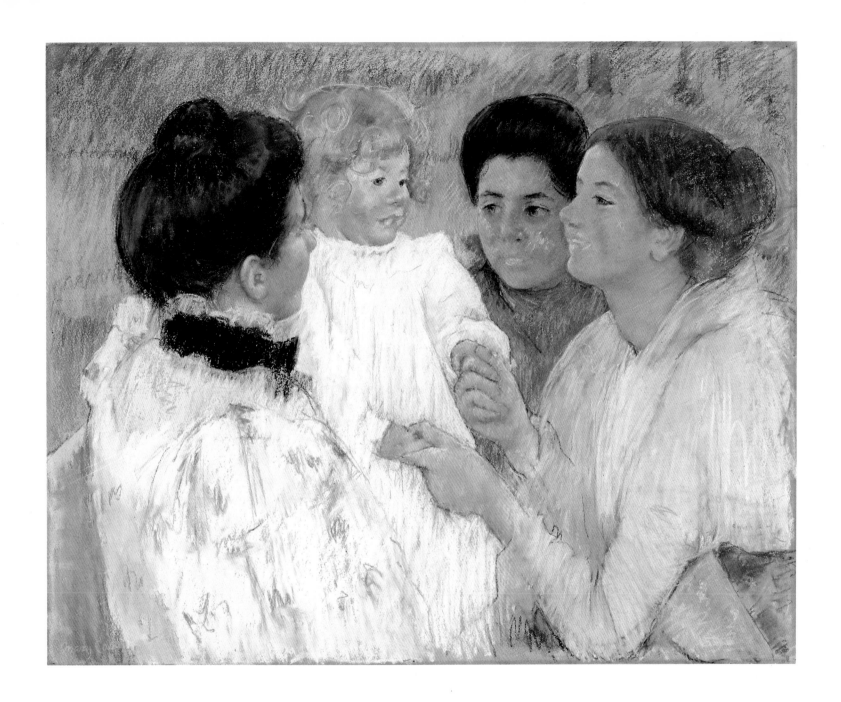

MARY CASSATT

Women Admiring a Child

A bold departure from the lyrical watercolors and tapestrylike oils for which Maurice Prendergast is best known, this canvas was part of a mural project conceived by Walt Kuhn, Arthur B. Davies, and Prendergast in 1914, shortly after Davies and Kuhn had completed two murals for the library of New York collector Lillie P. Bliss. Hoping to attract further commissions of this scale and importance, the three painters executed a set of four canvases, which they exhibited at the Montross Gallery, New York, in the spring of 1915. John Quinn, one of America's foremost collectors of European avant-garde art and a great admirer of the work of these three Americans, purchased all four works: *Promenade;* its companion piece, *Picnic* (Museum of Art, Carnegie Institute, Pittsburgh); Davies's *Dances* (The Detroit Institute of Arts); and Kuhn's *Man and Sea Beach* (now lost).

Though less tightly orchestrated than many of Prendergast's seaside processionals,

Promenade is typically organized into three horizontal bands of grass, sea, and sky. The friezelike arrangement of the figures is abstractly echoed in coloristic sequences of green, blue, and orange, which are for the most part applied in broad, rectangular strokes, with the white ground visible around and between the blocks of color. While the immediate inspiration for this technique can be traced to the French painters Georges Seurat and Paul Signac (whose works Prendergast studied on his trips to Europe and also at the Armory Show of 1913 in New York), Prendergast developed an individual style in which the dabs of color are so large they no longer are subservient to the scientific theories of the rendering of light, but are instead components of a colorful mosaic pattern.

The scene also reflects Prendergast's discovery in Venice of the fresco murals of Vittore Carpaccio. The Renaissance artist's richly detailed pageants and processions, enlivened by imaginative costumes, plants, animals, and other amusing details, offered Prendergast many ideas for compositions and stimulated an interest in subjects involving crowds, processions, and festivals.

REFERENCES

Hedley Howell Rhys, *Maurice Prendergast, 1859–1924,* Boston, 1960, pp. 46, 52, cat. no. 34.

Eleanor Green, *Maurice Prendergast: Art of Impulse and Color,* College Park, Maryland, 1976, pp. 26, 70.

Dennis Nawrocki, "Prendergast and Davies: Two Approaches to a Mural Project," *Bulletin of the Detroit Institute of Arts,* vol. 56 (1978), pp. 243–52.

Maurice Prendergast

American, 1859–1924

Promenade, **1914–15**

Oil on canvas; 2.254 × 3.404 m (7 ft. 4¾ in. × 11 ft. 2 in.)

City of Detroit Purchase (27.159)

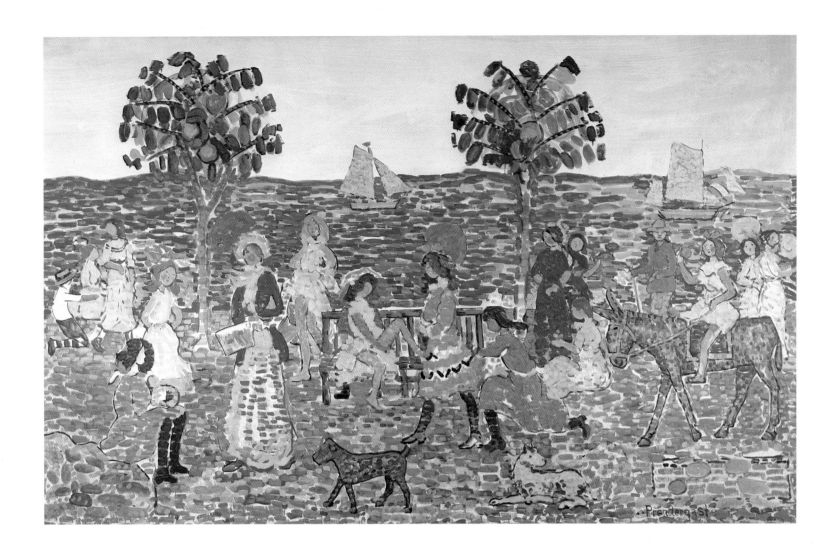

MAURICE PRENDERGAST

Promenade

Modern Art

THE identity of this portrait's subject is revealed in the inscription on the painting, which translates as *To my dearest friend Pallarés/Regards from your friend Picasso*. Manuel Pallarés, a Spanish painter from Aragon, was an old friend of Picasso; during a long childhood illness, Picasso had stayed at the Pallarés family home.

In this early work, the influence of Cézanne on Picasso's painting is evident in the analysis of form as bold, interrelated geometric shapes that incorporate only salient details. A limited palette and volumes defined by linear cross-hatching support this bold concept and at the same time lend the face strength and personality.

The portrait of Pallarés demonstrates Picasso's growing interest in representing form in the style that eventually would be known as Analytic Cubism. Picasso realized that a painting could represent its subject with an abstract arrangement of lines, colors, and shapes integrated on the surface. Rather than presenting pictorial space as an illusion of three-dimensional reality seen from a fixed point of view, he attempted to create form without relying on the traditional means of perspective. Picasso sought to present the totality of an object through a multiplicity of views. Breaking down the object into discrete, abstract facets subordinates the object to the act of visual analysis, so that the painting becomes a demonstration of the total way we see. The head of Pallarés is not presented as if seen in one fixed, all-encompassing glance, but rather is caught by a number of momentary glimpses, which must be organized in the mind and formulated into a portrait.

REFERENCES

Pierre Daix, *Picasso,* New York and Washington, D.C., 1965, p. 79.

William Rubin, ed., *Pablo Picasso: A Retrospective,* New York, 1980, p. 120.

Pablo Ruiz y Picasso

Spanish, 1881–1973

***Portrait of Manuel Pallarés,* 1909**

Oil on canvas; 67.9 × 49.5 cm (26¾ × 19½ in.)

Gift of Mr. and Mrs. Henry Ford II (62.126)

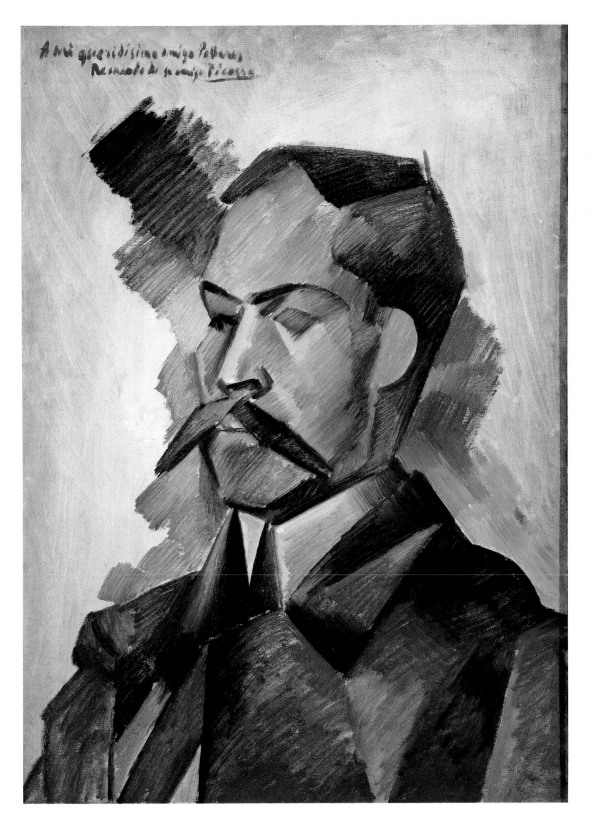

PABLO RUIZ Y PICASSO

Portrait of Manuel Pallarés

THE uncompromising realism of this self-portrait by Otto Dix is in marked contrast to the expressionistic paintings produced by many of his contemporaries. Though his early works show his experimentation with a number of styles, this work, painted when he was twenty-one years old and a student at the School of Arts and Crafts in Dresden, is characteristic of his mature style.

This painting is one of the earliest of many self-portraits done by Dix throughout his career. Here he has chosen to present himself in a consciously archaic pose—one that can be traced to German and Netherlandish portraits of the fifteenth and sixteenth centuries. It is ironic that this work, which draws so directly on the German tradition, was confiscated by the Nazis in 1937 as "degenerate."

Dix personalizes the traditional prototype by bringing to it his own immaculate draftsmanship, attention to detail, and clarity of form and color. Especially masterful are his renditions of various textures, such as the soft nap of the corduroy in contrast to the surfaces of the skin and the flower petals. These textures are defined by Dix's use of a technique that in itself is archaic; the panel is prepared with gesso and tempera, over which successive glazes of oil are laid—a technique similar to that used by late medieval painters and one which results in a uniformly smooth, enamellike surface. The disciplined handling of paint results in a figure lit by a harsh, even light, unsoftened by cast shadows. The lighting intensifies the severe, confrontational mood of this self-portrait, a mood already set by the direct gaze of the figure, his forthright scowl, and the constricted space in which he is placed.

REFERENCES

Diether Schmidt, *Otto Dix im Selbstbildnis,* Berlin, 1978, pp. 18–20.

Fritz Löffler, *Otto Dix: Oeuvre der Gemälde,* Recklinghausen, 1981, pp. 9–11.

Horst Uhr, *Masterpieces of German Expressionism at the Detroit Institute of Arts,* New York, 1982, pp. 60–63.

Otto Dix

German, 1891–1969

Self-Portrait, 1912

Oil and tempera on panel; 73.7 × 49.5 cm (29 × 19½ in.)

Gift of Robert H. Tannahill (51.65)

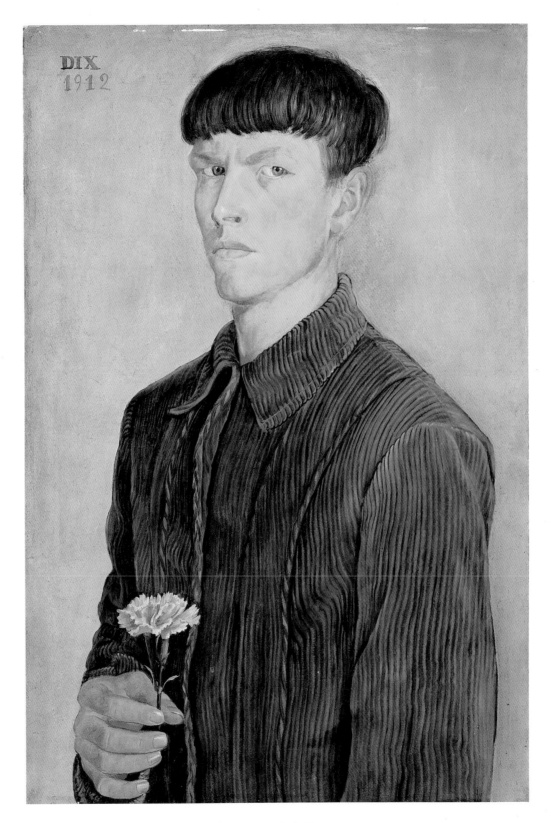

OTTO DIX

Self-Portrait

A calm, sunlit room and its adjoining balcony in Matisse's country house at Issy-les-Moulineaux form the ostensible subject of *The Window*. Because Matisse felt that only compositions "of balance, of purity, and serenity, devoid of troubling or disturbing subject matter" were appropriate for works of art, his frequent use of quiet domestic interiors allowed the relationships of color, shape, and composition to be of importance equal to the subject. By the time this was painted, Matisse had eschewed the strong colors of his earlier period, for which he had been labeled a *fauve* (wild beast), in favor of a more subdued palette. The strong, simple geometric shapes and the hint of multiple views in the circular tabletop are evidence of the influence of Cubism.

The Window depicts a room from which Matisse removed any clear indication of depth or perspective by using color to link horizontals and verticals and to tie together diverse textures. Thus the wall, floor, and rug—all different materials on different visual planes—are made to appear as a single object on a single plane by being linked through one blue-green color. The device of a window framing an exterior view, traditionally used to deepen perspective, here is merely a formal echo of the arrangement of the interior. The interior and exterior are united through the repetition of curved shapes as well as through horizontal and vertical lines. These lines are emphasized by their delineation in black paint, as are the rhythmic patterns of the curtain edge and parquet floor, all of which serve to enliven the composition as well as flatten the space. The scene is divided by a broad white band, which can be read as a stream of sunlight from the window and which becomes another abstract yet physical presence in this restful scene.

REFERENCES

Alfred H. Barr, Jr., *Matisse: His Art and His Public,* New York, 1951, pp. 190–91.

Jean Leymarie, William S. Lieberman, and Herbert Read, *Henri Matisse: Retrospective 1966,* Lausanne, 1966, pp. 14–15.

Pierre Schneider, *Henri Matisse: Exposition du centenaire,* Paris, 1970, pp. 37–41.

Henri Matisse

French, 1869–1954

***The Window,* 1916**

Oil on canvas; 146 × 116.8 cm (57½ × 46 in.)

City of Detroit Purchase (22.14)

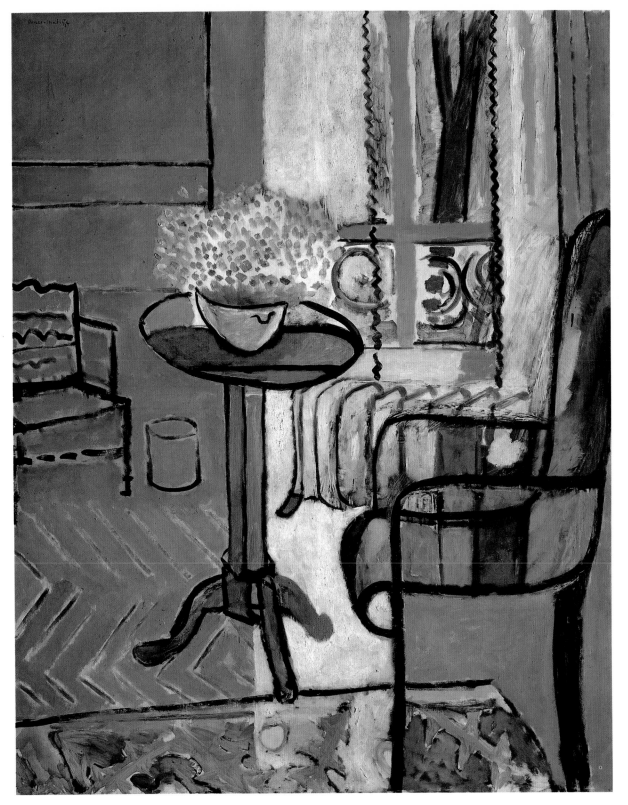

HENRI MATISSE

The Window

IN 1905 a group of artists led by Ernst Ludwig Kirchner banded together to form Die Brücke (The Bridge) to protest the materialism of German society and develop a new aesthetic based upon a greater communion between man and nature. As their spokesman, Kirchner advocated the return to a primordial existence as found in nature. Die Brücke artists developed an intense, emotional style, eventually combining the simplified forms of primitive art with a non-naturalistic use of vivid color.

Winter Landscape in Moonlight is typical of the pantheistic approach that Kirchner and other Brücke artists sought. The painting is one of a series of large mountain landscapes that Kirchner did shortly after he took up residence in Switzerland in 1918. Letters written on January 20, 1919, the day he began this work, indicate that it was meant to celebrate the artist's removal from the corrupt postwar Berlin society into a world dominated by the magnificence of nature. Since the subject of the painting is the dawn of a new day, as the moon pales in the lightening sky, the work also is symbolic of the artist's own triumph over his illness and depression of the previous few years. To convey these ideas, Kirchner heightened the grandeur and awesomeness of the alpine scene by the extensive use of large areas of primary colors and by the powerful sweeping brushstrokes.

Until 1937, *Winter Landscape in Moonlight* was in the collection of the Kaiser-Friedrich-Museum in Magdeburg, Germany. The idealism of the Brücke, as typified in this painting, was in direct conflict with the totalitarian approach to government that Hitler brought to Germany in 1933; the work was considered "degenerate art," and was confiscated by the Nazis.

REFERENCES

W. R. Valentiner, *E. L. Kirchner: German Expressionist,* Raleigh, North Carolina, 1958, pp. 24–25, cat. no. 26.

Donald E. Gordon, *Ernst Ludwig Kirchner,* Cambridge, Massachusetts, 1968, pp. 114–16.

Horst Uhr, *Masterpieces of German Expressionism at the Detroit Institute of Arts,* New York, 1982, pp. 102–3.

Ernst Ludwig Kirchner

German, 1880–1938

Winter Landscape in Moonlight, 1919

Oil on canvas; 120.7 × 120.7 cm (47½ × 47½ in.)

Gift of Curt Valentin in memory of the artist on the occasion of Dr. William R. Valentiner's sixtieth birthday (40.58)

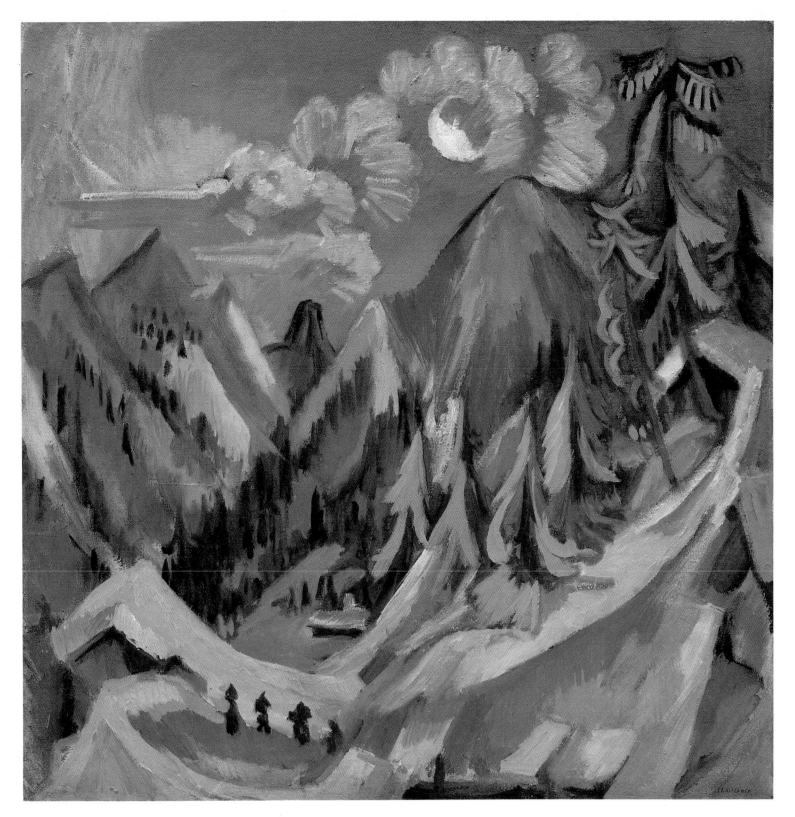

ERNST LUDWIG KIRCHNER

Winter Landscape in Moonlight

Although Oskar Kokoschka was trained in an Art Nouveau style, his mature work shows an awareness of German Expressionist art, particularly of the paintings of the Dresden group of artists—among them Ernst Ludwig Kirchner, Karl Schmitt-Rottluff, and Emil Nolde—calling themselves Die Brücke. *Girl with a Doll,* which was painted around 1921–22, approximately two years after Kokoschka assumed a professorship at the Dresden Academy, is executed in a style typical of Die Brücke artists with its bold palette and simplified, angular forms. Instead of the jagged, highly energized brushstrokes of Kokoschka's earlier work, broad areas of brilliant color applied with deliberate, firm strokes are now used to define and model the form. The juxtaposition of vivid primary colors with greens, ochers, and browns creates a dense, flat surface pattern and gives vitality and dynamism to the composition.

The mood of this painting is different from Kokoschka's earlier, more psychologically expressive works that reflect his pessimistic attitude toward the political and economic climate of Europe at the time of World War I. Here the sitter is depicted without sentimentality and introspection; she appears as a strong, lively child. The girl's radiance, captured by the intensely bold colors and dynamic surface patterns, reflects the satisfaction that Kokoschka had recently found in his new teaching position at Dresden.

REFERENCES

Hans Maria Wingler, *Oskar Kokoschka: The Work of the Painter,* Salzburg, 1958, cat. no. 143.

J. P. Hoden, *Oskar Kokoschka: The Artist and His Time,* Greenwich, Connecticut, 1966, pp. 114, 120, 161.

Horst Uhr, *Masterpieces of German Expressionism at the Detroit Institute of Arts,* New York, 1982, pp. 124–25.

Oskar Kokoschka

Austrian, 1886–1980

Girl with a Doll, **ca. 1921–22**

Oil on canvas; 91 × 81 cm (36 × 32 in.)

Bequest of Dr. William R. Valentiner (63.133)

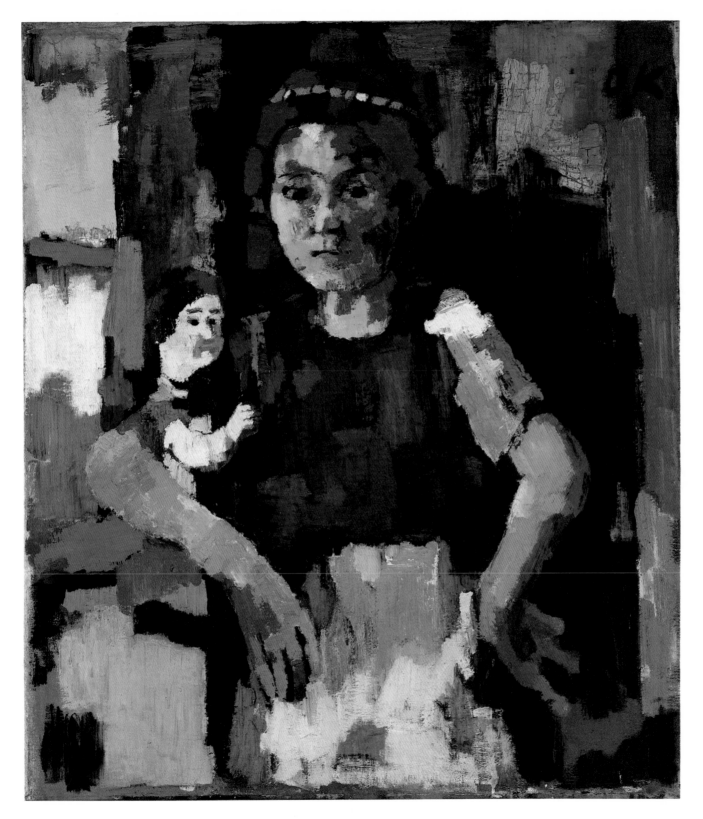

OSKAR KOKOSCHKA

Girl with a Doll

While riding a bus through the streets of Paris in 1923, Yves Tanguy saw two paintings in a gallery window which so impressed him that he got off the bus to look at them. The paintings were by Giorgio de Chirico, the Italian Surrealist painter, and at that moment Tanguy saw new possibilities inherent in de Chirico's enigmatic imagery and resolved to become a painter. Although Tanguy had always had close friends who were connected with the literary movement of Surrealism, his involvement in the movement as a visual artist did not begin in earnest until 1925, when he met André Breton. Breton encouraged Tanguy to develop his art and even used some of Tanguy's writing and drawings in his publication *La Révolution surréaliste*.

Tanguy was an untrained artist who until 1926 painted in a naïve, loosely representational style that compositionally and thematically owed a debt to de Chirico. Nearly all these works were destroyed by the artist himself. In the paintings of 1927, however, a personal style emerged that characterized the rest of Tanguy's career. The works of this period are the product of a personal vision. They portray an infinite space, its vastness demarcated only by a sharp horizon line. The dreamy, alien landscape of *Shadow Country* is populated by amorphous shapes, each casting a heavy shadow, their forms reminiscent of the dolmens that rise up from the misty gray landscape of Brittany. Seaweed-like plant forms suggest an ambiguity between landscape and seascape. This haunting imagery, at once familiar and unknown, is central to Tanguy's theme of the beginning of life and the cycle of existence.

His images reflect the concerns of the Surrealist group: the implications of dreams, the subconscious, automatism, and chance. His painstakingly realistic technique portrays objects and places that are nonexistent, thus blurring the distinction between abstract and figurative painting. This fusion of the imaginary and the real, as depicted in Tanguy's alien landscapes, exemplifies the Surrealists' search for a world beyond the confines of the individual consciousness toward a world perceived by the spirit.

REFERENCES

James Thrall Soby, *Yves Tanguy,* New York, 1955, p. 15.

Marcel Jean, *The History of Surrealist Painting,* Paris, 1960, pp. 159–73.

Dominique Bozo, *Yves Tanguy: Retrospective 1925–1955,* Paris, 1982, p. 88.

Yves Tanguy

French, 1900–1955

***Shadow Country (Terre d'ombre),* 1927**

Oil on canvas; 99 × 80.3 cm (39 × 31⅝ in.)

Gift of Mrs. Lydia Winston Malbin (74.122)

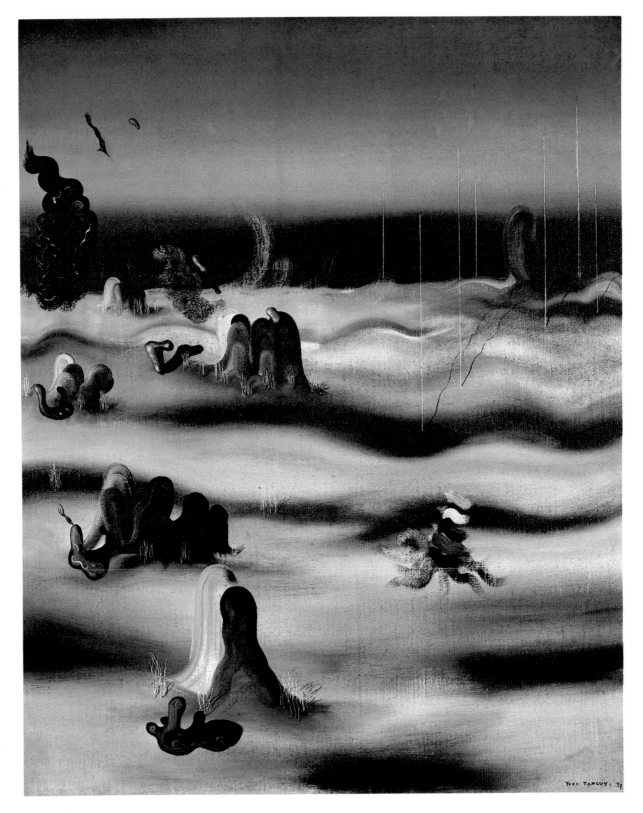

YVES TANGUY

Shadow Country

FOLLOWING the political revolution of 1910, Mexican artists sought to create an art for the people in their new democratic society. Drawing on the tradition of Mexican mural painting and the example of monumental Italian frescoes, Diego Rivera began decorating large wall spaces in public buildings. In 1931 he was invited by Edsel B. Ford and Dr. William R. Valentiner, director of the Detroit Institute of Arts, to create a series of frescoes for what was then the Garden Court of the museum.

The only restriction on this commission was that the murals be concerned in some way with Detroit. Rivera selected for his theme the complex automobile industry in Detroit and its corollary factories, as well as the natural and human resources on which these industries depend. During months of preparation, Rivera visited factories in Detroit to make drawings and photographs of people, machinery, and manufacturing processes. The subjects represented in the cycle of murals are the four races of mankind, agriculture, the automotive, pharmaceutical, and chemical industries, aviation, steam and electric power, and the application of science.

The large panels of the north and south walls form the core of the fresco cycle. On the north wall, shown here, two gigantic female figures in the top panel represent the American Indian and the Black races. Crystal formation of iron ore and layers of coal, both sources of energy, are represented below them. The main panel shows important stages in the manufacture of automobile engines, including molding the engine blocks, casting the molds, boring the cylinders, polishing the blocks, and final assembly. The predellalike panels in the lower register represent workers punching the time clock, on the left, and eating lunch, on the right; between these are scenes of stages in the manufacture of steel ingots.

REFERENCES

Addison Franklin Page, *The Detroit Frescoes by Diego Rivera,* Detroit, 1956, unpaginated.

Margaret Herden Sterne, "The Museum Director and the Artist: Dr. William R. Valentiner and Diego Rivera in Detroit," *Detroit in Perspective: A Journal of Regional History,* vol. 1 (1973), no. 2, pp. 88–111.

Linda Downs and Mary Jane Jacob, *The Rouge: The Image of Industry in the Art of Charles Sheeler and Diego Rivera,* Detroit, 1978, pp. 47–91.

Diego Rivera

Mexican, 1886–1957

Detroit Industry, **1932–33**

Fresco; 27 panels

Detail shown here: north wall
 upper register, left: 2.578 × 2.134 m
 (8 ft. 5½ in. × 7 ft.)
 upper register, center: 2.692 ×
 13.716 m (8 ft. 10 in. × 45 ft.)
 upper register, right: 2.578 × 2.134 m
 (8 ft. 5½ in. × 7 ft.)
 middle register, left: 0.68 × 1.854 m
 (26¾ in. × 6 ft. 1 in.)
 middle register, center: 1.327 ×
 13.716 m (52¼ in. × 45 ft.)
 middle register, right: 0.68 × 1.854 m
 (26¾ in. × 6 ft. 1 in.)
 lower register: 5.398 × 13.716 m
 (17 ft. 8½ in. × 45 ft.)

Gift of Edsel B. Ford (33.10)

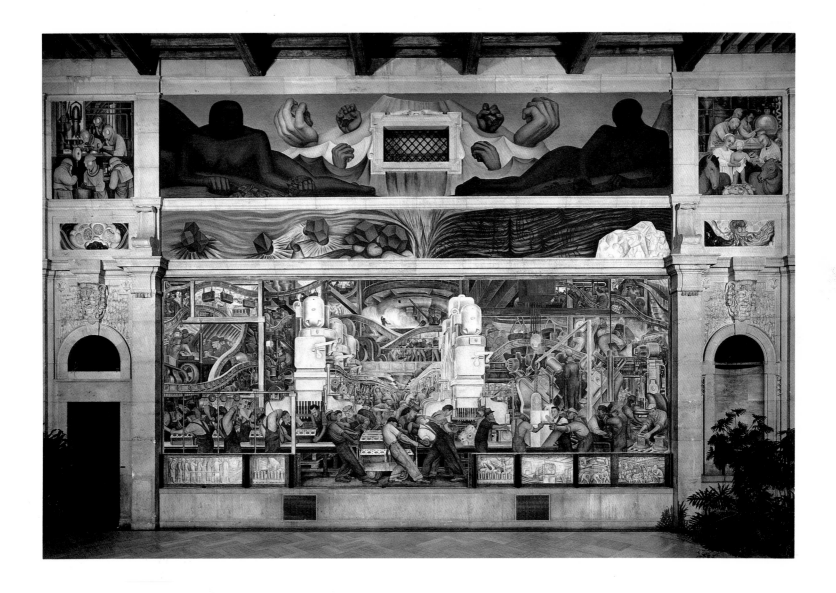

DIEGO RIVERA

Detroit Industry

SELF-PORTRAIT II is the sequel to a more realistic self-portrait, *Auto-Portrait I* of 1937–38 (Museum of Modern Art, New York). In his second version, Miró reduced and abstracted the elements of the earlier work so that its content as a portrait survives only through symbols. Like the parts of the body, these symbols exist in pairs, often in mirror images. The only recognizable elements remaining from the earlier self-portrait are the eyes, here enlarged to fill most of the canvas and retaining the astral shape used in the earlier work. Their prominence may suggest Miró's sympathy with the artistic philosophy of the Surrealists, who emphasized the metaphysical perception of the mind as symbolized by the eyes. Though Miró was less interested in the literary and illustrative aspects of Surrealist art, he did adapt the spontaneity and automatism of Surrealist technique to generate his characteristic abstract shapes.

The forms, images, and colors in *Self-Portrait II* are part of a vocabulary developed during Miró's long career. The unmodulated black background, a traditional device in Spanish painting, serves both to heighten the intensity of the primary colors of the biomorphic shapes and to suggest an infinite space behind them. The latter effect is contradicted, however, by the coarse burlap fabric, which shows through the paint and emphasizes the continuity of canvas and flat shapes.

Self-Portrait II is related to a series of works on burlap done during Miró's exile in Paris at the time of the Spanish Civil War. These paintings imply in their spareness a sense of isolation and uneasiness about the human condition, yet the freedom of the floating organic elements and the gaiety of color surely suggest the triumph of life.

REFERENCES

Clement Greenberg, *Joan Miró,* New York, 1948, pp. 35–37.

Thomas A. Messer, "Miró Twice Removed," *Bulletin of the Detroit Institute of Arts,* vol. 51 (1972), p. 105.

Charles W. Millard, *Miró: Selected Paintings,* Washington, D. C., 1980, p. 28.

Joan Miró

Spanish, 1893–1983

Self-Portrait II, **1938**

Oil on burlap; 129.5 × 195.5 cm (51 × 77 in.)

Gift of W. Hawkins Ferry (66.66)

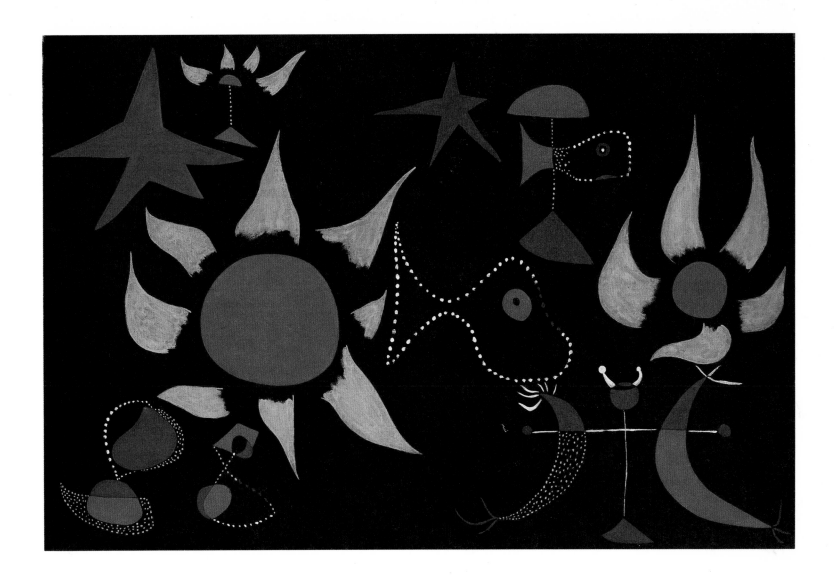

JOAN MIRÓ

Self-Portrait II

FULLY two-thirds of the sculptures of full-length figures done by Henry Moore are related to the theme of the reclining figure, and, with one exception, all are female figures. The Detroit *Reclining Figure* was his last piece done before World War II, and Moore feels that it is one of the most important of his sculptures of this type. It represents the culmination of his work during the 1930s and presages the postwar changes in his style.

Moore's fundamental idea in creating his series of reclining figures was to break up the image of the human body into one form that was truly three-dimensional and thus could be visually explored from every angle. Crucial to this concept is his juxtaposition of solids and voids. He has said that the holes in his work are its true subject; he believes that piercing a block of wood or a piece of stone makes the material immediately more three-dimensional. Moore preferred wood for some of his large-scale pieces because it allowed him the freedom to vary the depth and position of the holes. In addition, the pronounced grain of elm wood, used as a guide to the ultimate form of the sculpture, then suggests that it was partially shaped by nature. The inspiration of primitive art evident in some earlier reclining figures has given way here to the inspiration of landscape: the horizontal pose suggests distance, the undulating forms recall the rolling landscape of Moore's native England, and the tunnels and holes hint at the coal-mining country where he grew up.

The sculpture of Henry Moore defies categorization. Attempts have been made to fit it into various movements or schools of art, but his work remains as he has wished it to be: universal and timeless.

REFERENCES

Curt Valentin, *Henry Moore,* London and Bradford, 1944.

Donald Hall, *Henry Moore: The Life and Work of a Great Sculptor,* New York, 1965, pp. 81–100.

John Russell, *Henry Moore,* Middlesex, 1968, pp. 98–102.

Henry Moore

English, born 1898

Reclining Figure, **1939**

Elm wood; l. 200.7 cm (79 in.)

Gift of the D. M. Ferry, Jr., Trustee Corporation (65.108)

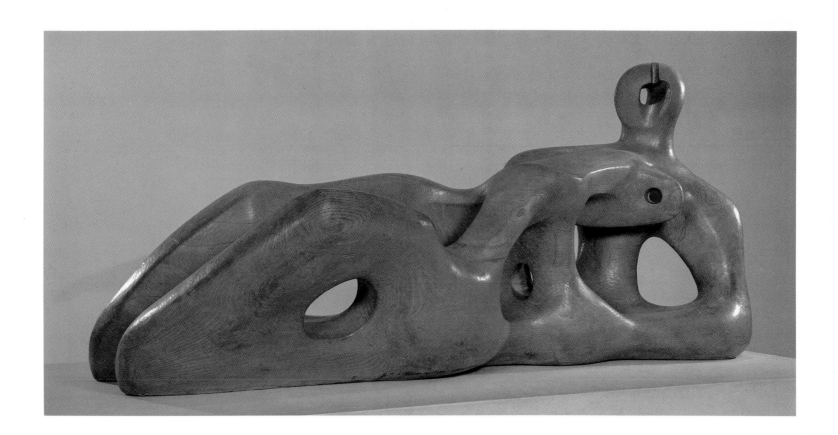

HENRY MOORE

Reclining Figure

BARNETT NEWMAN felt that being an artist was "the highest role a man could achieve." His cool, self-possessed works betray little of the long hours of study and concentration that went into each painting. Newman's titles and themes are drawn primarily from his fundamental concerns for humanity and nature and from a lifelong study of Jewish culture and mysticism. The title *Be I,* for example, connotes existence or being, reduced to a compelling essential command: Be! Subject matter was an intellectual rather than a visual concept for Newman, and all of his works interrelate on a theoretical level that is not readily linked to visual references.

Newman loved the original *Be I* (painted in 1949) so much that when it was damaged in 1959 and he was unable to repair it to his satisfaction, he began work on a second version. In the second version he increased the vertical dimensions of the canvas and changed from oil to a more opaque acrylic paint in order to create the sensation of being "drenched in the chaos of red." Newman has described the dark cadmium red of this painting as a symbolic reference to the earth. The unmodulated color is intensified by the precisely centered white stripe, which Newman called a "zip," and which suggests an instantaneous, rather elusive moment, like a flash of lightning.

While Newman's work is often linked with that of the Abstract Expressionists, his extremely spare style, coupled with his complex philosophical interests, makes his painting difficult to categorize. A painstaking craftsman, he produced only 112 paintings in his twenty-five years as a mature artist. *Be I* (second version) was one of the last works completed before his death in 1970.

REFERENCES

Thomas B. Hess, *Barnett Newman,* New York, 1971, pp. 58, 145.

John Hallmark Neff, "A Barnett Newman for Detroit," *Bulletin of the Detroit Institute of Arts,* vol. 56 (1978), pp. 159–67.

Barnett Newman

American, 1905–1970

Be I (second version), 1970

Acrylic on canvas; 283 × 213 cm (9 ft. 3½ in. × 7 ft.)

Gift of W. Hawkins Ferry Fund and Mr. and Mrs. Walter B. Ford II Fund (76.78)

BARNETT NEWMAN

Be I

GRACEHOPER is one of the largest of Tony Smith's sculptures. Fabricated in six pieces, it was assembled on the north lawn of the Detroit Institute of Arts in 1972 and remains there today.

Tony Smith was active as an architect and designer, as well as a painter; along with Barnett Newman, Mark Rothko, and Ad Reinhardt, he was part of the New York School of painters in the late 1940s and the 1950s. By 1960, Smith's diverse interests were reconciled when he turned his attention to sculpture. His work reflects his varied background: the modular forms, based on multiples of tetrahedrons and octahedrons, retain an architect's concern with grouping forms in space, as well as revealing Smith's personal interest in mathematics and crystallography.

Gracehoper is constructed of planes of sheet steel fitted together, attached to an interior framework, and painted. The solid cubic shapes are emphasized by the matte black finish. The grouped modules balance on four points, and the shape invites the viewer to walk around and through the sculpture. From within, there are open, soaring views of angular forms and suspended volumes; from outside, there are complex masses of form and changing exterior angles. The forms also associate themselves with the industrial landscape; Smith said that the upright center section of this sculpture reminded him of grain hoppers next to railroad tracks in the Midwest.

The title *Gracehoper* is a pun on both "grain hopper" and "grasshopper." The "gracehoper" also was a mythical beast in James Joyce's novel *Finnegan's Wake*. As Smith explained, "The gracehoper represents the modern world of, say, Bergson and Einstein, the world of dynamics rather than statics."

REFERENCES

Frank L. Kolbert, "Tony Smith's *Gracehoper*," *Bulletin of the Detroit Institute of Arts,* vol. 50 (1971), pp. 19–21.

Eleanor Green, "The Morphology of Tony Smith's Work," *Artforum,* vol. 12 (1974), no. 8, pp. 54–59.

Sam Hunter, *Tony Smith: Ten Elements and Throwback,* New York, 1979, pp. 7, 10, 11.

Tony Smith

American, 1912–1981

***Gracehoper,* 1972**

Sheet steel; 7.02 × 6.7 × 14.03 m (23 × 22 × 46 ft.)

Founders Society Purchase and Donation of W. Hawkins Ferry; Walter and Josephine Ford Fund, Eleanor Clay Ford Fund, Marie and Alex Manoogian Fund, and members of the Friends of Modern Art (72.436)

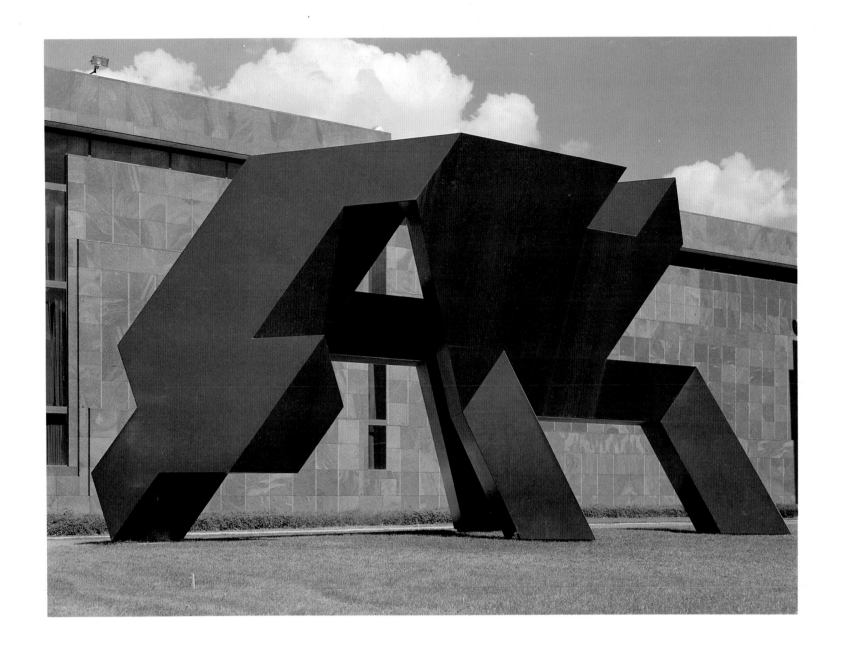

TONY SMITH

Gracehoper

Index of Names

Page numbers in *italics* refer to illustrations.

Abigail, 102, *103*
Adam, 156, *157*
Adamson, Robert, 162, 163
Akhenaton, 22
Albergati, Niccolò, 92
Albert, Prince, 162
Alexander the Great, 28, 38
Alexander VII (pope), 142
Amenhotep III, 22
Angelico, Fra (Giovanni da Fiesole), 18, 94
Anshutz, Thomas, 170
Aphrodite, 30, *31*
Ardashir (Persian king), 40, *41*
Ardawan (Parthian king), 40, 41
Athena, 30
Augustus (emperor), 36
Augustus the Strong (king), 146

Bahman (Parthian prince), 40, *41*
Bamgboye (Nigerian carver), 70, 71
Barberini, Francesco, 104
Bellini, Giovanni, 96, 97
Bergson, Henri, 232
Bernard, Emile, 126
Bernini, Giovanni Lorenzo, 104, 142, 143
Bingham, George Caleb, 196, 197
Black Kettle, Chief, 88
Bloch, E. Maurice, 196
Böttger, Johann Friedrich, 146
Boulle, André-Charles, 144, 145
Bowen, Nathan, 184, 185
Breton, André, 222
Britannicus, 36
Bronzino, Agnolo, 14, 15
Brown, Elias, 186
Bruegel, Pieter, the Elder, 13, 100, 101
Brunelleschi, Filippo, 136

Caravaggio, Michelangelo Merisi da, 18, 106
Carlin, Martin, 150, 151
Carpeaux, Jean-Baptiste, 152, 153
Cassatt, Mary, 13, 206, 207

Cavanagh, Jerome P., 16
Centeotl (Aztec god), 84
Cézanne, Paul, 16, 17, 18, 122, 123, 170, 212
Cézanne, Madame Paul, 122, *123*
Chāmuṇḍā (Indian goddess), 44, *45*
Chardin, Jean-Siméon, 114, 115
Chase, William Merritt, 170
Chigi, Flavio, 142
Christ, 148, *149*
Christus, Petrus, 92
Church, Frederic Edwin, 17, 198, 199
Claudius (emperor), 36
Cole, Thomas, 198
Constable, John, 110
Coombs, William, 188
Copley, John Singleton, 180, 181
Courbet, Gustave, 13
Cummings, Frederick J., 17
Custer, George Armstrong, 88

Darius I, 28
David (king), 102, *103*

David, Jacques-Louis, 116
de Chantelou, Fréart, 104
de Chirico, Giorgio, 222
Degas, Hilaire-Germain-Edgar, 13, 16, 118, 119, 164, 165
de Haan, Jacob Meyer, 126
Delacroix, Eugène, 126, 132
della Robbia, Andrea, 136
della Robbia, Luca, 136, 137
Demotte, Georges J., 14, 40
Demuth, Charles, 170, 171
de Senonnes, Vicomte Alexandre, 160
Devī (Indian goddess), 44
de Vries, Adriaen, 140
Dewing, Thomas, 13
Diderot, Denis, 114
Din, al-, Ghiyath (Mongol vizier), 40
Din, al-, Rashid (Mongol vizier), 40
Dionysus, 34
Dix, Otto, 214, 215
Dodge, Anna Thompson, 18
Dong Qichang (calligrapher), 54, 55
Dreyfuss, Henry, 176
du Barry, Madame, 150
Dürer, Albrecht, 156, 157

Eakins, Thomas, 15, 166, 167
Eastlake, Sir Charles, 162
Einstein, Albert, 232
Eluard, Paul, 174
Endymion, 104, 105
Eve, 156, 157

Ferry, Dexter M., 15
Firdausi (Persian poet), 40
Ford, Edsel B., 14, 16, 98, 224
Ford, Mrs. Edsel B. (Eleanor Clay Ford), 14, 16, 18, 98
French, Daniel Chester, 13
Fröhlich, Joseph, 146, 147
Fugger family, 140
Fuseli, Henry, 15, 116, 117

Gainsborough, Thomas, 18
Gao Shiqi (calligrapher), 54
Garnier, Charles, 164
Gauguin, Paul, 18, 124, 126, 127
Gautreau, Madame (Madame X), 204

Gentileschi, Artemisia, 15, 16
George III, 190
Gerhard, Hubert, 140, 141
Ghiberti, Lorenzo, 136
Giambologna, 140
Gilot, Françoise, 174
Giotto di Bondone, 122
Goethe, Johann Wolfgang von, 110
Goya, Francisco, 15
Gozzoli, Benozzo, 18, 94, 95
Gudea (Sumerian ruler), 20, 21
Günther, Franz Ignaz, 148, 149

Hals, Frans, 15
Harland, Thomas, 186
Hassam, Childe, 13
Hebe, 140, 141
Henry VIII, 98
Hera, 30, 34, 140
Hideyoshi (Japanese statesman), 56
Hill, David Octavius, 162, 163
Holbein, Hans, the Younger, 18, 98, 99
Homer, 116
Hoppe, Ragner, 168
Hume, David, 116

Ingres, Jean-Auguste-Dominique, 16, 128, 160, 161
Irving, Washington, 196
Ishtar (Babylonian goddess), 26
Ix Chel (Maya goddess), 82

Janson, H. W., 116
Jerome, Saint, 92, 93
Jia Qing, emperor, 54
Joyce, James, 232

Kālī (Indian goddess), 44
Kändler, Johann Joachim, 146, 147
Khan, Arpa (sultan), 40
Kiitsu, Suzuki, 62–63
Kirchner, Ernst Ludwig, 218, 219
Kirchner, Johann Gottlob, 146, 147
Kōetsu (Japanese painter), 63
Kokoschka, Oskar, 16, 220, 221

Landolt, Anna, 116
Lenox, James, 198
Leonardo da Vinci, 96
Little Rock (American Indian leader), 88
Locke, John, 116
Lonsdale family, 98

Loring, Hannah (Hannah Loring Winslow), 180, 181
Louis XIV, 144
Louis XVI, 150

Maar, Dora, 174, 175
Manet, Edouard, 118
Manship, Paul, 13
Marcoz, Marie (Vicomtesse de Senonnes), 160, 161
Marduk (Babylonian god), 26, 27
Martin, Ebenezer, 184
Matisse, Henri, 13, 16, 128, 168, 169, 216, 217
Mazarin (Giulio Mazarini), 104
Melchers, Gari, 13
Michael, Saint, 132, 133
Michelangelo Buonarroti, 140, 158, 159
Millet, Francis Davis, 11
Milton, John, 116
Miró, Joan, 226, 227
Modersohn-Becker, Paula, 17
Modigliani, Amedeo, 18
Monet, Claude, 13, 122, 124
Moore, Henry, 228, 229
More, Sir Thomas, 98
Munenao, Takahashi (Japanese calligrapher), 59
Munza (African king), 72

Nadelman, Elie, 13
Nanni di Banco, 136
Nebuchadnezzar (Babylonian king), 26
Nero (emperor), 36, 37
Newberry, John S., 16
Newman, Barnett, 17, 230, 231, 232
Ningiszida (Sumerian god), 20
Nolde, Ada, 172, 173
Nolde, Emil, 172, 173

Ocomatli (Vera Cruz god), 84
Ōkyo, Maruyama, 59
Oppenort, Gilles-Marie, 144
Orangun (African king), 70, 71
Ovid (Publius Ovidius Naso), 104, 116

Pallarés, Manuel, 212, 213
Palmer, Thomas W., 12
Panofsky, Erwin, 92
Pārvatī (Indian goddess), 15, 46, 47

Peale, Anna, 192
Peale, Charles Willson, 192, 193, 194
Peale, Eleanor, 194
Peale, James, 192, *193*
Peale, Rembrandt, 192, 194, *195*
Peale, Rosalba, 192
Perugino (Pietro di Cristoforo Vannucci), 18
Peter, Saint, 142
Philip the Good, 92
Picasso, Pablo Ruiz y, 18, 106, 128, 174, 175, 212, 213
Pisano, Andrea, 134
Pisano, Nino, 134, 135
Pissarro, Camille, 13
Plutarch, 116
Pointel, 104
Poirson, Paul, 204
Poirson, Madame Paul, 204, *205*
Poirson, Suzanne, 204
Pollaiuolo, Antonio del, 14
Pompadour, Madame de, 150
Poussin, Nicolas, 104, 105, 128
Pozzo, Cassiano dal, 104
Prendergast, Maurice, 208, 209
Pul (Biblical name for Tiglath-Pileser), 24

Qian Long (emperor), 54
Qian Xuan, 14, 48, 49

Randall, Richard, 184
Raphael Sanzio, 200
Ray, Man, 174
Reinhardt, Ad, 232
Rembrandt Harmensz. van Rijn, 108, 109, 194, 200

Reni, Guido, 106, 107
Renoir, Pierre-Auguste, 18, 118, 128, 129
Revere, Paul, II, 188, 189
Reynolds, Sir Joshua, 18
Ribera, Jusepe, 15
Richardson, Edgar F., 15
Rigby, Elizabeth (Lady Eastlake), 162, *163*
Rivera, Diego, 14, 224, 225
Rodin, Auguste, 15
Rothko, Mark, 232
Rubens, Peter Paul, 12, 102, 103, 128
Ruisdael, Jacob van, 110, 111
Ruskin, John, 202

Śākyamuni (historical Buddha), 50, *51*
Sargent, John Singer, 204, 205
Schmiedel, "Postmaster," 146, *147*
Scripps, James E., 12, 14
Selene, 104, *105*
Sellers, Charles Coleman, 192
Seurat, Georges, 18, 124, 125
Shakespeare, William, 116
Sheeler, Charles, 176, 177
Śiva (Indian god), 46, 47
Smith, Tony, 232, 233
Sōtatsu (Japanese painter), 63
Stearns, Frederick, 13
Steichen, Edward, 176
Stevenson, Sara, 162
Stieglitz, Alfred, 170, 176
Strand, Paul, 176
Stuart, Gilbert, 194

Tanguy, Yves, 222, 223
Tannahill, Robert Hudson, 17
Terborch, Gerard, 112, 113
Thoth (Egyptian god), 22
Tiglath-Pileser III (Assyrian king), 24, *25*

Titian (Tiziano Vecelli), 14, 15, 102, 106, 128, 200
Toulouse-Lautrec, Henri de, 124
Troyon, Constant, 13

Valentiner, William R., 13, 14, 15, 16, 100, 134, 224
van der Weyden, Rogier, 138, 139
van Eyck, Jan, 13, 92, 93
van Gogh, Theo, 120
van Gogh, Vincent, 13, 18, 120, *121*, 124, 126
Velazquez, Diego Rodriguez de Silva y, 200
Vermeer, Jan, 112
Victoria, Queen, 162
von Humboldt, Alexander, 198

Wagner, Richard, 118
West, Benjamin, 190, 191
Weston, Edward, 176
Whistler, James Abbott McNeill, 15, 200, *201*, 202, 203
Whitcomb, Edgar B., 14, 15
Whitcomb, Mrs. Edgar B., 14, 15
Winslow, Joshua, 180
Woods, Willis F., 16
Woodward, Abishai, 186, 187

Xerxes I, 28
Xochipilli Centeotl (Vera Cruz god), 84
Xuan Dong (emperor), 54

Zeus, 34, 140
Zhang Xu (Chinese calligrapher), 54, 55
Zhang Zhao (Chinese calligrapher), 54

Index of Names